MYSTICAL THEMES IN MILK RIVER ROCK ART

P.S. BARRY

MYSTICAL THEMES IN
MILK RIVER ROCK ART

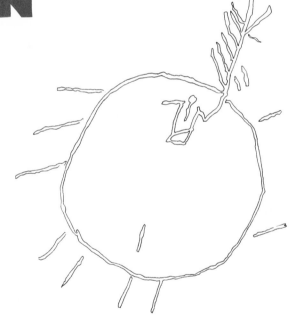

THE UNIVERSITY OF ALBERTA PRESS

ACKNOWLEDGEMENTS

Anyone undertaking a work of this sort which draws upon resources of many disciplines in the arts and sciences necessarily seeks the help of others. I am deeply indebted to J. Roderick Vickers, Plains Archaeologist, Archaeological Survey of Alberta, who read numerous drafts of the book, steered me through the controversial aspects of Plains Indian history and ethnology, and provided relevant publications I would have missed otherwise. I am also grateful to Joan M. Vastokas, Department of Anthropology, Trent University, who read a late draft and made many constructive suggestions. The knowledge and experience of these two specialists contributed much to strengthen the text.

As guides to Milk River rock art and to its natural and human history, Lawrence Halmrast of Warner, Alberta, and Ellen Gasser, a Calgary botanist and a former naturalist at Writing-on-Stone Provincial Park, deserve my gratitude. Halmrast generously provided the photographs essential for comparative study. For their special assistance I also thank Hugh Dempsey, Glenbow Museum; Judith Hudson Beattie, Manitoba Provincial Archives; William J. Byrne and John Priegert, Archaeological Survey of Alberta; Pat Weyerman Hollinshed, Arizona State Museum, Tucson; Douglas Cass, Tania Yakimowich, and Eldon Yellowhorn, Glenbow Archives; and the staffs of the Edmonton Public Library and the library of the Provincial Archives of Alberta.

Research for this book and preparation of illustrations and text were assisted by grants from the Alberta Historical Resources Foundation, and through the cooperation of the Archaeological Survey of Alberta in making the Milk River rock art inventory available for study and for publication. Both institutions are branches of Alberta Culture and Multiculturalism. The Alberta Foundation for the Literary Arts provided funds towards publication.

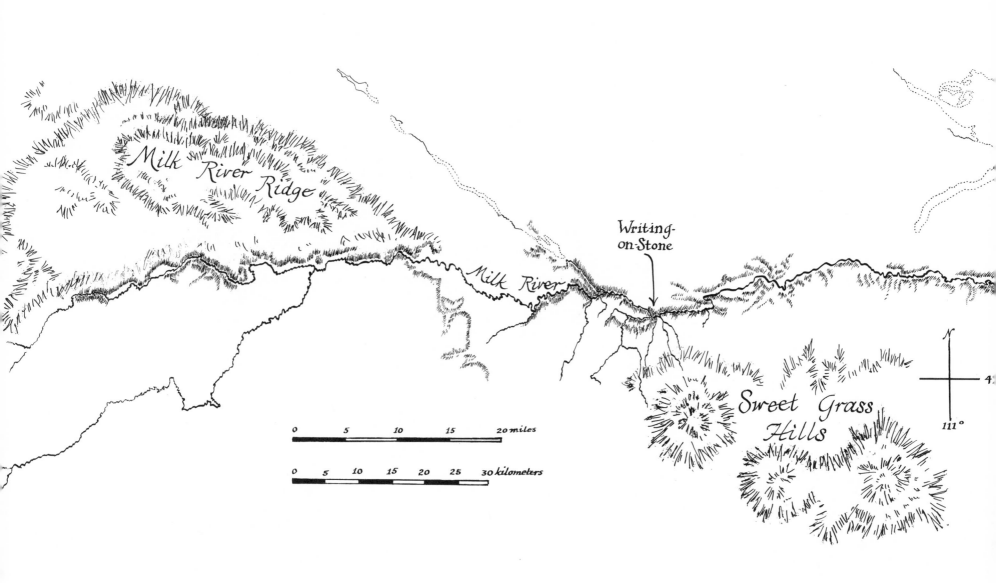

Milk River Ridge

Writing-on-Stone

Milk River

Sweet Grass Hills

0 5 10 15 20 miles

0 5 10 15 20 25 30 kilometers

N

111°

ONE

Documents
of the
Inner Life

Despite the remarkable technical achievements of archaeologists in recent decades, fragments of bone, stone, and earthenware continue to produce, not surprisingly, fragments of knowledge. We still have only a partial and very secular understanding of early Americans. Our perception of prehistoric people in the main reflects the character of the evidence we work with. Chips, flakes, and shards, remnants of grave goods, combings from rubbish heaps, siftings from the ash of old firepits – it is with this sort of piecemeal information that we grope toward what must be an everlastingly unfinished reconstruction of material life during the 12,000 or more years that human beings have occupied the so-called New World. And, as shovelsful of new evidence come to the surface and ever more precise methods of analysis are invented, what we think we know must continually be revised.[1] Indeed, archaeologists are not at all sure when the first people entered the Americas. Even where extensive and monumental ruins imply dense populations supporting urban conglomerations rich in artifacts, say in Mexico or Yucatán, the circumstances of ordinary life for the most part remain obscure and its continuity unclear.

How much more elusive, then, is the *immaterial* life of the ancient inhabitants. The life of the mind, no less real than the tools they manufactured or the dwellings and monuments they constructed, invested existence with ritual purpose and energy, and most objects, whether natural or artificial, with meaningful nuance. Our ignorance on this score is especially frustrating in the case of the people of the Northwestern Plains of North America – southern Alberta and Saskatchewan, Montana, and Wyoming – where populations were always relatively sparse and the evidence of their intellectual and visionary life scanty.

On the plains of the northwest, before the advent of horses in the seventeenth and eighteenth centuries (about 1730 for southern Alberta),[2] the demands of an economy based on the all-purpose bison and involving seasonal migrations over the vast grasslands precluded either the erection of spectacular permanent edifices beyond the scale of cairns and "medicine wheels," or the lavish production of imperishable luxury goods other than beads. Hence, the media of conceptual expression usual among more populous groups were for the most part absent. Here, society was egalitarian to the extent that everybody walked. No empire rose and fell. There was little surplus labour to build great temples or to fashion conspicuous furnishings displaying the symbolism of ideas sanctioned by an elite. There was no real artisan class at all, unless we stretch the term to include such specialists as the point-knappers. The manufacture of household goods was a family en-

terprise limited to such essential equipment as could be packed by dogs, women, and children to the next campsite, and to rough-and-ready tools easily replaced.[3] Normally, personal belongings made of organic materials perished rather quickly, regardless of how skillfully made and how expressive they may have been. In contrast to modern Westerners who are all but suffocated by their artifacts (not to mention what they dig up of others), pre-industrial nomadic people's most valuable and lasting personal possessions constituted for the most part a weightless baggage of "dances, songs, stories, rites and formulas, and names."[4]

As for institutional religion, historically the prime patron of the arts alongside the state and agents of commerce – that remained the province of the shamans, the "medicine men," as they are better known among native people.[5] Cultivation of the arts as a concomittant of sacred and traditional wisdom fell largely to them. Yet the rituals they conducted (including the communal bison and antelope drives), the cosmology they expounded, the cures they effected, and all the other oral and dramatic expressions making up the preponderance of their works acquired permanence primarily through repeated enactments and the rigorous training of young recruits.[6] The material evidence of the shamans' orchestration of community arts is just as scanty, being just as perishable, as household goods.

What is more, in courting mystical experience on an individual basis, the Plains shaman and his vision-seeking fellows found only occasional opportunities to express themselves in any concrete or lasting way. The natural sanctuaries in the mountains and coulees, where one could withdraw to communicate with the supernatural and note impressions on the living rock, were generally separated from traditional campgrounds by formidable distance. Until the historic period the journey had to be made on foot. One did not undertake a pilgrimage casually. Then, too, the prairie landforms, unevenly strewn with boulders and cobbles, did not readily yield the materials with which solitary individuals, equipped with a bundle of portable belongings, could express emphatically and lastingly an intense personal experience.

Not that the Plains people themselves actually sought permanence of expression for its own sake, or in the modern Western sense. To the traditional man, objects of the external world had no intrinsic worth, only a sacred value when animated by a spiritual force, the soul that lives in everything. Mircea Eliade compares our resistance to nature, our will to "make" history, with the archaic "rejection of history," and hence rejection of material permanence as a value in itself.[7] Sam D. Gill, an historian of North American native religion, believes that the main purpose of early people's art was "ritual contact" with the spirits residing in the symbols.[8] Permanence of expression was irrelevant. Nevertheless, *we* seek it among their traces to gain some insight into how *they* imagined reality.

In short, the surviving documents in which the invisible life of the spirit was expressed by the Plains-dweller are rare, scattered, often difficult of access, and exceedingly vulnerable to destruction. Their lingering existence is accidental, not a calculated purpose of their creators. The most obvious of these precious documents in the Northwestern Plains are small cairns, "medicine wheels," petroglyphs (engravings on rock walls), pictographs (pictures drawn in charcoal and ochre), surface boulder arrangements in effigy outline, and the sculptured stones called ribstones. There are also occasional archaeological remains of portable art, for instance, sculptures of bison.

Individually, these works present enigmas. Their apparent simplicity – a great circle of boulders with radiating spokes of stones, for instance, or an engraved diagram of a human form, perhaps headless or armless – seems at odds with a meticulous execution speaking clearly of intelligible purpose.

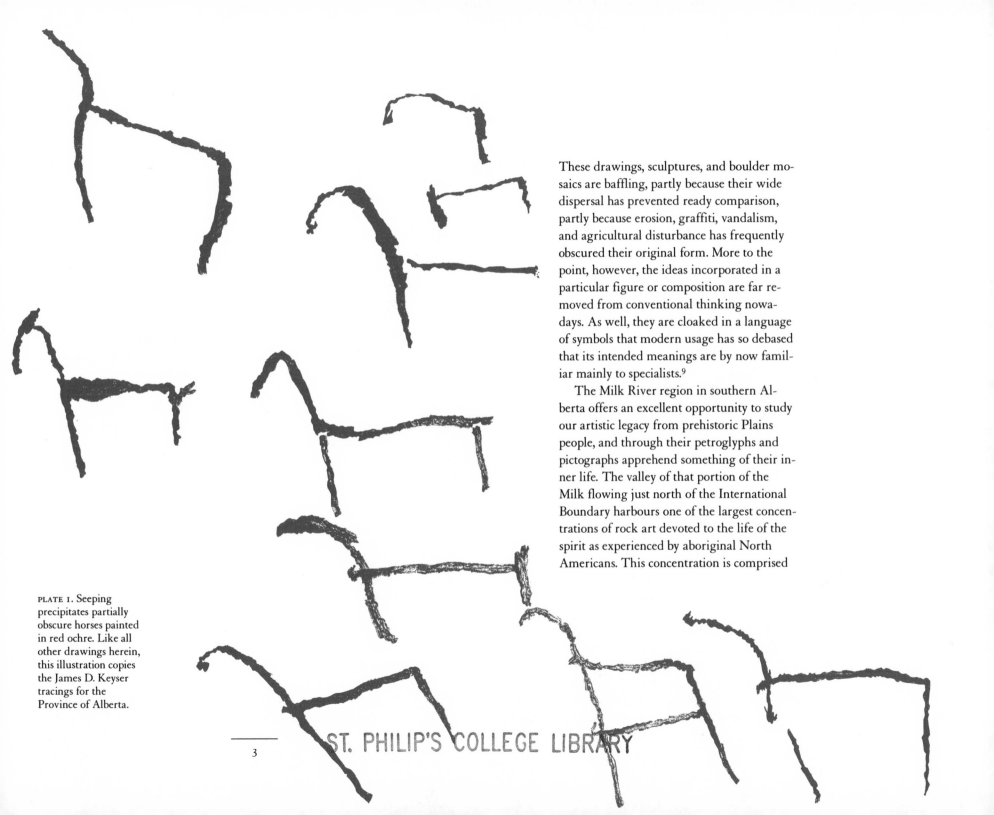

These drawings, sculptures, and boulder mosaics are baffling, partly because their wide dispersal has prevented ready comparison, partly because erosion, graffiti, vandalism, and agricultural disturbance has frequently obscured their original form. More to the point, however, the ideas incorporated in a particular figure or composition are far removed from conventional thinking nowadays. As well, they are cloaked in a language of symbols that modern usage has so debased that its intended meanings are by now familiar mainly to specialists.[9]

The Milk River region in southern Alberta offers an excellent opportunity to study our artistic legacy from prehistoric Plains people, and through their petroglyphs and pictographs apprehend something of their inner life. The valley of that portion of the Milk flowing just north of the International Boundary harbours one of the largest concentrations of rock art devoted to the life of the spirit as experienced by aboriginal North Americans. This concentration is comprised

PLATE 1. Seeping precipitates partially obscure horses painted in red ochre. Like all other drawings herein, this illustration copies the James D. Keyser tracings for the Province of Alberta.

3

of several thousand figures and abstract symbols engraved or painted on cliffs, on exposed rock faces, on flat-topped columnar "hoodoos," and in niches, caves, and shelters. In such wise, they occur on the bluffs along about twenty miles of winding river and tributary coulees.

Although locally Milk River art has been an appealing tourist attraction – and object of vandalism – since the late nineteenth century, Albertans have yet to appreciate it in its cultural context. Even those who might claim kinship with the artists seem unaware of the range and diversity of their works. Natives in the region still regard this part of the valley as a holy place, but a very few, among them the artists Jane Ash Poitras and Joane Cardinal-Schubert, have taken inspiration from the pictures they have managed to see.

In 1961 the provincial authorities took the first step toward protecting and conserving the Milk River pictures by establishing Writing-on-Stone Provincial Park, about 1,000 acres in size, centring on several complex panels and numerous isolated figures. Since then certain specialists – the park guides, a farmer-photographer devoted to archaeology and history, a dozen or so professional archaeologists – in other words people willing and able to search the miles of coulees and river banks, and scramble over fallen sandstone, packing their equipment – have become familiar with Milk River art more or less in its entirety. The fact that the pictures are widely distributed among some sixty definable sites situated among crumbling rocks and on undercut cliff-faces has discouraged further attempts to comprehend the whole array.

Canadians in general know very little about these engravings and paintings. The most refined study of Canadian rock art, an analysis of the profusion of glyphs on an outcrop of limestone near Peterborough, Ontario, draws upon analogs from Siberia to Mexico and from Scandinavia to Hawaii. No examples come from the Milk River.[10] The reason may be that the authoritative transcriptions were unavailable in any useful form in time for publication; besides, the linkages are not obvious between most of the Milk River images and those at Peterborough.

Some art historians are alert to the significance of the Milk River concentration. But although an immense literature exists dealing with the multifarious aspects of archaic art, pictures from southern Alberta have received scarcely any public attention. Two popular books touch upon them, but one author is preoccupied with notions of ancient "astronauts," while the other uses illustrations that are inaccurately transcribed.[11] Authoritative, but much less widely circulated, are Thelma Habgood's three pages of illustrations from Milk River, based on Selwyn Dewdney's sketches and tracings for the Glenbow Archives and the Royal Ontario Museum in 1960 and 1962; and James D. Keyser's 17 photographs and 125 drawings from tracings by his team for the Alberta Provincial Parks Department in 1976.[12] These are fairly well-known to archaeologists and specialized art historians. About 1,500 copies of *Story on Stone,* a booklet containing 240 black-and-white photographs of Milk River art, the most substantial work published on the subject, have been sold to local people and tourists visiting the park.[13]

Already the art of Milk River is disappearing. Most of it may vanish entirely long before arguments about its interpretation are settled. Where the pictures occur on open faces, usually southerly, westerly, or easterly exposures, the soft sandstone matrix is worn away by water and wind, and crumbled by frost. Artwork in protected sites is somewhat less vulnerable to damage. But precipitates from interior crevices have coated parts of the mural surrounding ten painted horses (Plate 1), while flaking walls and the collapse of roofstones have obliterated important figures elsewhere, most seriously in the charcoal and red paint series of the valley's largest cave (Plates 2 and 3). Besides defacing numerous panels, vandals have sawed sections of the easily-shattered rock in the vain hope of carrying off an entire group of figures intact (Plate 4A and B).[14] Since the park's

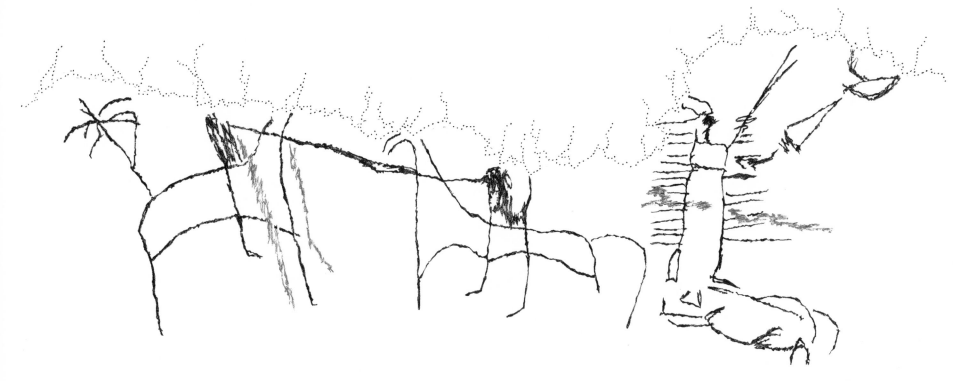

establishment, however, this sort of destruction has been greatly reduced. Nature now takes the greatest toll.

Lawrence Halmrast of Warner, Alberta, who has been photographing the pictures since the early 1950s and who contributed nearly all the illustrations in *Story on Stone,* as well as Plate 5 here, checks off one example after another in which the subject of his photos has deteriorated markedly under the influence of natural wear. At least thirteen sites have lost their images entirely since he began his work about thirty years ago. He explains ruefully that, as he gained in professional skill over the decades, and acquired better equipment, "the rock art was fading away before my eyes."

We must begin, then, to take seriously the art of the Milk River – what remains of it – while pictures still exist in their natural context. North Americans, who have inherited so little from indigenous antiquity compared to Europeans, Africans, and Asians, should become as familiar with their images from the past as, say, the Greeks and Egyptians are familiar with theirs. And such familiarity should foster a new respect, an attitude of thoughtfulness toward aboriginal art and the people who made it.

One aim of this book is to advance this respectful attitude insofar as the art of the Milk River is concerned. The first step is to remedy its neglect by presenting to a much wider audience than heretofore a substantial and representative portion of the pictures in the most authentic facsimiles available.

Two ambitious projects contribute to the purpose. The first is Halmrast's extensive photographic record, dating from the early 1950s when he accompanied the Dewdney party to record pictographs for the Glenbow Foundation; he has now prepared a complete set of prints from his photographs for deposit in the archives of Galt Museum, Lethbridge, Alberta.

The second line of valuable documentation is the inventory of pictures conducted in 1976 by a team of anthropologists led by Keyser. This work resulted in a report and about eighty rolls of tracings on polyethylene sheets, now in the custody of the Archaeolog-

PLATE 2. Touches of red paint overlay a fringed figure and two horsemen drawn in charcoal on a cave wall. Disintegrating stone damaged the mural along the dotted lines. Paint and charcoal are simulated in these tracings.

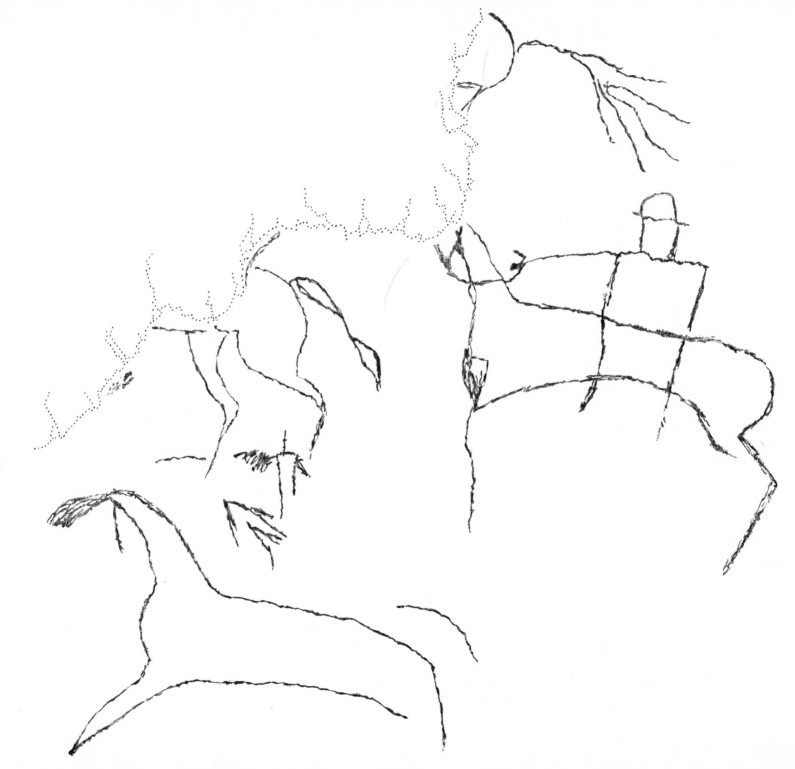

PLATE 3. Another excerpt from the same mural as Plate 2: crumbling rock (dotting) has obliterated parts of charcoal horses.

ical Survey of Alberta in Edmonton.[15] Furthermore, the figures on many of Keyser's sheets have since been photographed and reduced for ready reference. Keyser and his assistants actually found many more pictures than were previously known. It is thought that, with the exception of an inaccessible few already recorded by Halmrast, their inventory includes virtually everything extant at the time. Of further assistance are nine photos taken in 1895 by R.N. Wilson of Fort Macleod, and a few others by Charles M. Sternberg of the 1915 Geological Survey of Canada expedition.[16]

Conditions in the field being what they are and the weathering away of pictures only to be expected, it is not surprising that the Halmrast photographs and the Keyser tracings do not agree in all particulars. In most cases, slight differences seem to matter little. For other pictures they matter very much: traces of schematized internal organs drawn on human and animal figures are significant wherever found; so are indications of eyes, and subtle lines linking one figure to another or encompassing one within a larger. Nevertheless, one can work with the advantages of both kinds of record to overcome most of the disadvantages.

It is from Keyser's inventory that I have drawn most of the illustrations here of Milk River art. An exceptional three pictures derive entirely from Halmrast's photographs, along with certain features in other pictures that do not appear in the inventory.

This book intends to be more than an overview of Milk River images in that it works toward an understanding of the pictures' contents. Artists of modern Western civilization have commonly devoted themselves to copying nature, celebrating secular heroes, playing with form, light, colour, and texture, or simply producing decorative effects. But the creators of sacred art, such as we expect to find in a holy place like Writing-on-Stone, always imbue their work – often down to the smallest detail – with serious meaning. Their purpose is to depict invisible reality, the supernatural as they have experienced it.

This fact obliges us to go beyond the field archaeologist's parameters. We turn to the established methods of art historians who treat works of art not as a fringe activity superfluous to economic and social matters, but as documents and witnesses to all aspects of life.

The technique of analyzing archaic iconography has become feasible in recent decades by the development of global communications, putting at the disposal of scholars everywhere the data amassed by their colleagues. It is a familiar procedure to historians of literary art and drama, too, who have found that essentially the same motifs and themes repeatedly occur, and thus are basic to world literature of all ages and places, despite the myriad variations in context, types, style, attitude, and emphasis. Iconographic analysis has proved particularly useful in exploring the content of religious art, so that specialists in comparative religion now recognize that principal spiritual themes and mystic symbols, though continually reoriented, have always been more or less in conformity. Now, declares Eric Neumann, we are able to experience a "world art."[17]

The analytical method used here is essentially the same as that employed by Joan M. Vastokas and Romas Vastokas in their admirable treatment of native Canadian rock art at Peterborough. As Erwin Panofsky has formulated it, one begins with a systematic study of forms to identify their subject matter as conventional motifs or symbolic images belonging to the artist's culture. The next stage is to view the organization of these motifs into complex images, that is to say, compositions, which reveal deeper meanings of the work than isolated motifs convey. The final stage, termed iconology, is in fact, a synthesis, a provisional reconstruction of the intrinsic meaning of the work when placed against the background of its milieu. The controlling principle is familiarity with the myriad ways in which the "essential tendencies" of the human mind have been ex-

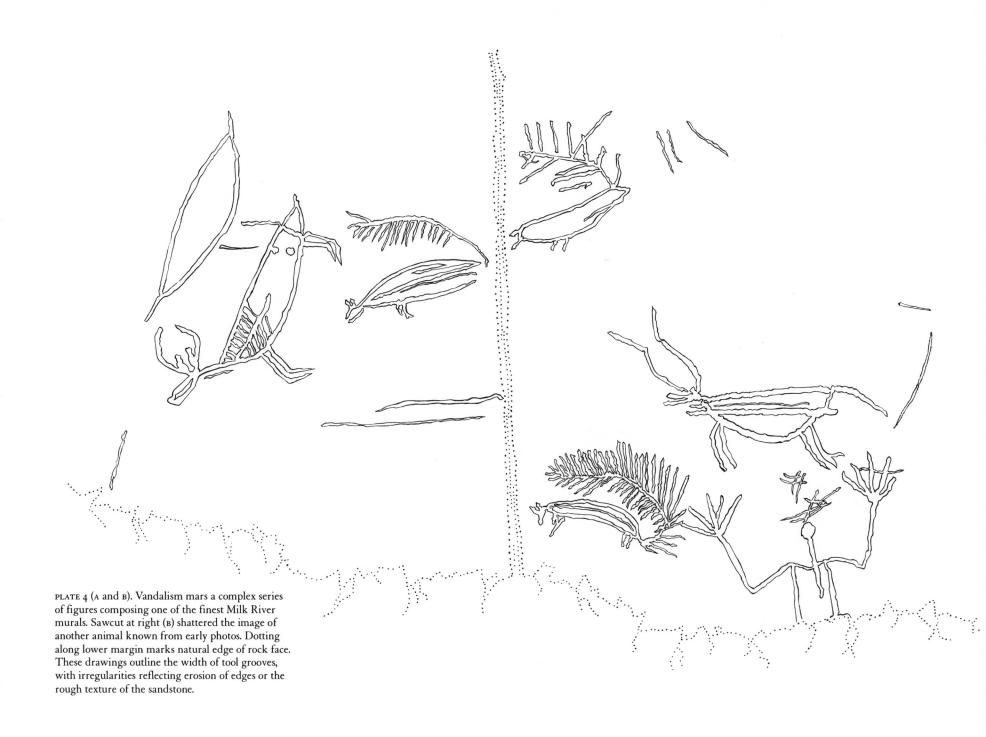

PLATE 4 (A and B). Vandalism mars a complex series of figures composing one of the finest Milk River murals. Sawcut at right (B) shattered the image of another animal known from early photos. Dotting along lower margin marks natural edge of rock face. These drawings outline the width of tool grooves, with irregularities reflecting erosion of edges or the rough texture of the sandstone.

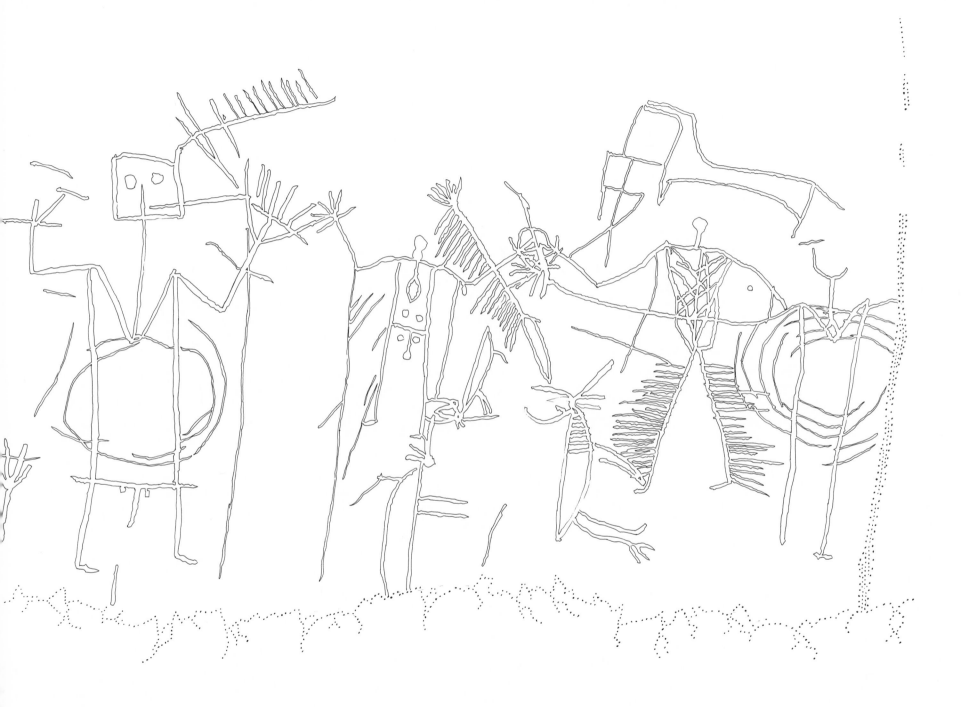

pressed by specific themes and concepts; hence the necessity of adducing relevant analogs. All the while, the practitioner is acutely conscious of his own cultural prejudices.[18]

According to another art historian, Jean Seznec, a disciplined iconography complemented by iconological synthesis allows us to identify a continuing tradition, tracing its direction as a stream in the history of ideas.[19] This is a special advantage for the study of Milk River art which spans the sudden conversion of a conservative people, whose vision of the universe was more or less settled, to the exuberant, wide-ranging, often violent horse culture of the Blackfoot and their neighbours. The method is also sufficiently flexible to deal with a multitude of diverse individual works executed by several different techniques over an indefinite period of time and spread over miles of rocky river valley.

The next three chapters aim to establish the historical, natural, and cultural context applicable to all pictures in the Milk River valley, whether sacred or secular in content. The rest of the book is a step-by-step examination of the pictures themselves. (Site location is vague in the interests of conservation.)

The principal forms through which Milk River artists expressed their vision fall roughly into three main groups: the human forms, the animal and bird forms, and the forms depicting horses. None of them is always entirely separable from the others. I consider each group in turn, along with motifs typically associated with them. Here and there I undertake provisional readings of pictures, synthesizing forms and motifs already discussed.

Along the way I cite many analogs from other cultures, not only from North and South America, but from Europe, Asia, and elsewhere. These comparisons establish the universal context in which these pictures should be viewed. They demonstrate that, while Milk River art is in many respects unique, it is not unintelligible across cultures. Its motifs are common to many local and regional traditions. Its themes belong to humankind. It speaks in much the same symbolic language always used when natural mysteries are the object of religious awe. Hence, the motifs and their analogs lead us directly to the mystical content of Milk River art, the aspect that most needs attention.

The pursuit of analogs is fruitful in another respect. It reveals that similar ideas of the sacred arose repeatedly, not just by means of tradition, diffusion, and migration, but also where there was no possibility of contact, through the inherent structure of the human mind. Like boats and animal impoundments, the soul and god were reinvented many times. The mystical content of horse-and-rider imagery of the Milk River exemplifies exactly this kind of spontaneous invention.

All ancient peoples experienced the same fundamental conditions marking out the main features of the world in relation to themselves: the sky overhead with bright circling bodies; the waxing and waning of the moon; the earth underfoot from which sprang the vegetation and multitudes of creatures, all nourished by sun and rain in due season. These fundamentals were everywhere the same, regardless of local and temporal variations. In other words, the tipis, the spiralling stone formations, the "medicine wheels," and the cosmograms beside the Milk River are bound to have something in common. And not only with each other, but also with the *kivas* of the Anasazi, with the pecked-cross stones of Teotihuacán, with the theatrical organization of Stonehenge and the Thracian temples of Romania, all of them symbolic alignments reflecting in some way the visible motions of the heavens which define the structure of the world.[20] This structure, based on sure knowledge from repeated observation, was much more obvious to archaic mankind than to industrialized and urban people who go indoors to study the stars.

The Natural History of a Sacred Site

The water has a peculiar whiteness, such as might be produced by a tablespoon full of milk in a dish of tea, and this circumstance induced us to call it Milk River.[1]

In this way the Milk River received its English name in May 1805. To Captain Meriwether Lewis, en route from St. Louis to the Pacific, it appeared a "deep and gentle" stream, bordered by "considerable cottonwood and willow." He guessed from his hasty three-mile detour upstream from the Missouri that it "may approach the Saskashawan and afford communication with that river."

Heretofore the Milk River had been known as *Kin-nax-is-sa-ta*, Little River. So it appears on maps that The Feathers and Little Bear, two Blackfoot chiefs, drew for Peter Fidler in 1801 and 1802 at Chesterfield House, the Hudson's Bay Company outpost on the South Saskatchewan near the Red Deer River.[2] These maps and one drawn by a Fall (Gros Ventre-Atsina) Indian show that the natives of the Northwestern Plains knew there was no connection between the Milk River and the Saskatchewan Basin. The fact that these rivers belonged to two separate drainage systems was not yet apparent to the European commercial interests, who until 1879 concentrated their western explorations farther north in the aspen parklands, the fur-producing "bush country," and so were quite unfamiliar with the prairie lands.[3]

Only during interglacial times was what we call the Milk River part of the Hudson's Bay drainage system. Then it flowed northeastwards, as did also the more southern Marias and Yellowstone rivers. But advances of the Wisconsin glaciers 22,000 to 16,000 years ago recontoured the landscape of southern Alberta. The Milk River Ridge, a remnant land form from before the ice age which stood 2,500 feet above the prairie floor, now formed, together with the glacial refugium of the Cypress Hills, a segment of the height of land known as the Missouri Coteau. Thenceforth the Milk River and several rivers to the south flowed into the Missouri-Mississippi watershed.[4]

Because in its final advances glaciation seems to have reached no farther than present-day Lethbridge and Medicine Hat, the plains bordering the Milk River valley may have been hospitable for human beings much earlier than the rest of Alberta. Moreover, some palaeoecologists think that the two lobes of the Wisconsin glaciation never coalesced. If they are right, Milk River country served for 55,000 years or more as the opening of a narrow ice-free corridor that extended between the Cordilleran and Laurentide ice-sheets from the Arctic coast to the Boreal forests fringing the glaciers, and led

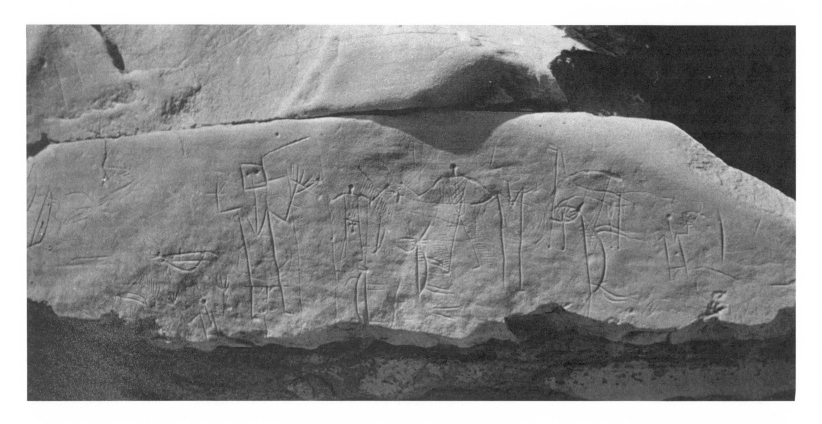

to grasslands beyond.[5] Thus it is possible that this river lay across the path of some of the earliest people migrating southward through the Americas.

However obscure the river's primordial involvement with humankind, its spectacular features, those associated with holy mysteries, plainly had their beginning in the melt-water pouring from the margins of the Cordilleran ice-sheet as the climate warmed.

The torrents continued for millennia, washing a valley 1,500 feet wide out of the upland forests and prairies of Montana and Alberta. In time, along a certain twenty-mile stretch, the water scoured two hundred feet into the earth to expose sandstone beds deposited eons before along the retreating shoreline of ancient seas. Some layers of these outcrops were hard and shaley, some soft, some more or less iron-rich and therefore red, while oth-

ers were gray with clay or studded with ironstone concretions.[6] The finishing detail was the ongoing work of wind and frost, cracking apart the sandstone slabs, eroding away concretions to leave pits and deep holes, enlarging chambers, shaping and smoothing the hoodoos, columns, and castellations out of rock of uneven resistance, crumbling surfaces into rough chips, and the chips once more into sand.

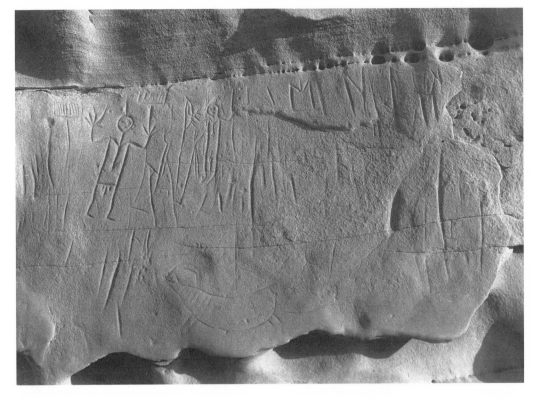

PLATE 5. Photographs show Milk River petroglyphs as they appeared several years ago: (A) the mural of Plate 4 as it was before a vandal's saw broke off the right-hand portion; (B) the mural of Plate 16, illustrating the kind of natural holes, cracks, and edges that could influence artistic form and meaning. Copyright © 1990, Lawrence Halmrast, Warner, Alberta.

As the glacier shrank, the river in these parts subsided into a modest stream, meandering broadly within its bordering outcrops and perpetually shifting its sandbars. At most, it was only eight feet deep. By this time, silt and sand were the "milk" in the Captain's tea.

Even today, in the contrast between the undulating, almost featureless expanses on the level of the short-grass prairie, and the deep descent among dramatic rockscapes and diverse riverine vegetation one can still feel something of the emotions experienced by the earliest visitors to Writing-on-Stone. To those sensitized to every nuance of their surroundings, as the aboriginal inhabitants surely were, this was a passage from one world of creation to another, each defined in distinctive forms of life.

The dry prairie above, spreading in subtle shades of green and brown toward distant blues, was the everyday world of the meat-hunter, the windy range of bison, elk, and antelope grazing on speargrass, bluegrass, and blue grama among the scattered sage brush and cactus. This country was virtually treeless; the scarcely noticeable landmarks were small depressions, shallow coulees, and ephemeral lakes and sloughs. The short turf was alive with jack rabbits, voles, deer mice,

and ground squirrels, the prey of owls, eagles, falcons, and skimming marsh hawks, of foraging coyotes, swift foxes, skunks, and badgers, and of the now-extinct prairie grizzly bears. In spring, patches of crocus bloomed, then successively, prairie roses, lupines, locoweed, and golden asters. Longspurs, pipits, meadowlarks, and grasshoppers burst from grasses and sedges ahead of the traveller's every step, while blue butterflies danced in the sun. Wolves and men followed the bison.

From the edge of this familiar country the Milk River valley opened with startling splendor on a phantasmagoria of variegated rock juxtaposed with pockets and crescents of vivid greenery, all dropping sharply away to the river itself which flowed beneath huge cottonwoods. Each level, each sheltered nook, each change of exposure of light, wind, and moisture generated a unique community of flora and fauna, an exotica peculiar to that spot alone.[7]

The high ledges overlooking the river and deep-cut coulees belonged to the eagles and falcons nesting there. An elevated rock table was the territory of a pair of nesting geese, renewed generation by generation. Cliff swallows by the hundreds plastered their nests against the underside of protuberant rocks. Bluebirds, phoebes, and rock wrens inhabited the smaller *tafoni,* the weathered-out holes permeating vertical

rock; in the larger holes lived great horned owls and countless bats. Lower down, where sage brush grew on dry southwest-facing slopes exposed to the wind, and juniper clung to bits of soil caught in cracks, the crannies were occupied by bushy-tailed woodrats, rattlesnakes, scorpions, spiders, crickets, and wasps. The moister flats and protected draws and slumps throughout the valley bottom where grasses, nettles, and larkspur could flourish, harboured cottontail rabbits. Mourning doves sometimes frequented the barest ground, the eroded "badland" parts and the hoodoos. More than a dozen species of lichen – white, yellow, bright green, brown-and-white, brick-red, and orange – encrusted the rocks and pockets of sand among sparse patches of sand grass and Indian rice grass.

At the riverside and in certain coulees elegant stands of spreading cottonwoods and willows shaded tangled roses, saskatoons, thorny buffalo berry, and poison ivy. Mule deer and porcupines browsed there, while songbirds feasted on insects and berries. Dragonflies, sparrows, and blackbirds enlivened stretches of wet meadow supporting reeds, cattails, silverweed, and mint. Marmots ventured from the rocks to feed on forbs along alluvial flats. Bobcats prowled the coulees and river margins hunting rabbits, voles, eggs, and scraps of beached fish. Kingfishers dove for chub and dace; great

blue herons came to fish in late summer. And in the thickets along coulee streams beavers laboured on their works; in their pools lived silvery minnows and choruses of frogs amid a plenitude of mosquitoes.

Out of this strange terrain, a crowded mosaic of interdependent life so different from that of the prairie, arose warblings, hums, rustlings, and unpredictable echoes. Hoots and shrieks animated the night, muted coos the shadowy hours of day. And whenever something stilled these sounds, clouds passing the moon, perhaps, or a rush of wind – or nothing nameable – the effect was breathless anticipation.

It is understandable that the Plains people regarded this remarkable quarter of their universe with awe and apprehension. In the first place, the "triptych" of stone, water, and tree has been, the world over, the hallmark of the holy site as a dwelling-place of spirits. These three essential elements, which Writing-on-Stone possesses in abundance, constituted a microcosm, a universe in miniature, proclaiming a resident supernatural power. Mircea Eliade, who has compiled and analyzed evidence of religious practices worldwide, explains one level of the symbolism incorporated in such typical sacred places:

Stone stood supremely for reality: indestructibility and lastingness; the tree, with its periodic regeneration, manifested the

power of the sacred in the order of life. And when water came to complete this landscape, it signified latencies, seeds, and purification.[8]

In the sacred world order of archaic cultures each of these symbols connected with others in an almost endless network of super-charged meaning linking natural phenomena, from the stars and planets to the least pebble and plant, a coherent system of science mixed with magic.[9] The tree, for one, was the centre of the universe wherever it stood, the meeting place of the underworld and celestial realms, a conception of the cosmos that Northwestern Plains Indians repeatedly expressed in the structure of their tipis and sun dance lodges, and, in the case of the Assiniboine and Cree, even in their buffalo pounds where they erected a central offering pole.[10] Indeed, the World Tree, analog of our Christmas tree, was commonly an avenue of the shamans' ascents and descents into the upper and lower regions during ecstatic trances. It is unlikely that the first discoverers of the Milk River sacred site were oblivious to the traditional correspondences inherent in the primary features of that place.

But this sanctuary offered more than a compact *imago mundi* as set forth by nature. It was extraordinary in the sense that the un-usual always characterized everything in which the sacred resided, everything that served as a sign of a powerful presence.[11] Its very location was signalled as far as a hundred miles away across the prairie by the looming Sweetgrass Hills, three darkly-forested igneous stocks south of the river which alternately veiled and revealed themselves in shifting mists and sweeping storms.[12] From the north and west the slumbering mass of the Milk River Ridge was the guide. Within the valley, shadows and colours mingled and faded in the changing light and unsettled weathers, so that hidden detail became suddenly visible, while apparently solid shapes would melt away. In the sun's low angles steep brush-covered hill-sides and naked rocks seemed about to rise as living forms. Crowds of hoodoos, pale in blazing noon, descended toward the river like ghostly ranks of ancestral spirits receding in memory. The sight of these forms, semi-human in shape, seemed to abolish time. They spoke of eternity.

Two attributes of Writing-on-Stone presented a significant paradox: the wasteland and the paradise combined in one prospect. The interplay of barren and stony terrain with groves of flourishing greenery must have affected meditations as well as visions. The ambiguities of the place, attractive yet repelling, refreshing yet sinister, were the sort to provoke ambivalent feelings in even the most unreflective soul. For the mystics and intellectuals, including the shaman artists, these contradictions furnished a starting point for philosophical speculations on the nature of divinity as a "coincidence of opposites," now benevolent, now destructive, sometimes both simultaneously. This very principle informs the ubiquitous tales of North American Indians in which Old Man or Napi of the Blackfoot, Coyote of the Sioux, Raven of the Haida, and such oxymorons mirroring the shamanistic personality, are by turns Creator and cheat, fool and sage, shape-shifter and psychopomp.[13]

Finally, the river valley itself, a broad opening in the mother earth, was a veritable birthplace of teeming life. Like the Peterborough petroglyphs, where the dominant element of a design filled with eggs, animals, and personified spirits is a large female figure incised around a natural vagina, beneath which a hidden brooklet runs, Writing-on-Stone was understandable as a womb. Wherefore its works of art, again like those at Peterborough, were integral with the landscape, and so inseparable from nature.[14] Truly, Writing-on-Stone was a place of transformations, pulsing with potential being.

THREE

"Aysin 'eep"

It has been written

The first people to leave traces of themselves in this numinous setting on the Milk River arrived, insofar as anyone knows, about 3,000 years ago.[1] The few scanty hearths Jack Brink found when excavating directly under panels of petroglyphs show that these picture sites were not themselves traditional campgrounds or ceremonial centres, but rather the object of repeated brief visits by few people. From the start, then, Writing-on-Stone seems to have been regarded as sanctified ground. In fact, most of the artifacts recovered from beneath the pictures – projectile points of high quality, pieces of bone, red ochre, glass beads, even the artists' tools – are best interpreted as offerings to the spirits resident in the pictures.

Substantial clues as to who these earliest visitors were and how they probably lived undoubtedly lie within a series of large settlement sites on the prairie level along either side of the Milk River to the east and west of the park. None of these sites is closer than a mile of the petroglyphs; the farthest are thirty or forty miles away. The larger ones contain clusters of fifty or more stone circles suitable for a full complement of domestic and communal lodges, from the individual household tipi to double-ring ceremonial structures for large assemblies. Some circles overlap, suggesting repeated use of the same spot, or perhaps even some of the same stones. Other patterns in stone are visible among the tent rings: spirals, concentric circles, cairns, medicine wheels with radiating spokes, animal and human figures, and various small forms possibly outlining sweat-bath lodges and vision-quest "nests," all testifying to an intense religious life inseparable from the community's social and economic affairs.[2]

Archaeologists have yet to excavate this series of settlements. After surficial studies over several seasons, Andreas Graspointer sees them as occurring in two general localities, each marked by evidence of a particular scheme of activity, and hence of seasonal use. The more western sites, he observes, are in the neighbourhood of known kill sites, including two major buffalo jumps not far from the park. On the other hand, lithic workshops, where point-makers left heaps of stone flakes, are associated exclusively with the eastern, or downstream sites.

These distinguishing features, considered together with the topography of the individual sites and the weather typical of each locality, lead Graspointer to think that in fall the inhabitants of Milk River country tended to move west from their eastern encampments, then back downstream again in summer – depending, of course, on the movements of the bison. At their winter camps in the protected western sites, close to wood for fuel and within the influence of warming Chinook winds, they could exploit in both

fall and spring the prolific herds wintering in the vicinity. In summer, by occupying the breezy exposures of the more arid country downstream, the people would escape the worst of the insects, and were near the summer range of the bison as well as good antelope habitat, berrying grounds, and the arroyos that supplied cobbles for manufacturing quartzite tools.[3]

This general rhythm of existence, though always subject to the unpredictable wanderings of the bison, seems more or less typical of prehistoric life on the Northwestern Plains, and is apt to be of great antiquity. As it happens, the oldest artifact reported from the Milk River settlement sites is an Agate Basin spear-point, found in a chipping station down-river from the Park.[4] The point is significant because it is of a type datable to about 8,200 B.C. Hence it belongs to the period when Plains-dwellers were shifting to communal hunting of bison, the economic system allowing them to elevate their standard of living much above that of mere foragers.[5]

There seems, therefore, a lapse of several millennia between the earliest of signs of human communities in the Milk River country and the first evidence of visits to the petroglyph sites. The lapse could be more apparent than real, of course, simply the luck of the draw, always a factor in Plains archaeology where the terrain is so vast and the digs

take so long; one expects that future finds will fill some of the gap.

But an explanation for the fairly recent initiation of the sacred site is implied in the work of The University of Calgary archaeologist Brian O.K. Reeves. On the basis of evidence from Head-Smashed-In, an Alberta buffalo jump used for the past 5,500 years, Reeves is convinced that only by 3,700 B.C. were communal bison drives becoming complicated affairs involving crowds of people for construction of drive lanes and pounds, for policing the camp prior to the drive, for manning the leads through which the animals were herded, and for butchering and processing meat and hides.[6] Drives of this developed sort, he says, required not only the organizing skills of pan-tribal sodalities to assemble and supervise the participants, but also a system of rituals to insure success. Games, songs, sacrifices, charms, consecrations, prayers, and purifications heightened the efficient tension of everyone involved in manoeuvers, from the poundmaster, scouts, and buffalo-caller to children heaping brush and muzzling the dogs.[7] Working in collaboration with the chiefs, the shamans or "religious formulators," as Paul Radin calls them, invented and conducted most of these rites, thereby enhancing their own prestige and entrenching their power in the communities.[8]

It follows that as they elaborated ritual with its supporting rationale of mythology

and cosmology, Writing-on-Stone became accessory to the shamans' expanding role. Here was a secluded place of retreat, properly awesome, where a visionary and intellectual could prepare himself to instruct the community in the holy manner of life necessary for survival. Here also documentary evidence of other-worldly beings and events could accumulate for the edification of others. But until that moment of need arrived, presumably about 1,000 B.C., the Milk River sanctuary apparently served no religious function, at least none that we can detect.

Besides the settlements on the prairie level, another site more intimately related to Writing-on-Stone deserves mention. This one, which like the others has never been extensively excavated and analyzed, is a large campsite on a broad terrace about three yards above the river's level, directly opposite the park headquarters. The terrace itself was probably formed only about 2,000 years ago.[9] The campsite on it was discovered in 1974 by archaeologists and historians preparing for reconstruction of a frontier outpost that the North West Mounted Police established there in 1887 to quiet the warring Indians and to control smuggling across the International Boundary.[10]

The prehistoric site underlying the police post is situated at one of the many places where the river is easily forded. Perhaps it is the same campsite marked on the map Little

Bear drew in 1802 for Peter Fidler. According to Little Bear, three north-south trails crossed the Milk or Kin-nax-is-sa-ta to connect the South Saskatchewan country with the Missouri valley. The middle-most Blackfoot route crosses the Milk directly to the north of Sweetgrass Hills, Fidler's "3 paps," and just there, close to where the park is now, the mapmaker indicated a campsite.[11]

The site on the terrace promises to have been a place of intermittent camping of an occasional nature, comparable to the sites excavated under the pictures. Incidental to their excavation of police buildings archaeologists uncovered five prehistoric hearths, along with indications of occupation on at least six levels. On the other hand, among the quantities of butchered bison bones strewn even into the river bed they found a folded iron tinkling cone, a relic of the late eighteenth century fur trade and typical of the shamans' paraphernalia of that time and region.[12]

The most interesting find at this site was a handful of potsherds. They indicate, first of all, that the campgrounds had been occupied during the 1,800 years of pottery-making in the Northwestern Plains, but before the incursion of European trade goods destroyed such native industries.[13] The sherds also suggest that people expected to return to this site. Rather than carrying their fragile pots with them everywhere, prehistoric Plains-dwellers usually provided themselves with hides and intestines of bison as easily transportable containers and as kettles in which to do much of their ordinary cooking.[14]

So far, the prehistoric settlements and campsites along the Milk River have contributed only indirectly to the question of dating the petroglyphs and pictographs. Nor are the pictures themselves much more helpful in this respect.

Except within certain broad limits to be inferred from context or content, it is practically impossible to date individual pictures or murals of the Milk River with any sureness. The usual scientific methods of dating by radiocarbon determinations, analysis of successive strata, and so on, do not apply there. Rock art on exposed faces has no discernible level of occupation. Painted or charcoal figures furnish too little organic matter for analysis. The engravers of some petroglyphs cut much deeper into the stone than did others who may have come later. Weathering occurs at variable rates, even within the same exposure, so that freshness or clarity of an image is no reliable criterion of its age. Some of the best preserved images, for example a series of animal figures (Plate 4), are still so sharply incised as to belie the evident antiquity of their formal tradition. Finally, the dates of artifacts and substances found in soils under the pictures cannot with certainty be linked directly to the execution of the murals on the rocks above.

In short, Selwyn Dewdney's experience should be sufficient warning of difficulties in the way of dating Milk River art. After much toil, he finally concluded that all his attempts to date rock art in northern Saskatchewan were "naive and superficial."[15]

Keyser proposed A.D. 400 to 1875 as outside dates for extant rock art of the Northwestern Plains in general, perhaps because he found no depictions of atlatls (spear-throwers), a characteristic weapon of Plains people for some 6,000 years before the bow and arrow came gradually to be accepted about A.D. 700.[16] His early date was also influenced by drawings and paintings close up under the present ceiling of Pictograph Cave, Montana, where artifacts in deep and clearly stratified deposits of fallen roof stones and washed-in soils persuaded William Mulloy to date the images tentatively to A.D. 500 and later.[17]

On the other hand, authors of *Story on Stone* see at least one representation of the atlatl at Milk River.[18] A contradiction of this sort is awkward to resolve because, aside from several unmistakable representations of guns and bows, depictions of implements or ceremonial wands, rattles, pipes, and the like tend to be ambiguous in the linear treatment characteristic of Milk River art. Furthermore, given the symbolic character of reli-

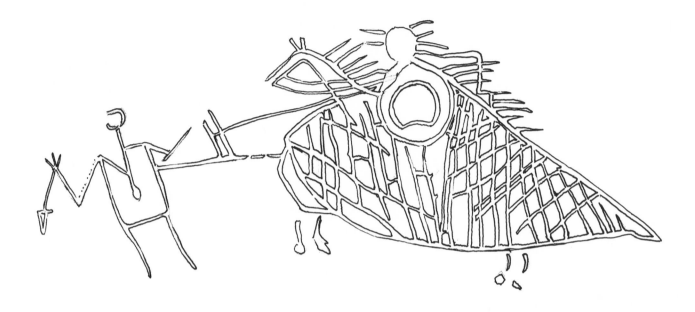

FIG. 3-1

gious art in general, one always risks too literal an interpretation of such motifs. What at first glance suggests a commonplace object may be a highly abstracted symbol carrying a freight of abstruse concepts. And since, as we know, the rate of erosion has been fairly rapid if uneven, for the past twenty-five years anyway, it is unlikely that many existing pictures date to the era of the atlatl, which ended about 1,300 years ago.

For depictions of horses and artifacts of indisputable European provenance the situation is somewhat different. Such representations have a reasonably sound, though always approximate seminal date. An engraving of a horse states implicitly: after

about A.D. 1730. Even so, an element of uncertainty intrudes where a Milk River artist may have interposed his new picture among the old, or when he created a chimera composed of parts of several kinds of animal and some possibly abstract motifs.

Three Milk River petroglyphs, now obliterated, show horses in armour and figures with shields (Figs. 3-1, 3-2, 3-3), drawn from Halmrast's early photos, the only record. They may be more narrowly datable than other horse images if linked to the Shoshone or "Snake" Indians of Idaho, who during the eighteenth century reportedly had advanced well into southern Alberta from the south.[19] Support for this identification comes from

Lewis and Clark, who said that Shoshone-Snake people alone constructed a kind of horse armour, the sort apparently pictured in this group of petroglyphs at Milk River.[20] Moreover, according to a Cree informant of David Thompson, during one of a series of battles about 1700–1720 somewhere between the North and South Saskatchewan rivers, a party of "Snakes" equipped with horses defeated a band of Peigan warriors on foot, an event regarded as the introduction of horses to people of the Blackfoot Nation.[21]

To be sure, the horsemen in our Milk River petroglyphs do seem to be attacking persons on foot. A date of A.D. 1700–1720 seems almost right for the kind of encoun-

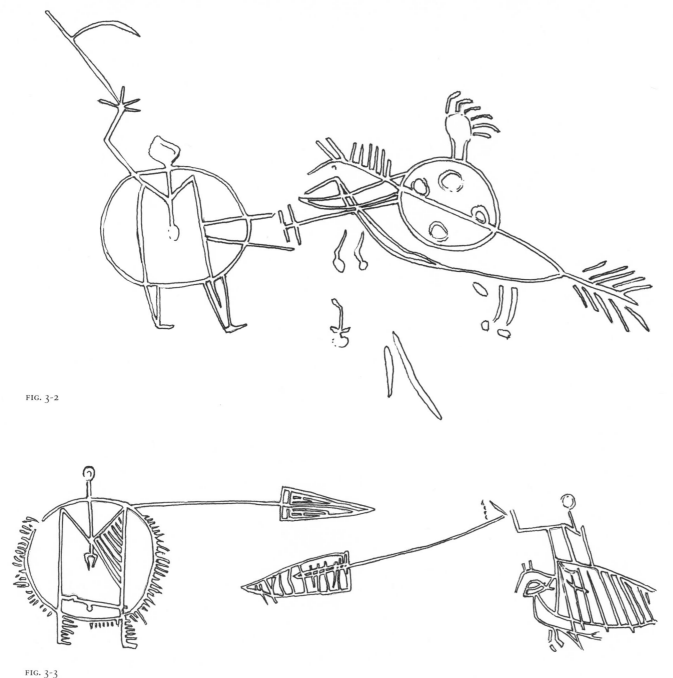

FIG. 3-2

FIG. 3-3

ters depicted, if they are to be interpreted literally. One could construe the whole group as a record of events in the story passed on by Thompson and the observations made by Lewis and Clark.

Still, there are serious objections to this rather arbitrary linking of picture and story. One difficulty is that the whole idea of historiographic art may be an import. It is not altogether certain that this European convention would have made its way as far as southern Alberta by 1720, or that when it did it affected the mystical art of the Milk River valley. Our three "Snake" horsemen could just as well – more probably, one might say – be the expression of a visionary experience only indirectly influenced by secular events and hearsay.

Secondly, the linking of the Shoshone or "Snake" Indians with certain petroglyphs and certain dates is entangled in the vexing question of tribal identities of Plains-dwellers prior to direct contact with Europeans. During the "proto-historic" period the aboriginal inhabitants of the Northwest rapidly adopted such amenities as horses, guns, and metal pots reaching them through native middlemen, and just as quickly abandoned their native industries which carried distinctive or diagnostic traits. The regrettable result is a hiatus in the evidence connecting historic tribes with people of the remoter past.

Richard Forbis declared some time ago that "not a single site or scrap of material culture can be positively ascribed to any historical tribal group."[22]

This stubborn fact, which is equally applicable to the people ranging in the neighbourhood of the Milk River and to those farther off, is hard to overcome by resorting to historical documents. The observations of explorers, fur traders and adventurers in the Northwest are coloured by their commercial preoccupations and European conditioning. Most were obsessed by the concept of territory, the legacy of centuries of political intrigue and wars in Europe.[23] They tended to attribute bounded districts to the natives they met, failing to notice fluctuating habits of movement over the half-million square miles of the North American plains. In addition, their information is frequently imprecise, contradictory, and inaccurate. William J. Byrne remarks that early chroniclers were "unable to use a uniform naming system when referring to North American tribes."[24]

As it turns out, the term "Snake" is ambiguous. Besides applying to the Shoshone, whose home was the intermountain region of the northwestern United States, the expression "Snake" as set down by early travellers and traders on the say-so of the natives is a term of opprobrium (sometimes meaning "enemy") applied by various tribal groups to others not of their kind. It was especially current among Algonkian speakers in referring to tribal Sioux.[25]

These circumstances considerable weaken the automatic equation of "Snake" Indians with the Shoshone, the consequential linking of the Shoshone with the armoured horses of the Milk River petroglyphs, and the dating of these petroglyphs in light of a story of Snake-and-Blackfoot battles. Furthermore, Lewis and Clark notwithstanding, other tribes besides the Shoshone are on record as using horse armour.[26] Finally, no artifacts have appeared so far to support the claim for a Shoshone occupation in Alberta.[27]

Nonetheless, Keyser has hypothesized that the prehistoric distribution of Shoshone people is traceable through certain rock art motifs, not only in the Milk River valley, but in Montana and elsewhere on the Plains. His ambitious theory encompasses the armoured horses and their shield-bearing riders, as well as all other figures with attributes that look like shields. He includes all "pointed-shoulder" or V-necked figures because they sometimes accompany the motifs he classifies as warrior's shields.[28]

From the foregoing, which of necessity oversimplifies the controversy, it should be obvious that the "ethnic origin" of Milk River art is just as problematic as its dating. Besides the Shoshone, which are a branch of the Uto-Aztecan language family, at least a dozen other tribal groups representing five separate language stocks have some historical or traditional association with southern Alberta. These other tribal groups are:

Algonkian:	Blackfoot, Blood and Peigan (the three tribes constituting the Blackfoot Nation), Gros Ventre (Atsina), and Plains Cree
Siouan:	Mandan, Gros Ventre (Hidatsa), Crow, and Assiniboine (Stoney)
Athapascan:	Sarsi (Sarcee)
Salishan:	Flathead and Pend d'Oreille
Kitunakan:	Kutenai[29]

People from any of these tribes are likely to have travelled through the Milk River's sacred grounds from time to time, long before the days of the fur trade, and even in historic times. Yet none of them has indisputable connections with the place, and in nearly every case their origins and movements are still obscure.

Only recently has serious research revealed that the so-called Gros Ventre (Big Bellies) were of two different sorts, one of Algonkian stock, also called Atsina or "Gros Ventres of the Plains," and the other, the Hidatsa or "Gros Ventre of the Missouri," a branch of the Sioux.[30] As often is the case of labels fixed upon North American tribes by

Europeans, "Gros Ventre" has the earmarks of a derogatory folk epithet that hardened into tribal designations. Perhaps the term refers, not to physical appearance, but to temper; *Gros Ventre*, a French expression, denoted a stereotype and meant, to put it in seventeenth and eighteenth century English, "high-stomached," proud, and readily offended.[31]

Be that as it may, Byrne has singled out the Siouan "Gros Ventre" or Hidatsa along with the Crow as the people most likely to have established and briefly occupied the fortified earthlodge village of Cluny on the Bow River east of Calgary. These short-term intruders arrived sometime after 1700, and left behind, along with a number of horse teeth, a distinctive ceramics similar to that found in North Dakota, Saskatchewan, at nine other Alberta locales, and near Fresno Reservoir on the Milk River in Montana.[32] Byrne proposes that, not the Shoshone, but Siouan splinter groups were the intruders into southern Alberta remembered by David Thompson's Cree interpreter as the people the Blackfoot eventually drove out.[33] Hence the "Big Bellies" and the "Snakes" may be one and the same, in this instance anyway. Since at least one of the Siouan motifs found on potsherds from Cluny – the "bear-foot" design – also appears more than once in Milk River art, the "earthlodge people" are

possibly among the contributors of the petroglyphs.[34]

The Blackfoot are the people logically associated with the pictures. Authorities generally agree that this nation, or at any rate their Peigan component, were in control of the country surrounding the Milk River by 1823. But this date hardly covers the period of all the extant pictures in the valley; numerous panels and individual figures contain no motifs whatever of the sort that fascinated artists caught up in the horse culture, as the Blackfoot certainly were. Some pictures, then, are considerably older than others, or at least represent the lingering of venerable traditions. The question is: did ancestors of the Blackfoot originate the prehistoric artistic conventions that, though transformed in varying degrees, carried over into the "protohistoric" and historic period of the horse?

Unfortunately, the origin and early movements of the Blackfoot are arguable. Edward J. McCullough presents evidence of Blackfoot occupation of the western boreal forest in northern Manitoba, Saskatchewan, and Alberta, postulating that the trade-minded Cree pressed them southwestward after 1670. The Blackfoot, with the Peigans in the vanguard, he says, finally emerged southward onto the plains immediately prior to white contact, about 1700, driving the "Snakes" (whoever they were) toward the

mountains of Montana and Idaho.[35] His views are compatible with arguments for a Shoshone-Snake occupation of southern Alberta early in the eighteenth century, and perhaps before.

But Reeves will have none of this scenario. He describes an ancestral Plains culture for the associated tribes of Blackfoot and Gros Ventre-Atsina (also Algonkian speakers) that occupied southern Alberta and the upper Missouri watershed for the previous 1,000 years or longer.[36] He denies that these people originated in the boreal forest. The natives' knowledgeable maps of the Northwestern Plains, one even indicating points of interest as far off as Spanish California, support Reeves's theory. So does the peculiar dialect of the Blackfoot tribes, indicative of a long separation from mainstream Algonkian-speakers; so specialized had their vocabulary and pronunciation become that in the late nineteenth century English missionaries equipped with a syllabic alphabet devised for the Cree undertook considerable revisions to make their hymns readable by Blackfoot converts.[37]

It may be significant that the Blackfoot never claimed responsibility for Milk River art. Their name for Writing-on-Stone, *Aysin 'eep,* means "it has been written," the passive voice and pluperfect tense denoting a vanished agent.[38] There are two ways of inter-

preting this distancing of themselves from the rock art within their purview. The word can be taken literally as meaning that no Blackfoot artist did the work; the pictures already existed when the people arrived on the scene. But the Blackfoot, like most native North Americans, are skillful and subtle rhetoricians, preferring to speak obliquely of sacred matters. They would rather say that the petroglyphs and pictographs are the work of spirits, even of the bluebirds that live in the rocky holes. In speaking thus they speak truly, for in symbolic language birds and spirits are the same. Both are metaphors for the human spirit, and as such equivalent to the artist in his mystical transformation.

In sum, only the rash would hope to assign this or that picture at Milk River to one tribal group or another, or attempt to see tribal affinities in certain "styles" of figure. As anthropologists recognized twenty years ago, North American rock art as a whole exhibits "an extreme intermixing of styles."[39]

The Blackfoot Indians and their neighbours all participated in the general culture of the Northwestern Plains, a culture that in part grew out of the communal bison hunt and the way of life determined by the Plains environment. All these people possessed a basic aesthetic sensibility as evidenced even in the points they knapped. All were characterized by a strong tendency toward mysticism, which stemmed from roots in Asia's timeless past and was concentrated in the persons of their practicing shamans. Hence, the outlook of the people of the Plains tended to vary more in detail and emphasis than in true substance. We can, then, dispense with an unrewarding search for the "ethnic origins" of Milk River art, and instead let the artists speak for themselves through their pictures on the rocks.

The Visitors

As often happens with holy sites, the Milk River valley became the setting for sacramental practices hinging on the reputed accessibility of spirits in that place. Its primal use as a retreat for the fearless shamans expanded in several ways. Shrines, oracles, graves – even the initiations alluded to in certain pictures (Fig. 4-1) – reinforced the eeriness of the atmosphere with their intimations of unseen presences.

The petroglyphs served early on, as we already know, as a series of shrines to which the devout brought offerings for the supernatural beings living in the pictures. Oblations of this nature continued until very recent times. Hugh Dempsey recounts the experience of Duncan Bottle, a Blood Indian who as a boy travelled to the Milk River with his parents in about 1924 to present "gifts for the ghosts" – cloth, beads, tobacco, clothing, and moccasins. The trepidation with which the family entered the valley was insensibly conveyed to their horses and dogs, whose restlessness throughout the night only heightened the terror of the children.

During this time [to use Dempsey's paraphrase], the father was praying to the spirits, begging them not to do any harm and promising to leave the gifts next morning "near the sacred wall of the hieroglyphics and pictographs we were to visit." In the meantime, the boy huddled beside his father in terror, hiding his head beneath heavy blankets and afraid to look into the night. "I began to imagine an ugly mirage in the darkness of the apparition haunting us," he said.

Next morning the children were taught the ceremony which would be performed when the gifts were presented to the spirits. The wagon was loaded and the party made its way to the pictograph site. The mother then sorted the gifts into several bundles while "our father also got busy with his medicine bag to get out his ochre to begin his other ritual to paint our faces." It was almost midday before the offerings were finally left at the holy place. There they went through the ritual of "approaching the site to leave the gifts without any talking. Only our dogs were making any noise."[1]

The father's motives in undertaking this pilgrimage are unknown. He may have been fulfilling a vow, performing an act of penance, or, as some ethnologists would have it, "trading" prayers and gifts for enhancement of personal powers.[2] It is clear nonetheless that the pictures themselves were the primary object of the Bottle family's devotions, and that the correct approach meant ritual face-painting to mask the everyday personality.

The oracular power of the images on the

rocks is a frequent theme in the oral history of the Blackfoot. Stories abound of lone persons, and even of whole war parties, who in passing through the valley consulted the pictures regarding the outcome of their ventures.[3] One could learn from the images about enemy tribes in the neighbourhood, the location of bison herds and lost horses, or hear one's name pronounced among tomorrow's dead. Nearly always the interpretation of the oracle was a sacerdotal office: "Those who had the power" could find the germane images and read an appropriate prescription for themselves and their comrades. The consulting of oracles blossomed into a popular practice during the "horse days" which brought increasing traffic through the sacred site. As oracle-reading became more frequent and word of it spread, it probably contributed to the Blackfoot tradition that the pictures were a kind of writing.

Here and there in obscure crevices are at least six nestlike graves.[4] As might be expected from the severe weathering, erosion, and proliferation of rodents, all those found are of comparatively recent origin. The oldest known, which dates to the late seventeenth century, contained the skeletal remains of a severely crippled man who, either by accident or sacrifice, had lost the joints of his little fingers. With his bones were his belongings, or perhaps gifts, that included tools, points of obsidian, and petrified wood.[5]

Two other graves in the valley contained red steatite pipes, the indispensable accessory of virtually every kind of ritual and seance, public or private, in the Plains Indian repertoire.

These graves represent a distinct departure from the customs of the aboriginal inhabitants. At the time of European contact the Blackfoot ordinarily exposed their dead on a scaffold or in the branches of a tree, well out of the way of dogs. The Gros Ventre preferred to place their dead in hutlike lodges. The body of an important chief might repose upon the low central cairn of a "medicine wheel" or on an imposing glacial boulder.[6] But such mortuary sites were generally in the vicinity of camps and settlements, and, once devoted to the purpose, created a local and familiar sacred ground reminding the living of their kinship with the dead.

But the graves in the holy precincts of the Milk River valley are in a select locale: at the juncture of all cosmic regions, as it were, and in the immediate presence of benevolent and malevolent spirits alike. Such preferential treatment, which incidentally meant an unavoidable trek by the living into the fearsome domain of powerful ghosts, points to special rank or privilege. Whether a shaman or a headman possessing shamanic powers, the deceased had been a person of consequence, one whose life involved a mystical relationship with the place, and whose death

FIG. 4-1

and afterlife called for suitable funerary effects.

Some authorities believe that Writing-on-Stone was also the setting of vision-quests, but the use of this term is frequently so imprecise as to be misleading. Though varying in particulars, the vision-quest was the central spiritual exercise among Plains and Woodland Indians; it was as essential for the cohesion of the native personality as it was for the transformation of youth into mature members of the community.[7] Parents began early to train their children in the discipline of fasting, the principal technique for inducing the visions that during passage into manhood furnished one with a guardian spirit – usually in animal shape – and a personal name. An effort of will and mental concentration, attended by prayer and repetitious ritual, the vision-quest inculcated the mystical sensibility characteristic of the Plains Indian, and set the tone for a common religious feeling. The vision-quest was part of a general pursuit of magical and spiritual efficacy in dealing with the uncertainties of life, a "normal and universal human behaviour," for there is a mystic of some degree in every man.[8]

Although certain elements of shamanism – particularly the underlying theme of death and resurrection as initiation – had crept into the vision-quests of popular custom, local conditions and local expectations inevitably shaped their outcome.[9] The leaders of the tribe closely supervised the all-night vigils required of every boy at puberty. They brought the youngster water – ritually, of course – at crucial moments of the ordeal, and discouraged excessive fasting. They were apt to reject as "too powerful" the vision of an over-enthusiastic boy, and send him back to dream again. The sites of the children's vigils, and even those of young men, it seems, while set off some distance from the settlement or camp, were yet not far away, and sometimes took the form, as Graspointer thinks of vision-quest "camps," used repeatedly.[10] By all accounts, it is improbable that Writing-on-Stone was the scene of vision-quests of the laity. On the other hand, the sanctuary within the river valley was eminently suited to the needs of the shamans, whose spiritual life, as we shall see, differed qualitatively from that of the community in general.

If we consider religion as the experience of divinity, then shamanism is one of the oldest expressions of religious thought and feeling among our species. Joseph Campbell surmises that it arose as long ago as the interglacial period in company, or rivalry, with the worship of the "Venus" of the Palaeolithic mammoth hunters.[11] He suggests that in the Magdalenian cave paintings of 16,000–9,000 B.C. costumed shamans perform one of their typical roles, that of the dancing Master of Animals, counterpart of the Blackfoot buffalo-charmer. One of these exceedingly old murals pictures the shaman in an ecstatic trance while conjuring an enormous bison, a scene whose content is uncannily like a northern Saskatchewan rock painting of much more recent origin, and which parallels in theme several Milk River engravings.[12]

The apparent antiquity of shamanism is impressive, but equally so is the vast span of its influence as a shadowy but potent phase of the archaic perception of the universe.[13] Its range is circumpolar throughout the northern latitudes, in the Orient extending southward and eastward into Indonesia, Australasia and Oceania, in the Americas all the way to Tierra del Fuego. The techniques and symbolism of yoga, an indigenous component of India's mysticism, seem to have a deep and mysterious connection with shamanism that filtered into Buddhism in China and Shinto in Japan. The ancestors of the Indo-Europeans, the semi-nomadic pastoralists who invaded Russia, then India and the Balkans between 4,000 and 1,500 B.C., seem to have carried with them, as collateral of the Vedic system, elements of a shamanic ideology anticipating mystical elements of the main religious movements, from Zoroasterism to Islam.[14]

This circumstance has persuaded one scholar that "man has remained inwardly the

same, even through millenniums, perhaps centuries of millenniums," and another that "almost all the religious attitudes man has, he has had from the most primitive times."[15] We can smile at the thought of Christian zealots as unwitting heirs of the same ageless tradition they hoped to extirpate among our native population.

Evidently, then, the shamans participated at the outset in the fundamental spiritual aspirations of mankind. Small wonder that major themes of shamanism continue to pervade the visionary literature and art of the world. Still, even now, and only superficially "modernized," shamanism re-emerges from time to time to perplex or disturb us by touching forgotten but deep-seated proclivities of human nature.

The strength of shamanism among North American Indians is not surprising, considering that a core region of its practice, namely south central Siberia between the Yenisei River and Lake Baikal, is the ancestral homeland of the main waves of pre-Columbian migrants to the New World.[16] What *is* astonishing is the consistency of shamanism from earliest times. Its special features persisted as an unbroken cross-cultural vein of tradition descending through time and space while more or less adapting to myriad local and regional conditions. Inexplicable as it seems, always and everywhere shamans have had more in common with each other than with their own tribal groups in which they formed a gifted elite.

Among the Plains Indians as elsewhere the shaman's definitive speciality was his "technique of ecstasy," a personal capacity for throwing himself into a trance induced by ritual pipe-smoking, drumming, dancing, and singing, whether in his tipi or in some remote sanctuary – a trance in which his soul left his body to freely roam extraterrestrial regions. In other words, instead of awaiting spiritual communications through visions brought on by fasting or herbal drugs, he called the spirits to him or visited their domains. This remarkable capability arose in the first place from his election by the spirits themselves, that is, his initiatory seizure when he was transported to the sky, tortured, dismembered, and returned to earth reborn as a new personality.[17]

As a result of his election he was the master of fire and of magical flight. He could transform himself into the shapes of animals, and become a bird, so that these in effect were himself in other guises. The shaman alone directly encountered and conversed with supernatural beings at all levels: the demons of the underworld, his ancestors and dead tutelary shamans, spirits with whom he engaged in mystical sexual acts, and the overall Great Spirit from whom he obtained his personal and presumably divine powers.

Thus the shaman escaped the human condition by resorting to mind and imagination. Abstracting himself from the mundane level of existence he meditated on his mystical physiology – the skeletal parts and organs of his body – as the basis of life renewal. And in contemplating the data of his inner life he interiorized the archaic cosmological scheme to the extent that his own person seemed to encompass the entire universe and all its possibilities.

The North American shaman lived a double life. By virtue of his occult power over nature and his euphoric journeying into invisible worlds he was useful to his society, although the rewards of his intellectual independence and mobility of spirit were often envy, fear, and loathing. Besides acting as a charmer of animals and interpreter of oracles, he served as prophet, repository of mythology and theology, innovator of ritual and protocol, and escort of the dead into afterlife. But his chief contribution to society was healing: expelling evil spirits causing illness and rescuing souls abducted into the underworld. For this, Europeans erroneously assumed that doctoring was the focus of his career. It was not. The shaman's true vocation was shamanizing, that is, transporting himself to levels of reality unimagined by his fellows, oftentimes for the sheer joy of it.

Men such as this, independent agents who stood apart from the generality, sought solitude, yet functioned within the cultural hori-

zons of the tribe, are responsible for many of the pictures in the Milk River valley. Analogs cited here show that an impressive portion of North America's archaic rock art is clearly shaman's work. Among the multitude of images still visible we recognize the subjects that preoccupied these higher mystics, and the congeries of motifs belonging to their mental universe. Their principal convention, the symbolic self-portrait identifying the artist with the divine spirit within the rock, is a basic type of icon. The work of these artists is most often engraved, generally with sureness and reverent care, perhaps incorporating some natural feature of the rock, and significantly though rarely touched with red paint.

Besides furnishing the shamans with a proper milieu among the spirits and a convenient medium for their art, the Milk River valley seems also to have been a long-time arena for the occasional ritual activities of their chief competitors for power: the secret men's societies or sodalities which were a ubiquitous feature of Algonkian and Siouan cultures. American ethnologist George Bird Grinnell identified ten such lodges among the Blackfoot, including the Horn Society, as forming the dim semblance of a hierarchy defined by age groups and social standing; by the late nineteenth century at least two of these societies had evolved into warrior groups.[18] Other men's associations among

the Plains Indians amounted to specialized medicine cults or sects, organized under the signs of emblematic animals that were common guardian spirits.[19] In 1943 Ewers witnessed a dance conducted by the Blackfoot Horse Medicine Society, which by that time had declined into a healing cult selling services to local people.[20]

The compulsive secrecy of these societies as well as the breakdown of native culture obscures the boundaries of their influence and the interrelations of such groups. Even so, the information available permits several generalizations relevant to rock art.

First of all, in contrast to the shamans, the foremost interest of the brotherhoods was *social*. A social orientation inspired not only the gatherings of the members and their sharing of secret teachings, but also the relations of the membership vis-à-vis the tribe. In aspiring to mystical experience and supernatural power a degree above the ordinary, the secret societies constituted an influential level of piety and behind-the-scenes authority. Through an interest in the return to mythological origins and reverence for ancestors they often regulated the public ceremonies that provided the community with substantial psychological security. The members performed in festive dances, games, and races, and administered to the sick according to the limits of their powers. Their leaders met with the chiefs to decide such important

questions as when and where to move the camp.[21]

Paradoxically, in view of their many social involvements, the men's lodges were keen to conceal from the public the identity of members. The masks and animal costumes they paraded, their sacred wands or weapons, their shields emblazoned with personal heraldic devices were in part a defence against hostile spirits, and in part the ostensible proof of magical participation in the spirit world.[22] But a surreptitious purpose of this regalia was to beguile the onlooker, cloaking the wearer in the anonymity of group disguise. The costumery of the shaman was, on the contrary, an expression of his profession and inner self; he made no pretense of anonymity, for a shaman was always known for what he was.

Membership in Plains Indian secret societies was purchased. The associations were open to anyone who could pay the fees and tolerate the initiatory tortures.[23] That is, the members were not chosen by the spirits as in the shaman's case, but were self-elected, albeit subject to social sanction. Their initiation, though another echo of the shamanic death-and-resurrection theme, was actually a demonstration of bravery before competent witnesses, in principle quite unlike the shaman's solitary ordeals. In short, whatever the secret societies did was done in consciousness of audience, whereas for the shaman,

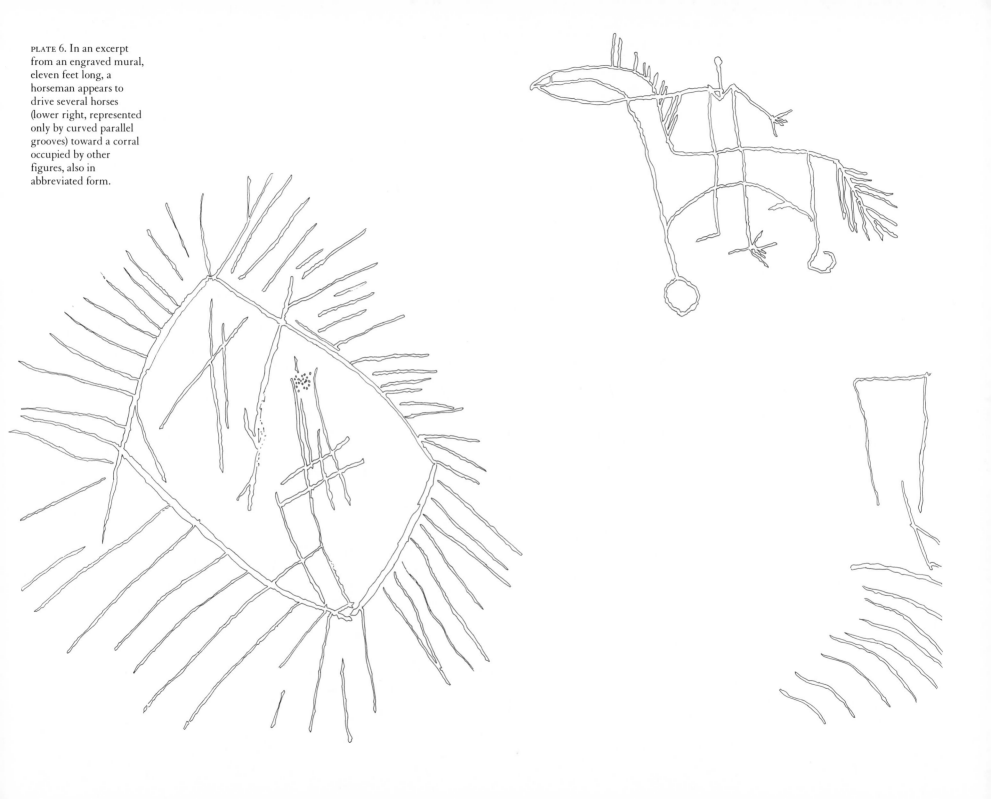

PLATE 6. In an excerpt from an engraved mural, eleven feet long, a horseman appears to drive several horses (lower right, represented only by curved parallel grooves) toward a corral occupied by other figures, also in abbreviated form.

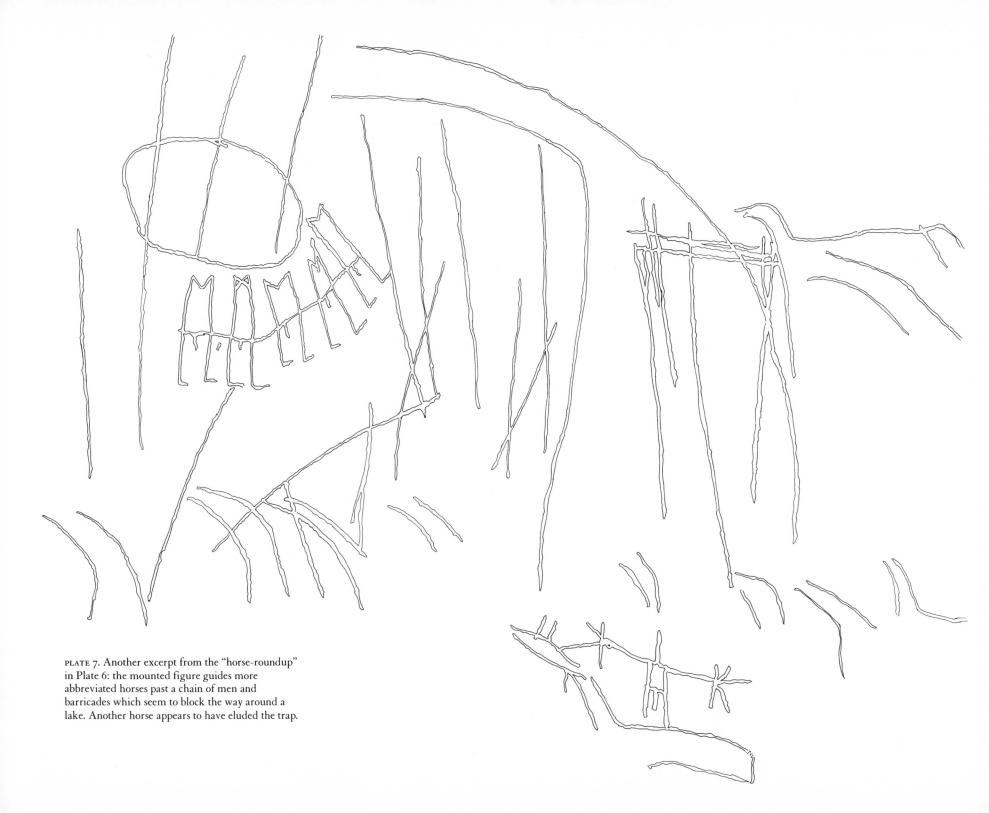

PLATE 7. Another excerpt from the "horse-roundup" in Plate 6: the mounted figure guides more abbreviated horses past a chain of men and barricades which seem to block the way around a lake. Another horse appears to have eluded the trap.

most expert of performers, charming the public was but another sideline of his much higher calling.

While customs peculiar to the men's societies reveal conceptual differences between them and shamanism per se, it is certain that the shamans mixed deeply in brotherhood affairs. But even Eliade is at a loss to define precisely the shamans' place in societies of any sort.[24] It is apt to have been highly variable. As for the situation among the Blackfoot, Ewers offers a slender but fascinating clue. Normally, he says, the Blackfoot preferred domesticated horses to the mustangs, which even the best horsemen were unable to rope; except for the occasional yearling or colt captured from the wild herds roaming the plains, the Blackfoot bought, traded, borrowed, or stole their mounts. Only the Horse Medicine Man, a prominent figure in the Horse Medicine Society, was capable of charming wild horses into captivity.[25] This is a skill equivalent to that of the old-time buffalo-caller, who was none other than the shaman in his character of Master of Animals.

Ewers's tidbit of information – which incidentally suggests a line of interpretation for an extensive mural in the Milk River valley (Plates 6, 7 and 8) – gives an inkling of a secret society organized around one of the traditional powers of the shaman. It provides a fleeting glimpse of his directive hand. In this light, we cannot dismiss the possibility that the shamans themselves led their brotherhoods into the sanctuary of the spirits, where the members, their courage fortified by numbers and an influential guide, found a setting for seances of a rare and special kind.

Ewers believes that the men's societies documented among the Plains Indians were grounded in customs of deep antiquity. Indeed, one category of art in the Milk River valley tends to support this contention when considered along with similar imagery at sites farther south. These pictures, whether in charcoal, paint, or engraved in rock, are Keyser's "shield-bearing warriors," which, supposing them signs of Shoshone occupation, he has attempted to map out.[26]

Although minor details vary according to the artist's skill or whim, many – but not all – shield-bearers adhere to a single formal convention. They invariably present frontally a circular emblematic shield, behind which stands – or hides – a schematic human figure (Figs. 4-2, 4-3, and 4-4). In short, the *real* personality resides in his emblem. This convention, insisting upon identity as revealed in occult signs, neatly conveys the spirit of membership in a brotherhood: a conformist sensibility devoted firmly to tradition, coupled with the wish to seem inscrutable and a love for magic symbols.

Mulloy's plausible dating of such pictures in Pictograph Cave, Montana, and Keyser's own study of their distribution on the Plains

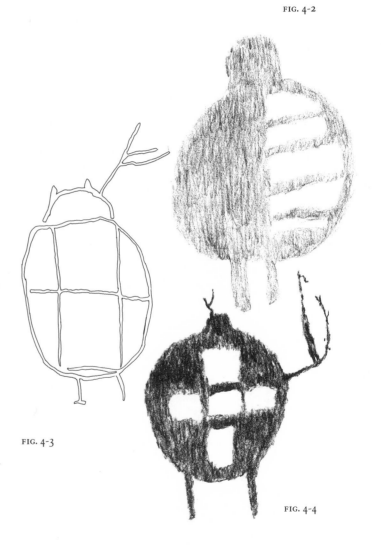

FIG. 4-2

FIG. 4-3

FIG. 4-4

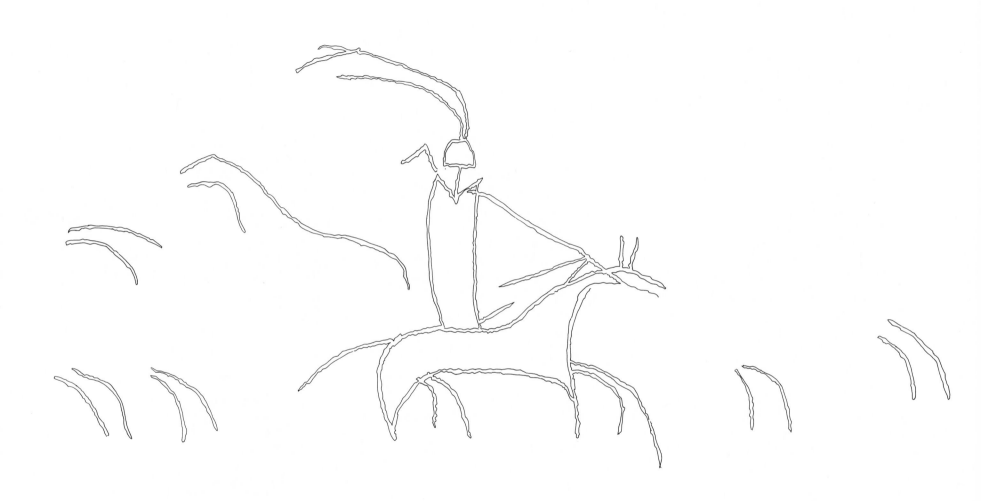

PLATE 8 (A and B). In a longer excerpt from the same mural as Plates 6 and 7 more horsemen work the herd toward the left; the stream of abbreviated horses extends several feet farther to the right to a corner in the rock.

make the point that this distinctive formula was probably current between A.D. 500 and 1300, centuries before the inhabitants were caught up in endless warfare among themselves. We would be wrong to assume, as Keyser does, that the shield-men are essentially pictures of pedestrian warriors, or that his map describes the range of an agelessly aggressive tribe. More likely, certain of the emblematic figures were accessory to the men's societies, images with sacred properties that illuminated secret religious rites. In fact, one such guards the entrance to a large cave suitable for ceremonies (Fig. 4-5; dots indicate features drawn from Halmrast's photos and used with his permission). At any rate, Keyser's map indicates in part the diffusion of a single artistic device among like-minded folk.

The formulaic shield-figures are in clearest contrast to the individualistic art of the shamans, who in range of subject matter and subtlety of expression surpassed their friends' clichés. Even so, motifs peculiar to each sort are apt to appear together. The central emblem of one of the oldest shield-figures on record, a charcoal or black paint drawing in Montana, is typical shaman imagery, and common at Milk River.[27] The well-known history of a Blackfoot shaman-warrior's thunder-shield, its design revealed to him at the moment of election to shamanhood, teaches that shields were not

invariably equipment for feats of arms. Wolf Collar's shield is a type of medicine bundle, a power-laden protection against supernatural dangers and a memorial of the first spiritual crisis in his life.[28]

Horses changed nearly everything, bringing war, wealth, and the chase as disruptive elements into life on the Northwestern Plains. The pace of events accelerated. Rhythms of camp movements changed. The communal bison drive disappeared, superseded by the communal hunt. And the basis of tribal authority shifted to new criteria of prestige. The old custom of occasional raids to capture women or punish an insult escalated at once into mounted forays for more and yet more horses, followed by revenging strikes and ambushes, and unremitting tribal wars. Compounding the violence was the trade in guns and whiskey; exacerbating the confusion was the pressure of eastern tribes crowded westward by the advance of Europeans. But the need for horses, as Ewers makes plain, was the motive spring of the bloody strife that lasted for 150 years.[29]

Everyone sought possession of this radical new animal, whose speed and manoeuverability seemed tantamount to flying. Surely a great many undistinguished people were close to encroaching on one of the shamans' spiritual prerogatives. The mystique of heroism on a horse seized the imagination of the whole population, unleashing feelings of in-

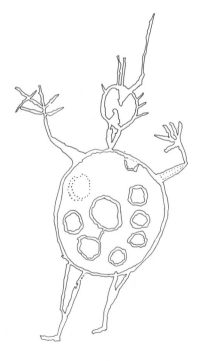

FIG. 4-5

dependence that stolid tradition had heretofore held in check. To the dismay of their elders, young boys, presuming a man's abilities, felt the charge of heady power as they galloped out of sight. A wave of innovation enriched the manual skills, naturopathy, and recondite magic practices, all of which promptly focused on the horse. For countless generations the performances of the shamans and the brotherhoods' theatrics had sufficed for dramatic excitement; now the glory of the horse days stimulated an outburst of ostentatious ceremonial that for colour and pomposity rivalled chivalric pageantry anywhere on earth.

The sacred site in the Milk River valley could hardly escape the impact of a revolution in mobility and broadened horizons. Writing-on-Stone, common ground in the overlapping ranges of mutually hostile tribes, lay on the war-path of raiders who repeatedly used that route.[30] Moreover, the horse possessed marvellous faculties which its owner alone controlled. The high magic of this living, breathing, and most intimate companion bolstered a young man's confidence. Under the impulse to violent action, then, and a diminished fear of the unseen, increasing numbers of visitors came more often to a place avoided in the past.

The result of so many popular incursions was an explosion of art in the Milk River valley, an art reflecting the surge of individualism in a transformed culture. Clumsy or skilled, naive or profound, the artists of the equestrian age hastened to depict their personal visions of mystical reality, which almost without exception were fixed upon the horse. Along the river and far up the coulees, the image of the horse – and that of the horseman, too – took up residence in the rocks with the rest of the ghostly troops. Just as in the past, the act of making art was still a holy act: the image once created embodied the spirit pictured in the work.

Spirits in Human Shape

Even the most casual observer notices that certain of Westerners' long-cherished aesthetic expectations are irrelevant to Milk River art. Perspective, which is the illusion of objects in space as they appear to the eye, is almost entirely absent. So is respect for the so-called natural proportion of one thing to another. These artists never deal with landscape, and rarely with the mass or volume of human and animal form. We miss also photographic realism, the detailed and literal depiction of material objects. Hence portraiture, in the sense that the features of the everyday human face denote personal identity and character, has no place in the canon of this art. These are all matters of taste, precepts of artistic worth that rise and decline in the history of cultures.

Milk River art is devoid of practically all the aesthetic conventions that governed the arts of western civilization from classical times until the "revolt of the moderns" – Gauguin, Picasso, the German Expressionists, and the rest – against the illusionism of European salon art. Instead, "conception overrides perception," as art historians say of both primitive art and the modern art it has inspired.[1] The mind supersedes the eye. Thought is something more than received sensation.

Nor should we think of Milk River art as advancing toward a greater "realism" and "naturalism" during the historic period, the era of the gun and the horse.[2] Naturalism of a sort appeared 16,000 years ago in the cave art of southern France; extreme simplicity of form suddenly burst forth in early twentieth century European art after centuries of realism. The notion of progressive stages culminating in more refined conventions has little bearing on the activity of making art, least of all on that of Milk River. Moreover, such a view evokes schemes of racial, social, and cultural superiority which nineteenth century Europe infused with theories of straight-line evolution. Social Darwinism, which furnished the ground for doctrines of "Aryan" supremacy, that is, of the white man as top ape, still lurks in the popular imagination. Although anthropologists discredited this mythology long ago, it continues to foster naive attitudes toward art.[3]

It also seems wrong to treat as different "styles" the formal variations in the human figures of Milk River art. Often several of these forms, some of which had persisted from the earliest datable rock art in the Northwestern Plains, are joined in a single composition, so that to isolate them as styles renders their context unintelligible. Rather, they constitute aspects of Milk River style as a whole, just as the forms employed at Peterborough or those along the Pacific coast contribute to their particular rock art styles. The

term style properly applies either to art in this broader sense, or else to the characteristic manner of an individual artist.[4]

A style enters a new phase, as it did at Milk River, when its permanent features commingle with new developments, resulting in an admixture of motifs. Such changes do not necessarily proceed at the same pace in the different arts of the same culture. In the case of Milk River, the place was holy, and so was its art. Most likely, the engravings, paintings, and drawings there were conceived on a level quite distinct from the historical hide paintings, winter counts, and ledger drawings promoted by Europeans unsympathetic to the religious significance of native forms and the archaic system of symbolism. Because rock art and hide paintings represent two different categories of art, the mystical and the secular, one hesitates to translate directly from the one to the other on the basis of superficial similarities of form.

The diversity of human figures in Milk River rock art, then, represents the choice of formal possibilities open to the artists to express certain of their mystical preoccupations. These conventional human forms, like the other forms associated with them, are symbolic in that they distill concepts of exceeding complexity and variable meaning into simple shapes, a process governed by habits of thought and endorsed by ancient

FIG. 5-1 FIG. 5-2 FIG. 5-3 FIG. 5-4

precedent. We should keep in mind that such symbolic forms, which occur in many archaic cultures, may not only imitate in a schematic way the "something" they represent, but also contain that "something." A source of their power for early people was that the symbol itself could act and be acted upon in place of what it represented. Hence, "to act upon the symbol is conceived as tantamount to acting upon the thing symbolized, and consequently magical powers are imputed to the symbol."[5]

In Milk River rock art the most common and easily recognized forms representing the human figure – or spirits in human guise – look as if shaped by the letters M, O, and X (Figs. 5-1, 5-2, and 5-3). These basic shapes, which of course held no alphabetical meaning for the artists, seem to be the oldest forms used in Plains rock art to depict humanlike figures; variants of them occur widely in North America, even into the near present.[6]

A fourth basic form, an ancient artistic device found all over the world, is recognizable only occasionally among the Milk River pictures, although its abbreviations may not be immediately apparent. It is popularly known

37

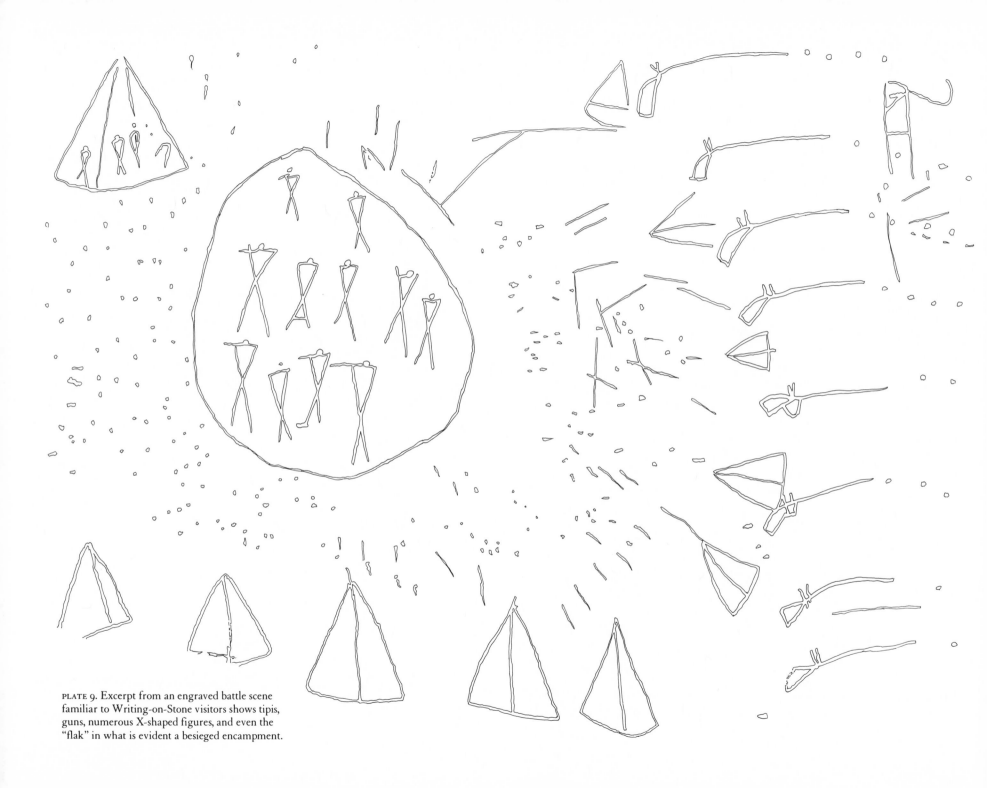

PLATE 9. Excerpt from an engraved battle scene familiar to Writing-on-Stone visitors shows tipis, guns, numerous X-shaped figures, and even the "flak" in what is evident a besieged encampment.

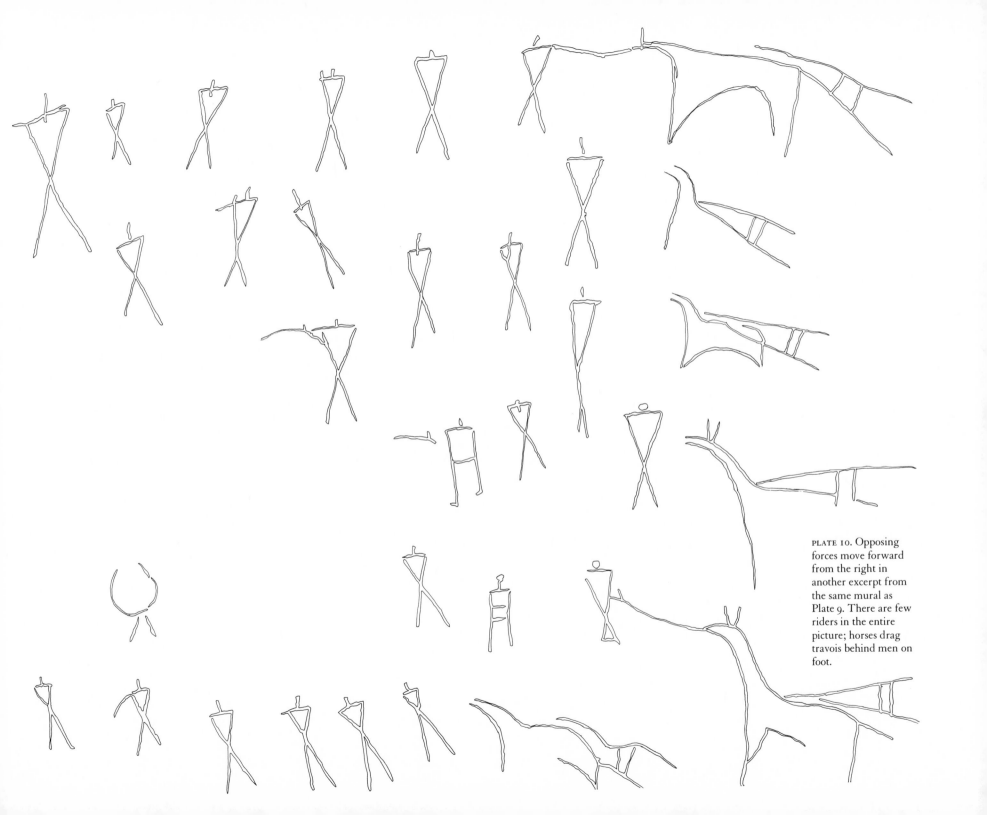

PLATE 10. Opposing forces move forward from the right in another excerpt from the same mural as Plate 9. There are few riders in the entire picture; horses drag travois behind men on foot.

FIG. 5-5

as the "stick figure" (Figs. 5-4 and 5-5).[7] The torso, which consists of a simple straight line, may find an explanation in certain motifs employed by Milk River artists. Other humanlike shapes abound, however. Square-shouldered and round-shouldered figures are numerous, some more flexed or supplely articulated than others. At least one figure has a pentagonal torso. A few are bottle-shaped or vase-shaped. Several are based on heavily-gouged parallel tool grooves. Such departures from the typical usually derive from the basic forms mentioned, but held special significance for the artists.

The forms just described are executed al-

most exclusively in the linear mode that is a primary attribute of the Milk River style. That is to say, they are composed chiefly of lines, whether drawn, painted, incised, or scratched on the rock surface, or defined in part by lines of tiny drilled holes.

Other techniques have produced additional human forms. Among the engraved pictures are pecked and intaglio figures in which the body is shallowly chipped or ground out as a depression in the rock. The resulting shapes range from loosely amorphous bodies with froglike protruding arms and legs to a figure with a sharply-defined ovoid torso.[8] The body outlines of a few of the figures drawn in charcoal or red ochre have been filled with pigment in such a way that we seem to recognize coats and boots (Plate 11), but these figures are unusual.

Beyond the basic structural conventions described here the human figures resist any thorough-going attempt to classify them according to some standardized scientific scheme. One reason is that drawing is essentially a spontaneous activity, acutely sensitive to the artist's impulses and the temporal conditions of his handiwork. Hence the basic forms are endlessly varied. Of the hundreds of M-shaped figures, whether clear or dim, which at some sites are repeated almost monotonously, it is doubtful if any two are exactly alike. Then, too, as well as mingling, merging, and elaborating forms, some artists

have freely combined techniques: charcoal drawing with painting, linear engraving with intaglio, pecking, or paint, and deep broad strokes of the engraving tool with almost feathery scratches. In a mural done in red ochre chalk on a coulee wall (Plate 11), traditional linear M-shaped figures contrast strikingly with three others filled with pigment; this innovative device probably should be interpreted symbolically, as must a similar figure in charcoal and paint in a nearby cave (Plate 2) – possibly the work of the same artist.

Nearly all of the human forms pictured in Milk River rock art (and this applies as well to the animal figures) carry intense concentrations of meaning. The very structure of the linear figures – those of M, X, and other basic shapes – minimizes the material elements in the artist's concept, stressing instead their incorporeal character. In other words, these are disembodying forms, reducing the human figure to its spiritual essentials to equate it with supernatural entities.

The emphasis in each of the typical human forms and their countless modifications, is usually on the space in the middle of the body, symbolically the seat of inward energy, and on the mystical attributes added on as varying motifs. The body itself, when limited to a mere outline, is effectively transparent. The mingling of transparent and opaque figures argues that for more than

one artist the technique of filling expressed the idea of material nature in contrast to the immaterial.

The human form described above as M-shaped (Fig. 5-6) others have labelled the "pointed-shoulder" and "V-neck" figure.[9] The meaning of its distinctive accent, the V, is not clear, but reasonable guesses are possible. On the empirical level, the V may allude to the costume worn by shamans in their transformational exercises or public ceremonies: a breast-piece, perhaps, a pendant, or a medicine shirt, such as the Arikara chief Bloody Hand wears in a George Catlin painting of 1832, or the pointed yoke pieced into a Sioux scalp shirt.[10]

But that said, the motif is a symbol of a symbol, and more questions follow. Does this V, whether in pictures or actual costume, cryptically point to the mystical physiology of the shaman himself, who was so conscious of his inner being that he sometimes wore garments embroidered with organs and bones? Does it perhaps allude indirectly to a soul of particular quality? – for a shaman could possess as many as six souls, each with different capacities. Or, as seems the case with Siberian shamans, does it refer to the bony structure of a bird?[11] And, if associated with costumery, does the V betoken a special category of spirit the figure itself represents? Further from this, do the many square- and round-shouldered figures which have no central V signify inferior spiritual ranks, spirits lacking an elevated version of the soul?

There may be no straight-forward answers to questions like these. The only certainty is that the V-neck endowed human figures with a singular spiritual meaning, for otherwise it would not have appeared so often in the sacred pictures. The study of motifs associated with human figures, and discussions of compositional themes further on should sharpen our insights into the matter, though it seems ultimately unfathomable in any definitive sense.

Two properties of the M-shaped figures are their frontal monumentality and symmetrical rigidity, accounting in part for their impact as apparitions, especially the larger, more firmly chiselled ones. Some that rise two and three feet from vague pediments preside high up in shrinelike angles of the rock or overshadow assemblies of lesser figures (Fig. 5-1). Spirit and human in one, they present a disturbing ambiguity in their potential for transformation. They call to mind that, independently of time and place, artists have long imagined divine and demonic spirits – from gods and angels to Beelzebub – in some sort of human shape.

A different set of symbols inspired the human figures based on the X-shape. The most obvious effect of many is the impression of motion. An X-shaped figure seems to move, or about to do so, which may partially

FIG. 5-6

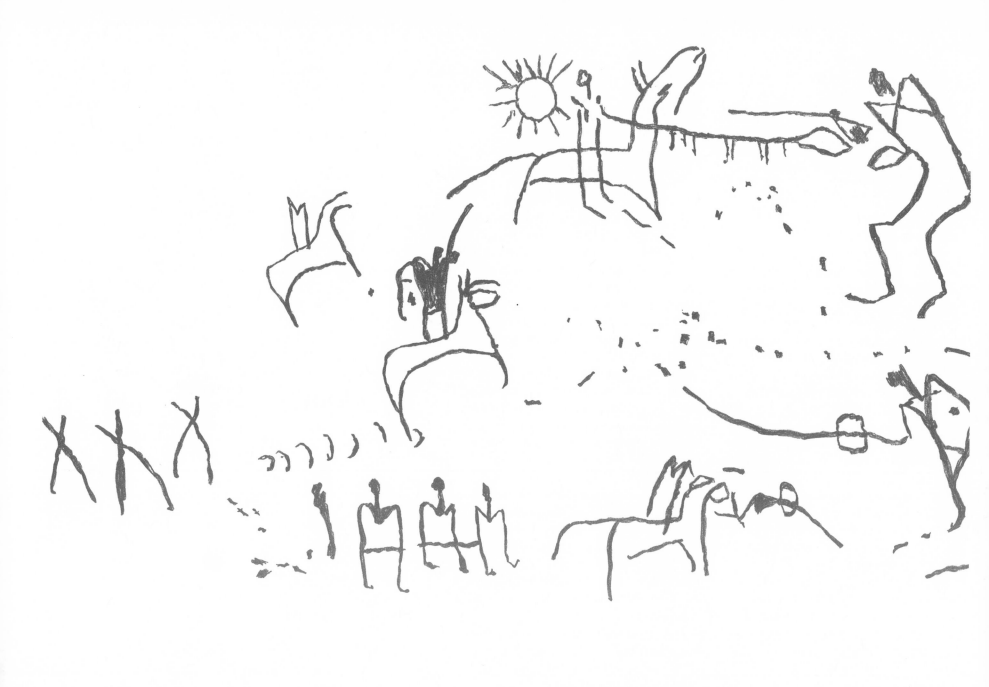

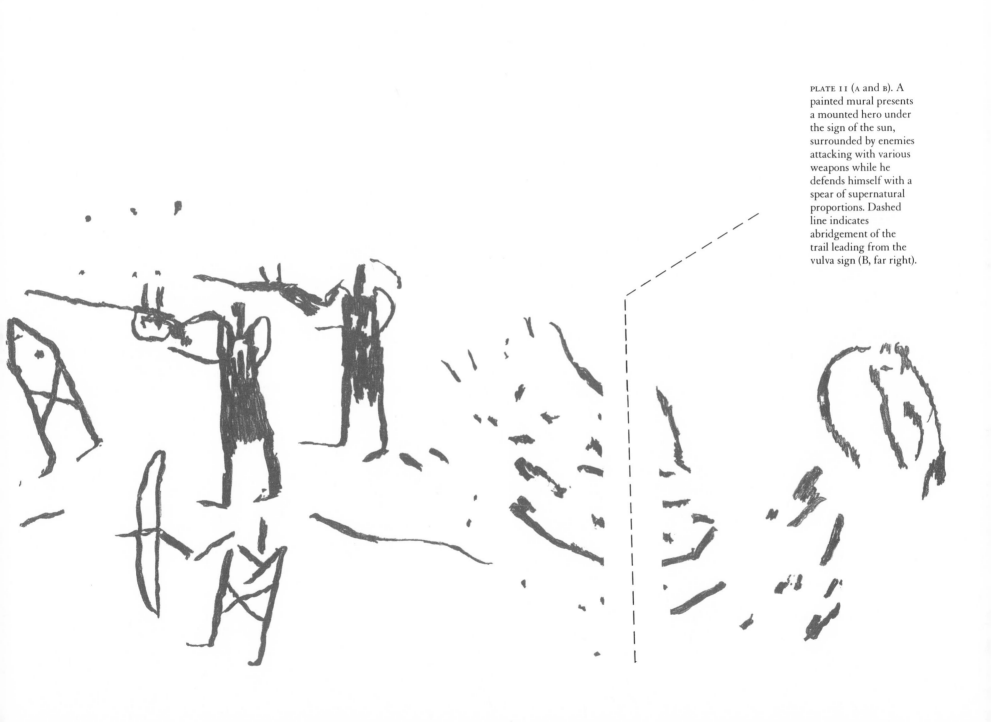

PLATE 11 (A and B). A painted mural presents a mounted hero under the sign of the sun, surrounded by enemies attacking with various weapons while he defends himself with a spear of supernatural proportions. Dashed line indicates abridgement of the trail leading from the vulva sign (B, far right).

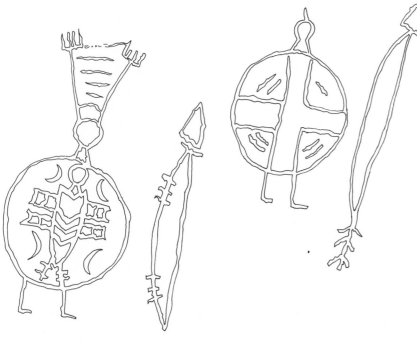

FIG. 5-7

explain its frequent appearance in panels involving horses, drawn when the new feeling for movement was demanding expression. In a large and complex mural within the park a troop of X-shaped figures, accompanied by other human forms, marches across the rock face, advancing before a line of horses dragging travois (Plates 9 and 10). Yet the chief attraction of an X-shaped form for the human figure most likely derives from conventions dating from much earlier times, namely the Thunderbird imagery.

Of the humanized figures constructed on the basis of a central circle or O-shape, the

most obvious are the shield-men. In Milk River rock art the tiniest of these, petroglyphs 1¼ inches to 3 inches in diameter, are the most exquisite of their sort (Fig. 5-7). Only a few painted shield-figures survived for photographing and tracing, but these also seem drawn with care and precision (Figs. 4-2 and 4-4).

In many of these images the shield is actually a special motif hiding the body lines of the human figure supporting it. The shields in turn frequently carry additional motifs as emblematic symbols, and such is the case with similar images elsewhere on the Plains, from Pine Coulee and King Buffalo Jump, Alberta, and Pictograph Cave, Montana, south through the Uintah Basin of Utah and deep into Texas, California, and Arizona.[12] But just as often the shields in Milk River art are empty, and where these accompany the emblematic kind they imply a mystical dichotomy (Foldout 1).

Motifs on the shields include the basic human forms already discussed, and their variants. At least two bear the cryptic X. On what is evidently a much abbreviated shield-bearer (only the shield itself is visible, with no human parts remaining) a smaller shield-bearer is the emblem. A fourteen-inch shield, one of the largest petroglyphs of this sort, carries traces of a V-neck figure; although the emblematic image lies aslant its

shield, suggestive of floating or rising, it is still conceptually related to a more conventional version in charcoal in Pictograph Cave, Montana.[13]

The figural scheme of the shield-bearer has produced a number of interesting anomalies. Some of the shields are transparent, revealing a conventionally-shaped body behind. Clearly the larger transparent shields in Fig. 3-2 and 3-3 are not of the same order as those carried by the horsemen in this group of pictures.[14]

Occasionally the shields are squared off, ovoid, or only loosely circular rather than perfectly round. Such departures were doubtless intentional, though we may not know exactly what is meant. In Plate 12 is a shield formed from an 8¼ inch concretion, engraved with short rays all around and with tiny human parts added underneath. In the same mural is an inverted V-neck form with one leg drawn round in a circle to encompass the entire figure in one continuous line.

At a casual glance, a twenty-two-inch V-neck figure seems to be carrying a shield, but it proves to be arms akimbo, carved in semi-circles from shoulders to legs. A similar ambiguity characterizes the apparent shield-bearers flanking the interlaced group in Plate 4. Here, what look like shields are actually finely-drawn concentric arcs that seem to vibrate with rhythmic energy suggestive

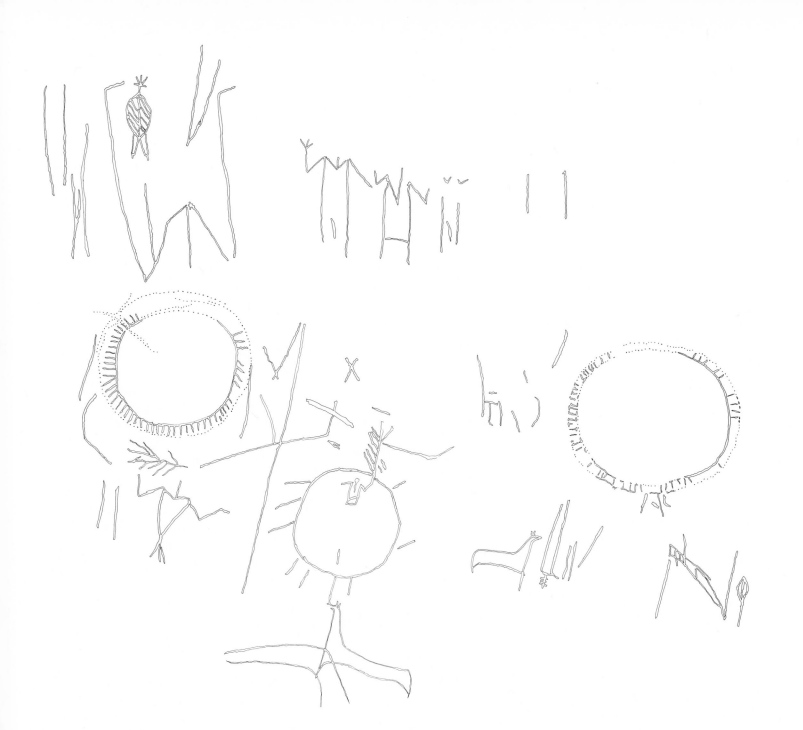

PLATE 12. Concretions, which the engraver embellished with fringe, inspired the shield-shaped motifs repeated in this panel (of which Fig. 5-7 is the upper register). The right-hand concretion still has a foot, leg, and phallus; the one at left is the head of an inverted M-shaped figure.

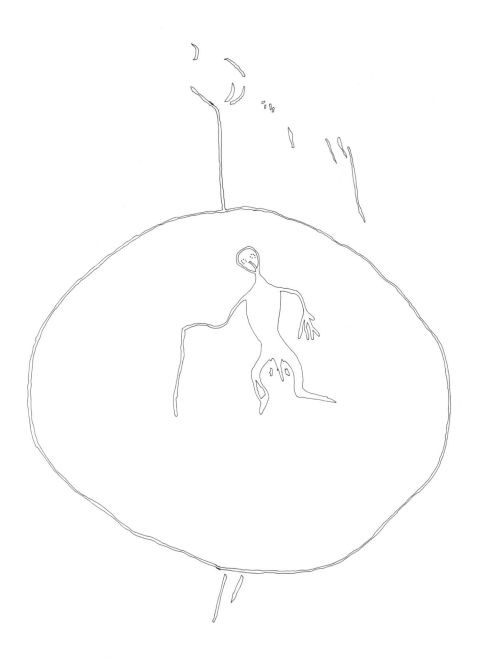

FIG. 5-8

of dancing. And this impression of dancing as a variant of the shield-figure leads to further observations along this line.

To those who habitually deal in symbols it needs no great leap of the imagination to merge the identical shapes of shield and drum, thus vesting the one with attributes of the other. Hence the shield, like the drum, perhaps serves as a magic instrument of mystical transportation. That Milk River artists sometimes thought this way is plain from pictures in which the human form appears *within* the shieldlike circle, as if a passenger conveyed to unearthly realms. One of these is among a varied array of shield-figures; the shield-as-drum displays near its top, as if forming the handle, the upper portion of a tiny human figure, one arm extending through the circular frame itself to wield a large branch or feathered object (Plate 12). In another panel nearby an impressive intaglio figure is widely surrounded by a sixteen-inch circle, lightly incised or worn, which on close inspection turns out to be the body of a shield-figure, the neck and head of which are barely discernible under graffiti (Fig. 5-8).

In these two pictures the figures within the circles are more than emblems; they exist as separate, independent entities, significantly different from the centred, formal, often abstract designs of conventional shield-bearers. In the one, the inner figure reaches

beyond the round frame, while in the other, the human form is so deeply incised as to declare its special level of reality in contrast to the less distinct surrounding figure. For both of these inner figures, the drumlike circle is a vehicle, which in one is actually the body of a larger, less visible being. Black Elk reminds us that the drum is equivalent to the universe, and so it appears in Fig. 5-8 as well. Such treatment of the drum as universe, as living spirit, and as protective shield seems unique to Milk River when compared to figures wielding drumlike shapes in other western American rock art. Yet precisely the same conjunction of ideas, though handled differently, is the theme of designs on shamans' drums of central Asia.[15]

As these images depart from the form thought to be the standard shield-bearer of Plains Indian rock art they illustrate certain confluences of meaning when the identity of one thing shifts into that of another through resemblances of shape, function, or effects. A simple circle may express any sort of round thing, from a turtle egg or a vulva to stars or the concept of the universe. Thus, the form of the Milk River shield-figures readily slips into subtly related ideas. And this phenomenon of the sacred circle conveys something of the unity of all things in the spirit world, despite what seem to us their incongruities. Large globular figures, balancing inflated bodies on strangely inhuman legs suggest,

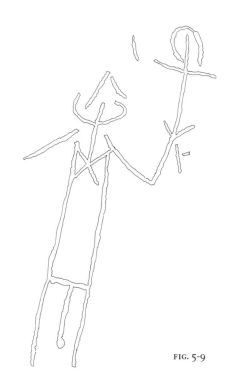

FIG. 5-9

FIG. 5-10, FIG. 5-11

not the stalwart little fellows on guard behind firmly rounded shields, but exalted beings pictured as vague and swollen cosmic powers. Yet the formal connections between both kinds is undeniable. Complicated groups of circular figures, some with human-like appendages, some without, evoke the pageantry of events transpiring in supernatural realms among mysteriously protean forms.[16]

The throngs of armless, legless, and headless shield-shapes mingling with others variously marked as human forms calls attention to a recurring difficulty: how to distinguish figures partly obliterated by lichens, erosion, crumbling rock, cattle rubbings, and so forth from those purposely abbreviated by the art-

FIG. 5-12

PLATE 13 (A and B). The device of abbreviation extends a charcoal drawing of horse and rider (A) into a procession of figures straining forward, their ochre-tinged trail (B) suggesting blood stains. This mural, in the same cave as Plates 2 and 3, is probably by the same artist.

ists. The valley's rocks are covered with scores of headless human forms, far too many for accidents of nature to explain. Nor can chance account for all the human forms pictured only from the waist up, as if emerging from broken rock or from a deep dark hole beneath them; plainly some of these locations were chosen by engravers accustomed to integrating their art with natural formations.[17] In this way the spirit within the living rock merges with that in the pictured form.

The habit of abbreviating, the impulse to concentrate meaning into ever simpler figures eventually arrives at unintelligible abstractionism in private ideographs. Where

artists have regarded conventional signs for human appendages as irrelevant or redundant they have pared down the figure to a mere cross or circle, to roughly parallel lines, or even to a single stroke of brush or burin. Extremely reduced, the resulting figure is apt to coincide with abbreviations of other conceptual images, the sun, perhaps, or the phallus, or the arrow. At this point, mystical meanings intersect. For the artist himself, accustomed as he was to a boundless network of multivocal symbols, such coincidences doubtless enriched meaning. But those of analytical bent are obliged to seek helpful clues, and unless these are found, we must pass on to images that speak a bit more clearly.

Clues – or rather identifying motifs – are often scarcely perceptible. They require careful study and a nice discrimination. One engraver has allowed a waistline and a ring-shaped head to give a coherent, if sketchy impression of a human being. Another presents two parallel legs, a shoulder line, and, helpfully, a phallus. A tiny figure is readable from different details: a large intaglio head and an arm protrude from the briefest of body lines. Until we are accustomed to the occasional picturing of human figures upside-down, the form beside the horse in Plate 12 may seem meaningless, though it has a shoulder line, the stub of an arm, and a peculiar triple-crossed head; this being seems to be

pulled obliquely toward the rayed concretion forming a shield-figure only two inches above. But what of the two shorter parallel lines at its side? Are they an abbreviation of the inverted figure in some transitory spiritual state? There is nothing definitive to enlighten us except the proximity of one to the other.

It is easy to guess that the four vertical lines rising from the back of a horse (Fig. 5-5) are supposed to represent human or quasi-human beings; the intaglio knob-shaped head on each, as well as their position on the horse are pertinent. Similarly, a knob-head and two short legs define another stick-figure; yet just below it are two more headlike

knobs of the same size and shape caught in a conglomeration of grooves, and these we cannot fathom. On a cave wall a conventional V-neck figure is holding – or causing to grow from its hand – a cruciform with a circular top, this part repeating the shape of the main figure's head; we tentatively interpolate from one head to the other and see this odd attribute as a second human form emanating from the first (Fig. 5-9).

Now and then a figure in one picture illuminates a mystifying form found elsewhere. A mural on the face of an overhanging cliff displays a headless "walking T," a trim little androgyny with several well-defined human features: feet, phallus, pregnant mid-section,

and stumps of arms (Fig. 5-11).[18] Its singular basic shape is essentially the same as that of a coarser, partly pecked (unfinished?) intaglio figure in another part of the valley; this one is almost featureless (Fig. 5-10). Despite its lack of detail and its different technique, the larger, vaguer form assumes something of human significance by comparison with the other.

The method of comparing figures at different sites has limitations. On the east wall of a tiny cave a small figure is formed by two painted lines meeting at the top, crossed by another line curving upward like arms, and having a circle at the apex for a head. The reasonable inference is that this figure repre-

sents, if not a human in the strict sense, at least a being with human traits. Have we the confidence to transfer this interpretation to the featureless V-shaped figures flying through other murals (Plate 12)? Not quite. Discretion says there is insufficient evidence and, besides, this particular form is not as distinctive as the foregoing example. Yet intuition tells us that the possibility remains.

Generally speaking, the more reliable clues to abbreviated meaning appear close to the figure in question, from the composition's internal evidence, as it were. We have already glanced at the tiny marching X-shapes in Plates 9 and 10, some with heads, or at least with necks and shoulders, others with an arm. All are undoubtedly human figures, despite the incompleteness of many. In another mural, eight much larger X-shapes range across the upper register. One of them is missing a leg; all are featureless except for one with a shoulder line and another with V-neck and partial head. We justifiably see them as a series of human forms, variously abbreviated like those in the battle scene. In such situations abbreviated figures are the artist's way of saying "etcetera."

An impressive example of this conventional device of abbreviated repetition is in the lower register of a series of pictures extending for some six feet along the wall of the large Rattlesnake Cave in a tributary coulee. Although considerable portions are worn away to mere traces, and the artist has besides indulged in the customary abbreviation, this picture is fairly readable (Plate 13). A sixteen-inch portion in the left-hand section is devoted to a row of parallel lines in charcoal, all leaning in the same direction behind a horse, and embellished with fine swirls and dabs of red ochre. A few of these slanted lines are elaborated in such a way as to represent torsos of conventional human shapes. Once we postulate that this series of lines represents a procession of abbreviated human forms, their regular slating imparts the feeling of enormous strain. Indeed, the procession trails off to the right for about 2½ feet of scattered charcoal tracks, over which the ochre swirls more profusely. Other details tend to bear out this preliminary reading of a work well deserving the title "The Bloody March."

Reduction to parallel grooves and lines is probably the most common method of abbreviating the human form in Milk River rock art. Paired lines appear everywhere, scattered among V-neck figures, as emblems on shields, often with the forms of horses. Although most are unreadable with any degree of confidence, an important few possess motifs expressing interesting dimensions of primitive spirituality. For instance, a glyph for a phallus lies between two parallel grooves which are also furnished with a round head; another engraving uses a vertical neck and protruding sinuous phallus to proclaim a human form. From this information a headless figure in yet another mural also translates as a phallic being, one definitely associated with a more fully defined human figure just below it.

Finally, moving on to a still different site, we find that the humanizing motifs of an abbreviated figure (Fig. 5-12, left), together with the symbolic "equation" cryptically engraved beside it, clarify adjacent glyphs that otherwise would be unintelligible. Both neighbouring figures are headless, in the usual sense, but both are phallic in a special way, and furthermore, they are constructed of oddly irregular pairs of "legs," which make them versions of the first figure. Interestingly, a "leg" of one neighbour (Fig. 5-12, centre) is pronouncedly serpentine, and in fact it terminates in the triangular head of a snake, the universal phallic symbol that serves as emblem of the libido's dual creative and destructive power.[19] Taken all together, this little set of glyphs implies an equivalence of head and phallus as loci of libidinous forces in the human spirit.

Motifs that Amplify Meaning

The most important motif associated with the human figure in Milk River rock art is the posture of upraised arms (Figs. 6-1 and 6-2). More clearly than any other detail, this single feature reveals the spiritual motivation for a large portion of the pictures. Without it we would have no concrete idea of the functions of such art.

The origins of the motif, which has enriched the sacred arts of Asia, Europe, and Africa as well as North America, are lost in time. A rock drawing in Algeria indicates that raised arms could have served in the Palaeolithic to express the magical power of a goddess and her priestesses, who, as Soviet ethnologists believe, may have been the first shamans, already in action during the age of the mammoths.[1] The same gesture occurs in paintings and figurines of predynastic Egypt (c. 4000 B.C.), in Minoan statuettes, in pictographs and stone idols from Neolithic Spain, in the earliest seals found in western Iran, and even before that in figures on bronze pins and finials deposited as votive objects in a Luristan shrine. It is the attitude of Lilith, Sumer's Goddess of the Dead (2000 B.C.), of Isis in the tomb of Thutmosis IV (c. 1400 B.C.), of bird-headed demons in Hittite stone reliefs (c. 1300 B.C.), and the basis of the hieroglyphic *Ka* symbol.[2]

On a sixth century B.C. Egyptian vase, as on a Korean ceremonial crown of 1,200 years later, the primordial formula of the upraised arms merges with that of the branching Tree of Life, an enduring shamanistic symbol. In Greece, India, Cambodia, and Thailand this posture evolved into the multi-armed deities displaying symbolic attributes. Christian Europe did not disdain the motif either, despite its pagan origins: it marks a personification of "Earth" in an illuminated manuscript of eleventh century Italy, for instance, and is implicit in innumerable representations of Christ, whether on the Cross, or ascending from the tomb as in Matthias Grunewald's altarpiece at Isenheim (c. 1511–1512).[3]

Some authorities, Erich Neumann tells us, regard the upraised arms as an attitude of worship, prayer, supplication, or invocation. Others believe it represents the dancing posture of participants in communal ritual, perhaps as in the Milk River petroglyph (Fig. 6-3). Assuredly their ideas are valid for certain contexts. But Neumann himself, who has assembled examples from both Old and New Worlds, holds that such interpretations, while plausible, overlook a more fundamental religious concept inherent in the gesture, and from which other meanings ultimately derive as imitative responses to the divine image. The posture of uplifted arms, he says, is "the posture of 'epiphany,' of the moment when the godhead appears." Mallery learned a century ago that among North American Indians the posture proclaims the presence of a supernatural power, equating the figure

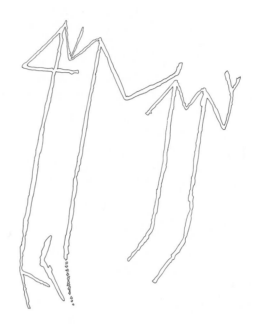

FIG. 6-3

with a holy spirit. Indeed, it is the posture of a god, even of the Supreme Deity, as both an Alaskan shaman's idol of the sun-god and a relief on the Spitalkirch in Tübingen, West Germany, make explicit.[4]

At the same time, the raised-arms motif in the indigenous art of North America is invariably associated with the shamans, marking their sacred costumes and other paraphernalia, and in some places the images of themselves in animal shape. Whatever else the artist chose to incorporate in his picture,

this particular pose at once identifies a figure as a shaman. In rock art, therefore, such pictures are spiritual self-portraits. To borrow words from Vastokas and Vastokas, the creative process, that is, the very making of the pictures, "was thus acknowledged as a sort of divine inspiration."[5] It might well be added that, given the history of this ancient motif, the uplifted arms present the shaman as a demi-god, if not indeed as an avatar of the Supreme Being, as so obviously is the case in an Ojibway medicine lodge parchment where four medicine men or shamans assume the same posture as several "manidos" in various forms, animal and human.[6] The interpretation of the shaman-artist as extra-human and endowed with divine powers holds good also for the many abbreviated or worn figures displaying traces of this sanctified posture.[7]

In Milk River art, then, the human figure with upraised arms is the shaman figure proper. The foremost purpose of all rock paintings and engravings in which this gesture appears is to affirm the mystique of artist and shaman in one image, and to identify him with the divine energy of the universe.

If the uplifted arms of the artist-shaman's self-image posit his spiritual identity and the source of his sacred powers, exaggerated hands and splayed fingers show where his personal power supposedly resides. Artists, musicians, sometimes even poets, instinct-

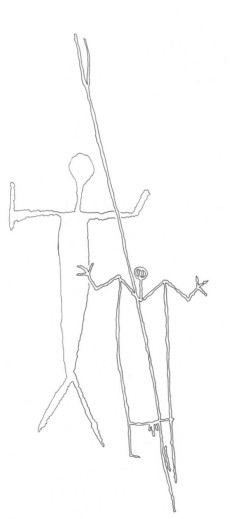

FIG. 6-1 FIG. 6-2

52

ively celebrate their creativity as a product of their hands; for Picasso himself this motif – the outline of his hand emitting lines of force – meant that the figures he drew were not merely the products of his manual dexterity, but the creatures of his manipulative magic.[8] Analogs already cited demonstrate that, in mankind's fund of symbols, the sign of the hand asserted, almost everywhere and in any age, the location of personal sacred power. Nor was the efficacy of this symbol confined to the shaman's art. Clay seals shaped as hands, the palm incised with the mystic spiral, imply that as the stamp of divine power this device protected merchants' goods in pre-Columbian Mexico (1150–550 B.C.).[9] Within the historic period, body paint designs, display of trophies, and warriors' sacrificial mutilations reflected the general belief of North American Indians in the potencies located in the human hand and fingers.[10] In a coulee of the Milk River valley, the artist's fingertips dipped in red paint personally sanctify his panel of engravings.

Milk River shaman figures display hands and fingers with more emphasis than usual in rock art. Some engravers accentuated this motif by deeply incising the fingers in contrast to light and shallow scratches composing other body parts. The enlarged hands and elongated fingers of so many figures almost qualify the stress given this motif as a stylistic trait of artwork in the valley. Exag-

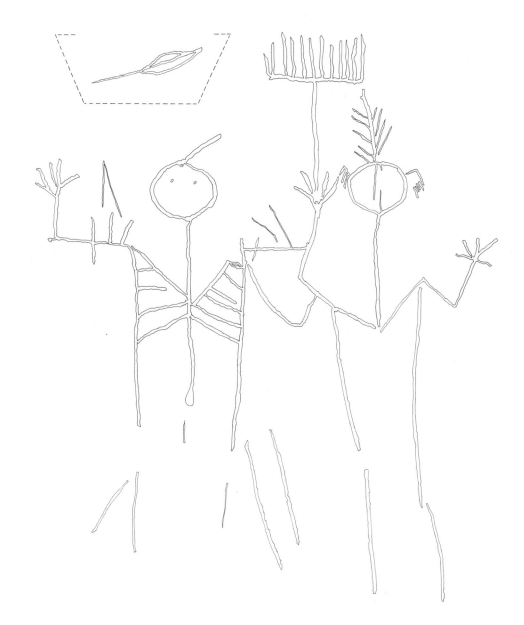

PLATE 14. The joint arm of two engraved figures signifies their identity as phases of the same human spirit. Inset (dashed line) is their heart which floats several inches overhead. The pair belongs to a series of panels expanding on the theme of mystical transformation (Foldout 2 and Fig. 9-7).

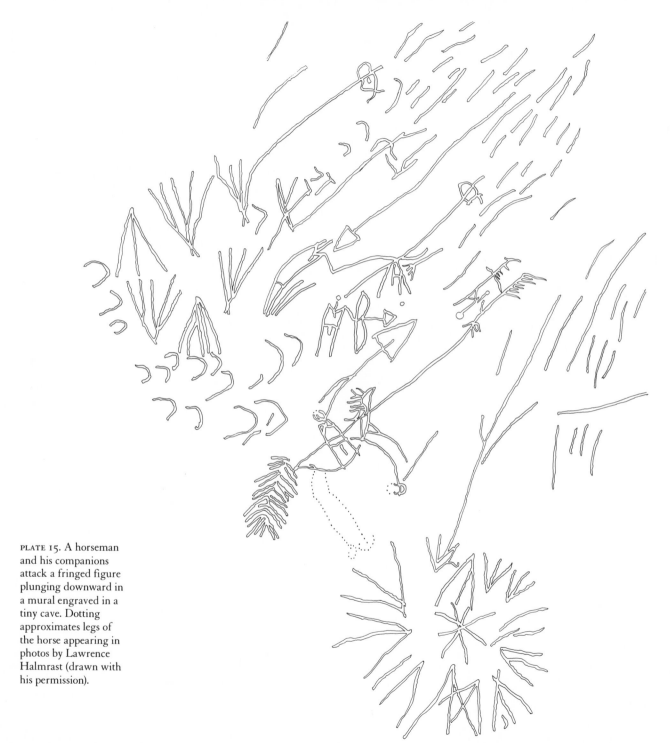

PLATE 15. A horseman and his companions attack a fringed figure plunging downward in a mural engraved in a tiny cave. Dotting approximates legs of the horse appearing in photos by Lawrence Halmrast (drawn with his permission).

gerated size and attenuated form, expressive of transformational mysteries in religious art everywhere, are based of course on the archaic principle that true proportion has to do with supernatural power rather than with differences visible to the eye. The Milk River power-hand sometimes connects with imagery that defines its potentialities with unusual precision. A figure mentioned earlier that holds up a much abbreviated version of itself (Fig. 5-9) makes it possible to read other panels as variations on the same idea: the power in the shaman's hands for transforming himself into a perhaps less visible, but more exalted being. In Plate 14 a shaman shares an arm and great hand with the alter ego beside him, another succinct but obvious sign of transformation through the power of the hand.

Plate 4 illustrates the same formula repeatedly, first in the uplifted and elongated arms linking a row of four separate human figures, three of them with their fingers knotted in a snarl. A few inches away and just a little below the group, a small half-figure rises from the rock's edge; his swollen fingers are spread wide, the tip of one finger contacting the tail of an elegant little skunk. From his position in relation to the much larger tangled group above, the shaman with his crowd of animal spirits may be the point of origin for the transformations happening overhead – at a higher level and therefore on

a larger scale. His creative powers as a Master of Animals are at least equal to a shadowy horned figure painted in Horse Canyon, Utah, from whose great fingers spring a bird, a rabbit, and a seed-bearing plant.[11]

Something quite different is happening in a complicated scene engraved on the back wall of a cramped little cave (Plate 15). In the centre a three-inch shaman, his fringes streaming upward, dives down head first, one finger of his lifted hand extending some four inches farther to reach the image of a horse and rider lunging toward him from below. One might construe this scene as a creative act on the shaman's part, a conjuring of the horseman on his magic bird-beaked horse, or a transformation of himself as we see in other pictures, were it not that two more figures are bearing down on him directly, brandishing their supernatural weaponry and other magical devices. Here, then, in a secret entrance into the depths of the earth, is a miniaturized vision of a struggle in the underworld, where a shaman's defence against hostile spirits blocking his way (other shamans?) is a finger loaded with sacred power.

Associated with the imagery of upraised arms and powerful fingers is the "rake," so called because of its shape, although it resembles no known artifact, ceremonial or otherwise, in Plains Indian culture. Few analogs exist to help interpretation. Habgood has assembled examples from rock art as far south as New Mexico in which fingers and toes of human figures are much like the rigid tines of a Milk River "rake"; although they may be conceptually related, the treatment is not quite the same. More comparable are rakes in the hands of a shaman figure on an Apache medicine hat, cited by Bourke, and the rake from Pictograph Cave, Montana, published by Mulloy, which stands on its long handle, tines uppermost, beside a horned figure.[12]

Among Milk River petroglyphs where rakes are elevated by shaman figures, the handles may be elongations of a single finger, or extensions of an uplifted arm. In Plate 4 a triangular rake expands in the hand of one figure to connect with a neighbour's hand. In Plate 14 a rake is held up by the joint arm of two figures standing side by side. Rakelike forms also may rise from a figure's head (Plate 16) or from a headdress (Plate 12). Sometimes the tines resemble flames, an allusion perhaps to fire and the sun (Plate 17).

The rake occurs in curious contexts. One formed on an arched base rises from the back of an abbreviated animal, probably a horse. The nose-pieces of horses are sometimes very rakelike. Rakes may attach to no figure whatever. Their tines and handles may be lost, broken, or upside down. One isolated rake seems to support from below a composition involving a quartered universe and variously connected human figures.

The action in Plate 17, where Keyser sees a gun as a weapon belonging to the figure on the right,[13] shows a rakelike object wielded by the figure on the left on a slightly higher level. Little flames from the rake reach toward circular forms between them, suggestive of drums. The figure in possession of the rake emits from its head a stream of power represented by a series of tiny round holes. The composition demands an explanation along mystical lines. It may picture the defeat of the lower figure by the upper one, in which case the "rake" symbolizes a spiritual weapon – a stronger medicine, so to speak – in a power contest. But it is also possible that the composition expresses the transformation of one figure into another by way of magical devices, the meaning implied by other panels where rake-bearing figures connect with each other through interlocking or common lines.

In any case, the "rake" as it appears in Milk River petroglyphs is unrelated to any earthly object. This strange motif belonging to the archaic language of symbols is one of the terms for which it seems we no longer have ready cognates. Whatever it means in itself, its presence nevertheless stamps a picture as a mystic's glimpse of other-world phenomena.

The motif of the crippled shaman occurs

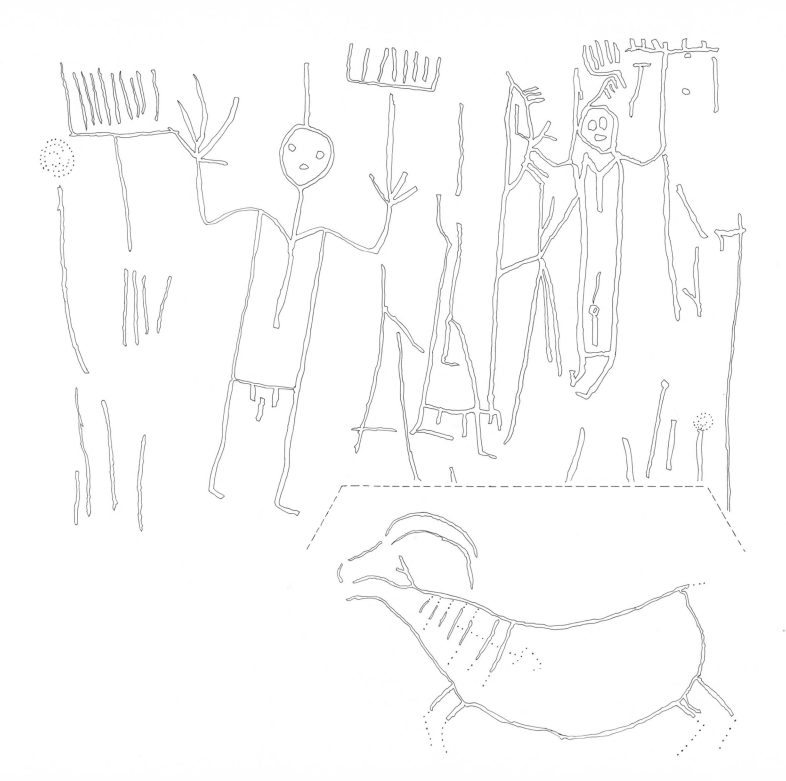

PLATE 16. Male and female figures, transitional forms between them, rise from a bow-shaped "sheep" (inset) marked with skeleton and heart. A tool groove at far right, shaped like the number 7, connects upper and lower registers of the panel. Dotting approximates features appearing in photos by Lawrence Halmrast (drawn with his permission).

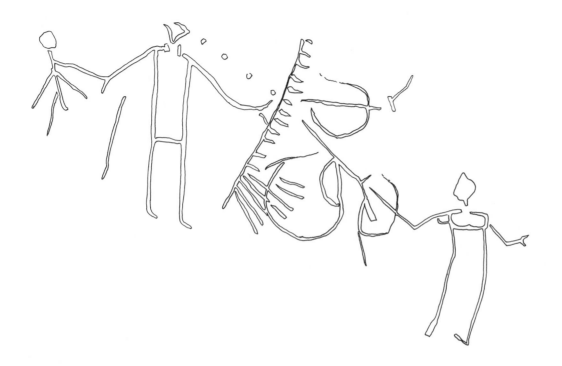

at least once in Milk River art, where a hunched figure supports itself on a cane (Fig. 5-8), just as do two figures in Utah published by Delcie Vuncannon.[14] Their closest analog is the lamed stellar god, Tezcatlipoca, pictured in a pre-Columbian Mexican codex, but all belong to an ancient line of thought, of which one branch leads through Neolithic Asia and Europe to the deformed gods and kings associated in literature with the mysteries of smithcraft. As a Siberian proverb has it: "Smiths and shamans are from the same nest," for both are masters over fire and both pursue esoteric professions. The reason for the traditional deformity in characters like

Vulcan and Weiland the Smith is unclear, although both E.C. Krupp and Joseph Campbell see in this motif the shaman's vision of himself as an actor in astronomical phenomena.[15]

Despite the overall impression of frontal and vertical rigidity in Milk River forms, some figures are dancing, reclining, or floating, postures associated with the very act of shamanizing. Bent knees, joined hands, and rhythmic gestures identify the dancers. The intaglio figures dancing together around a concretion (Foldout 4) resemble in form the four-foot tall acrobatic frogs painted in Utah, which in turn seem related to certain Pueblo

pottery designs.[16] Several short strokes of red ochre embellish the right hand of an engraved shaman, evidently to signify that he is dancing. Rhythmic markings contribute movement to a dancer drawn in charcoal (Plate 18), easily the liveliest human figure in the whole valley.

Reclining figures are by no means common at Milk River, but the few that exist spell out the relationship of the shaman to the imagery surrounding his portrait. From a recumbent form in the lowest register of a sprawling mural an upright figure rises twenty inches high, uplifted arms extended as if to bracket the entire scene above as a

PLATE 17. A unique version of the "rake" as weapon or instrument of supernatural power has flamelike tines. Figures in this engraving show a personal artistic style of handling conventions.

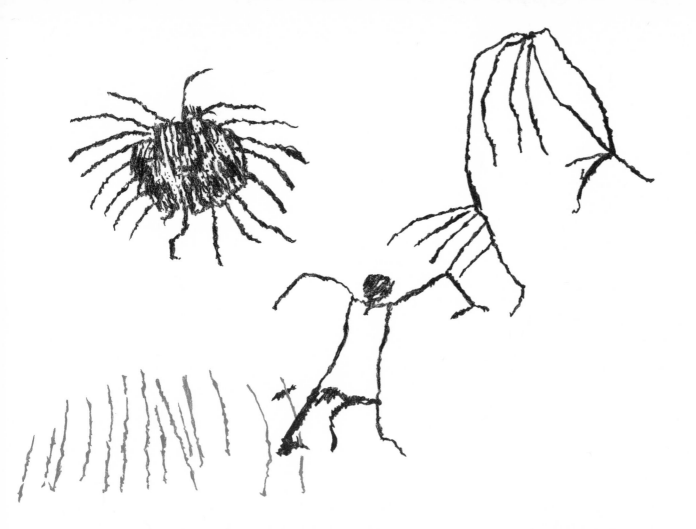

FIG. 6-4

PLATE 18. A dancer, drawn in charcoal with rhythmic strokes in red paint, connects with a winglike form, perhaps an incipient Thunderbird. The fringed circular figure, above left, may be a Thunderbird more fully formed. The ochre itself possessed sacramental value.

spectacle envisioned in ecstasy (Foldout 1). A thin drawn-out shaman twenty-three inches long lies full length along the narrow smooth lip of a fissure, his trance seemingly induced by smoking, for a long-stemmed pipe crosses his brow, from which ascend pictures of himself in at least two distinct transformations (Foldout 2). At another site a horse and rider rise from the torso of a supine figure, the starting point of a sequence of horse, bird, and animal forms progressing upward along an oblique crack in the rock. A similar combination of reclining figure and rising horse is on a nearby panel.

Floating figures, which are elevated in relation to the forms around them, lie horizontally, on a slant, or upside down (Fig. 6-4). A headless, armless V-neck figure only 1½ inches long soars above a complicated picture composed of merging and incomplete animal forms of much larger size. Hovering above the horns of the large beast on the left

in Foldout 3 is a stick-figure buoyed by a long wand. In another mural a floating shaman (Fig. 6-5) overlaps several shield-figures, as if he and they are aspects of each other. But two figures in the upper register of the composition shown in Foldout 1, like the fringed diver in the tiny cave, seem to be drifting downward, as if inverted in a nether world. It is worth noting, however, that in Algonkian iconography an upside down figure signifies it is dead; nevertheless, some Milk River artists may have extended that meaning to connote a metaphysical kind of death.[17]

The practice of abbreviation could explain the numerous headless figures in Milk River art. Yet many figures do have heads, and the juxtaposition of the two sorts, some directly linked together, is worth attention.

In such pictures omission of a head seems to be more than simple abbreviation or condensed meaning. It is interesting, too, that deep and violent tool gouges may separate head from body – an intimation of the dismemberment experienced during ecstatic trances, one of the enduring themes of shamanic lore.[18] Headlessness – and other devices of reduction, as well – may also signify the gradual onset of invisibility, the passage from one spiritual state into another. And, just as half-figures rising from the rock's surface depict an emergence into visibility, the forms with heads vanishing into a natural formation, such as a concretion or a crack, or with heads partly pecked away as if exploding, possibly represent the spirit withdrawing or propelled from one phase of mystical reality into another. Further, when a natural hole or concretion becomes the head of a figure, as in Plate 12, it seems to specify the identity of the shaman-artist with his sacred environment.

A typical form of head on human figures is the intaglio knob, which in some variations approaches the head-shape of certain bird figures. Other intaglio heads are rather hooked, after the manner of those on X-shaped Thunderbirds. Some heads are of irregular shape, one or two suggesting a human skull. Still others are a mere dot or tiny drilled hole, in archaic designs the common sign for a star, so that an assembly of dot-

headed figures possibly refers to astral configurations important to the artist. In fact, four such dots compose the head of a fringed figure, the whole adduced perhaps from a certain constellation.[19]

Another conventional head shape is the circle or ring, oftentimes shown only in part, or distorted for obscure reasons. Typically, ring-shaped heads at Milk River are blank, as if the senses residing in ordinary human features are of little use in supernatural surroundings. Yet a few figures stare out of unfocussed eyes, their pupilless vision looking into dimensions beyond everyday sight. The eyes of the crippled shaman centred in the personified drum (Fig. 5-8) show in Halmrast's photo, though not in the tracings. Material counterparts of these disquieting apparitions are the shamans' transforming blindfolds, face paint, animal-skin cloaks, and spirit masks, all of which enabled them to see the invisible through the special power of an "inner light."[20] The bearskin robe with eye holes worn by the Blackfoot shaman that George Catlin painted in 1832 belongs to this vein of transformational symbols, and so does the "weeping eye" motif associated with cultures of the southern Great Plains.[21]

The artist responsible for the floating shaman in Fig. 6-5 reveals something of the complexity of thought behind the motif of mystic vision. The eyes of his little figure are repeated as testicles either side of the serpen-

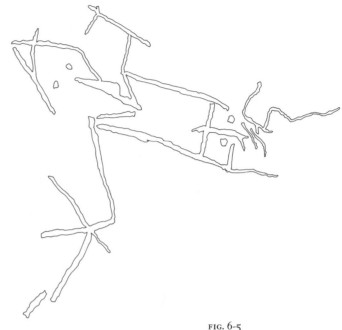

FIG. 6-5

tine phallus, which thereby doubles as a second spirit-nature. The same concept is also expressed in another Catlin painting where a Mandan shaman warrior wears as an apron over his loins a wolverine skin with eye-holes.[22]

In place of heads some Milk River artists drew shapes of insignia ordinarily attached to magic implements or other mystical symbols identified with the shamans' profession. One such substitute for the head is a two-pronged form, like the letter Y, which also terminates the staffs or wands carried by other figures. This Y serves as a head on a

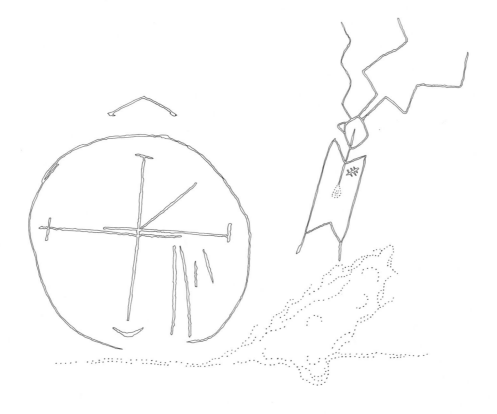

number of figures at Milk River and other
Alberta sites.[23] The same Y caps a line of
worn vertical grooves, of which at least two
or three are also furnished with heart-
shaped forms, raising the possibility that
they are meant as a series of abbreviated spir-
itual beings with hearts and heart-lines some-
what resembling arrows. In the engraved
hanging scene well-known to archaeologists
a Y forms the head of a V-neck figure, the
apparent executioner. The forked head may
sometimes be a version of horns, another
shamanic sign of divine power, but on Sibe-
rian wands the two prongs, each with facial
features indicated, were identified as "the fa-

ther and mother of fire," and thus were em-
blematic of the shaman's claim to bisexual
character, as well as his mastery of fire.[24] In-
deed, the same forked form appears as an ex-
tension of a phallus on one Milk River mural.

When treated as the head of a human fig-
ure in Milk River's sacred art, the sign of the
cross, as distinguished from the X-based
body, encourages naive interpretations. Some
observers regard it as the sign of a Christian
person. Others assume such figures repre-
sent Europeans, on the grounds that a sim-
ilar form, said to represent a hat, was put on
figures of white men in secular winter
counts painted on hides during the nine-

teenth century. Possibly this is correct for a
small figure near a horse and wagon in a
panel where mystical and secular imagery is
oddly mingled. But for other such figures,
this interpretation hardly does justice to the
subtleties of the shaman-artists, who were
well-versed in archaic symbolism. Their ico-
nography was rarely one-dimensional.

The cross was never exclusive to Christi-
anity, but had already developed complexi-
ties of meaning in the Neolithic period. It re-
mains the most comprehensive, succinct, and
universal symbol ever devised, its referents
ranging from cosmic order to the notion of
the individual as archetypal hero com-
pounded of the Four Elements. On the per-
sonal level the cross signifies the self as a
unity of opposites and ruler of an inner
world, a Hellenistic concept revived and glo-
rified by Renaissance magi for whom man
was the measure of all things.[25] But long be-
fore, the sign had acquired much broader im-
plications.

In Egypt of the sixteenth and fifteenth
centuries B.C. the *crux ansata* with upraised
arms appended was worshipped as the di-
vine symbol of life. Pagan Celts of Ireland
and Scotland, still clinging to vestiges of an-
cient modes of worship, carved stone crosses
adorned with stylized breasts and interlaced
entrails, possibly to honour some Great
Mother, a formula later modified to comply
with Christian doctrine. As the framework

of the Zodiac, whether in Mesopotamia, Bali, Coptic Africa, Medieval Europe, or twentieth century Toronto, the cross exfoliated into a revolving compass of the heavens, bearing astral emblems – a zoo in the sky – of the whole man's salient characteristics. Buddhist, Mayan, pagan Norse, as well as Christian imagery frequently merged the cross with the shamanic Tree of Life, Death, Rebirth, and Enlightenment. It was the Axis of the World, sometimes with the shaman's bird as its terminal emblem.[26] As in Oriental mandalas and Aztec mythology, so in Plains Indian ritual: this quintessential symbol mapped the imagined structure of the universe.[27]

In light of the extreme antiquity and wide-spread diffusion of its converging and overlapping meanings, it is no surprise to find the cross at Milk River in interesting, perhaps unique contexts. We have already looked at a shamanic figure upholding a cruciform (Fig. 5-9). In Plate 19 the cross, in a circle nine inches broad, is clearly a cosmic diagram, like the scheme on Mongolian and Chilean (Mapuche) drums, but with what seems to be the human element within reduced here to two sets of parallel grooves in the lower right quarter. These abbreviated figures have some relation to the armless lightning-struck figure rising out of a deep irregular hole beside it. The cross as cosmic diagram appears again as the motif on a 2½-inch shield (Fig. 5-7) where the engraver,

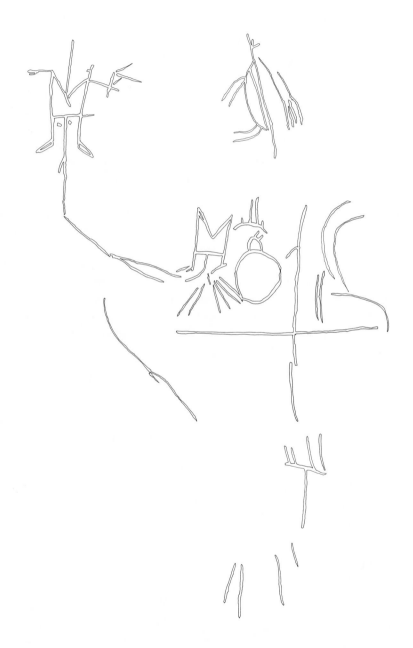

PLATE 20. The horizontal arm of a cross supports representations of human figures, one connected phallicly with another on the upper level where a winged animal ascends.

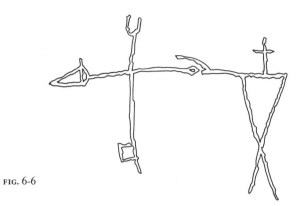

FIG. 6-6

hinting at transparency, has completely merged the human and cosmic elements by extending the lines of the cross to form the shield-bearer's legs and neck. But this figure incorporates yet another idea: beside it and beside its neighbouring shield-bearer stand their attributes – phallic "weapons" in the shape of erect arrow-headed bows.

A panel where a cross with ten-inch arms rises from a detached tine of the "rake" carved below elaborates the significance of the cosmic diagram by combining it with symbols of libidinous energy and generation (Plate 20). The horizontal member of this cross supports several figures as if they belonged on the mid-plane of the world. In the quarter to the right is a double set of parallel grooves of the sort found in Plate 19. On the left a horned shield-figure with a halo of rays crowds against three more sets of parallels and a headless V-neck being. This latter figure connects "phallicly," one might say, with a similar figure soaring above and beyond the diagram; one of the arms of this upper figure branches slightly as if becoming a wing. And just opposite, directly over the diagrammatic cross, a winged animal ascends, another shape, so we surmise, of the spirit incorporating all the forms below.

For those prepared to read its array of motifs this remarkable composition is an opportunity to see how symbolic logic lent a semblance of coherence to the shaman's world. As Eliade explains, although the shamans probably did not create archaic cosmology, they "interiorized" it.[28] The universe that was the content of their knowledge and experience was identical to themselves. By asserting the cosmic character of his own person, as the multivocal cruciform implies, the artist responsible for this composition justifies his claim to mediate between mundane levels of life and the upper world visited during ecstatic flights. His mystical transformations guarantee the generation of life on the middle level of a universe supported and held in order by the occult power of his symbolic magic "rake."

By placing the cross as the head on shamanic figures, then, other Milk River artists expressed the idea of the mystic's mind as an inner world of universal proportions. A bow-and-arrow cross held by a cross-headed figure (Fig. 6-6) fuses the cosmic element with an image of magic flight as mental activity, the same "bows of my mind and the arrows of thought" that protected the poet William Blake's sacred double vision.

Again, a cross-headed figure displaying power hands is neighbour to a shield-figure, which, though partly crumbled away, is nevertheless plainly marked as a cosmic diagram: the cross within the circular shield. The parts of a similar figure at another site are inextricably entangled with the feathered bird-human beside it. These petroglyphs, at a cursory glance incomprehensible, are varying expressions of personal consciousness of omnipotence, a typical experience of shamans.

Mystical Physiology

Of all the motifs that enrich Milk River iconography, the skeleton and its variants are indisputable evidence that this art is preeminently the shaman's art. The belief possessed the minds of shamans everywhere that imperishable bone was essential to their initiatory mystery of dismemberment, renewal, and rebirth; it inspired their meditations and supported their claims to the metaphysical experience of suffering. Hence the sacred skeleton motif summarizing the "drama of death and resurrection" is a prominent design in their garments and accessories.[1]

The urge to give visible form to an inner structure that only they could see helps explain why Milk River artists favoured certain conventions for their spiritual self-portraits. The minimal outlines of the human body emphasized the transparent mid-section as a space reserved for the imagined bony structure and viscera, and was the place to indicate the presence – or perhaps the significant absence – of important mystical organs.

Skeletal figures in several Milk River murals are easy to recognize. Parallel ribs branch from either side of a central backbone running between the regions of head and phallus (Figs. 7-1 and 7-2), precisely the same design carved on the hollow torso of a wooden dancing puppet personifying the presiding spirit in ceremonials of a Haida sha-

man society.[2] Although these figures seem modelled on the bony structure of living creatures, they by no means imitate biological fact. Especially in its most obvious form the skeleton more nearly resembles the shamanic Tree of Life, and probably is, at least partially, an interiorization of that symbol with all it implies.

Elsewhere treatments of the bony structure depart freely from the biological model. Some represent the skeleton as a pattern of horizontal lines (Plates 21 and 22), similar to the design of hair-bone vests of the Plains Indians, which doubtless referred in turn to the same mystical concepts.[3] Other human forms are filled with oblique grooves as if the ribs had been re-organized or the backbone collapsed. Several artists engraved the torso with a network of criss-crossing lines, or reticulation, that conveys a sense of the labyrinthine depths of the inner self (Plate 4). Reticulation is comparable to the lattices, spirals, running scrolls, interlacings and other convoluted patterns in the archaic arts from China and New Zealand to Celtic Ireland and North America, all expressing hidden energies of nature. Reticulation seems to be rare in North American rock art outside Milk River and Montana sites, although Hedges has published a female figure from Southern California which is filled with such a network, proof that the motif is not simply a local one.[4]

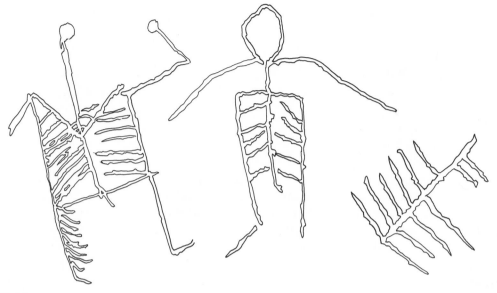

FIG. 7-1 FIG. 7-2 FIG. 7-3 FIG. 7-4

Once familiar with typical Milk River skeletal patterns, one soon notices their less obvious presence: on the body of a double-winged creature emblazoned on a shield (Fig. 5-7); as a tiny insignia engraved on a lightning-struck spirit (Plate 19); as the inner structure of a hand (Fig. 7-4). Disembodied skeletons and bits of bony structure (Fig. 7-3) drift across the walls of a rock shelter and here and there within a number of complex compositions.

Milk River artists evidently regarded the backbone as a channel of vital forces circulating throughout the spiritual body. In a related scheme of mystical physiology this main stem becomes a heart-line associated with significant organs: heart, kidneys, and

phallus. Some engravers stretched out the heart-line as a very long neck, or made it bisect the figure's head. Milk River petroglyphs freely combine elements from both systems – the skeletal and the visceral – and reduce the parts to perfunctory abbreviations. "Stick figures" may in actuality be extreme reductions of the human body to a mere backbone or heart-line. The heart-line in simplified form has long been an element of folk design, as on the painted tipis of the Blackfoot tribes, but only in the Milk River's rock art did it receive the much fuller expression the shamans could give it.[5]

A close analog of a version of the heart-line scheme that appears in Milk River petroglyphs is a beaded human effigy in a Plains

Indian shaman's bundle used for medicinal purposes. A limbless torso with head and eyes, it is marked with kidneys, a heart, and a heart-line that reaches a mouth (for sucking out evil spirits?). It is patently an image of the shaman's spiritual self with curing features emphasized.[6]

Depending on the artist's motivations, the heart in Milk River imagery takes diverse conventional shapes: a slight widening at the junction of the V-neck grooves, a teardrop, a pointed bulb, an arrow or lance head. Occasionally it is simply a natural depression in the rock in the middle of an engraved figure. Compartmentalized (chambered) hearts suggest yet further meanings for this motif.

Although traditionally the skeleton was

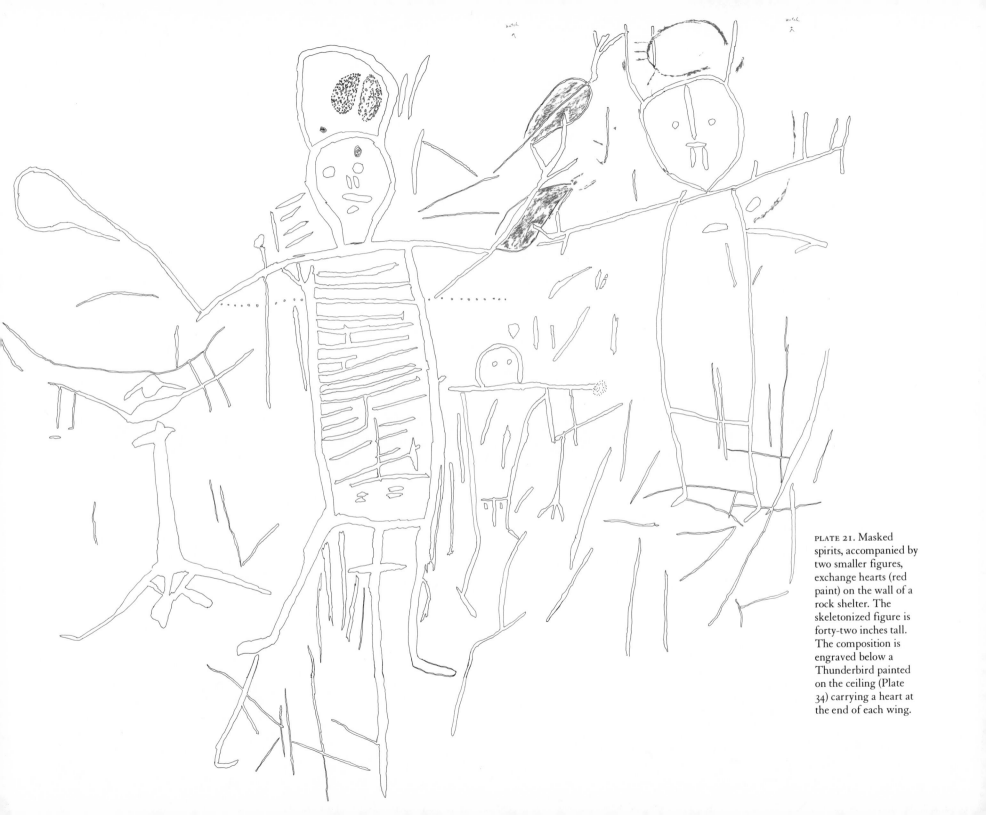

PLATE 21. Masked spirits, accompanied by two smaller figures, exchange hearts (red paint) on the wall of a rock shelter. The skeletonized figure is forty-two inches tall. The composition is engraved below a Thunderbird painted on the ceiling (Plate 34) carrying a heart at the end of each wing.

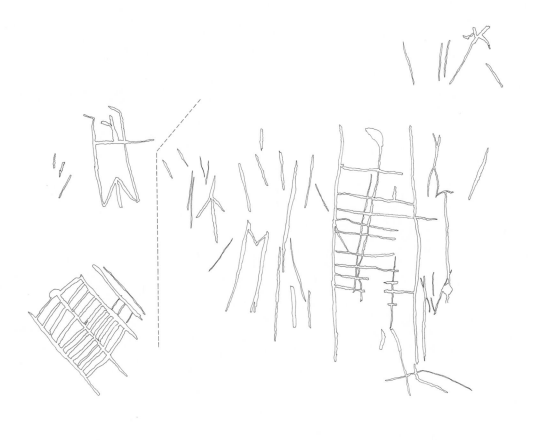

PLATE 22. Engravings on another wall of the same shelter as Plate 21 include human forms and skeletons both rightside up and upside down, as well as a unique treatment of the power hand (lower right). Dashed line represents abridgement of empty space between the glyphs.

the seat of the shaman's perdurable soul, many Milk River artists seem to have shifted that function to the heart as well, for, just like the escaping bony patterns, the typical heart shapes emerge from body images and sometimes soar away independently, as in Plate 14. A chambered heart on a heart-line may protrude straight out from a figure. A figure carved on the floor of a rock shelter (Fig. 7-5) stands with heart-line and heart in hand, as if it is a ceremonial staff.

Migrating hearts and skeletons frequently appear in the same or related murals. On one wall of the shelter mentioned above – actually a shallow cave – two large engraved figures exchange hearts painted in red ochre (Plate 21), while directly opposite them float skeletal torsos and dismembered figures, some of them upside down (Plate 22). On a shelf in another cave a bulbous pointed heart, swung on its own heart-line, bursts from a reclining V-neck form and opens like a blossom amid an explosion of rib bones and drilled holes; a disembodied but assembled skeleton lies at the same angle a few inches away (Plate 23).

It is no coincidence that the heart imagery of Milk River artists converges with the shapes they gave to other motifs, for it seems one of the devices of archaic logic to load the simplest of forms with richness of meaning. The triangular heart within a figure is repeated in ostensible arrows and spears, in the

fringed lance passing through a shaman's arm (Plate 4), and in a thirty-six-inch upright spear fletched with patterns that allude to skeletal forms as well as to feathers. The same sort of blobs and pointed and chambered bulbs that depict hearts within some figures reappear also elsewhere as parts of arrows and lances.

Hearts also shoot out of a rayed concretion (Fig. 7-6) and from a starlike engraving, plunge downward from a "heaven" filled with X-based figures, pierce or protrude from a tiny shield-figure venturing against an underworld beast, or stand upright among a row of abbreviated human forms. In an engraving sometimes construed as a combat scene, but better regarded as a mystical initiation, a long fringed spear reaches from one shield-figure to the head of a small one, from which swells a round shape with heart and heart-line extending even farther upward (Fig. 4-1).

Engraved on the back wall of the rock shelter already referred to is a heart on its heart-line erupting from a tipi and taking on the likeness of a long-necked animal; from its back rises a phallic human form and a cross (Plate 24). Joined to the left side of the tipi is a set of human forms which seem to be dissolving. Whether this linked series of forms is to be read as sequential or simultaneous events one cannot say, but the heart is obviously the predicate of the whole passage.

In short, the motif of the heart in Milk River art supports endlessly varied fusions of meaning through its likeness to other forms. Art readily transformed the heart and soul of the shaman-in-ecstasy into a mobile, penetrating, and generative implement invested with celestial and cosmic powers. In no way do such ambiguities reflect mere literal facts and artifacts of the material world, however, the repertoire of symbols may have been adapted from mundane phenomena. Like the play on words which is their counterpart in poetic expression, multivocal shapes draw paradoxical concepts together to distill their hidden harmony.

The interplay of significant form that could equate the soul-bearing heart with mystical weaponry and animated being comprehends phallic imagery, too. For instance, the pointed arrowlike shape of heart and heart-line in a standing figure exactly duplicates the phallus of the reclining figure from which it springs (Foldout 1). Arrow-tipped bows that are unmistakably phallic stand beside the tiny shield-men in Fig. 5-7, and in the grip of the shaman in Foldout 3; at the same time these bows, with their branching tails, duplicate one of the conventional animal forms of Milk River art. Elsewhere, a shield-figure clutches a great phallic arrow of evident power. On the whole, so interchangeable are these shapes of heart, phallus, weapons, and animals that we can hardly

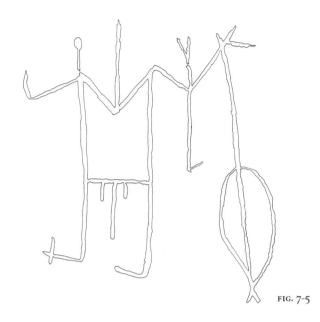

FIG. 7-5

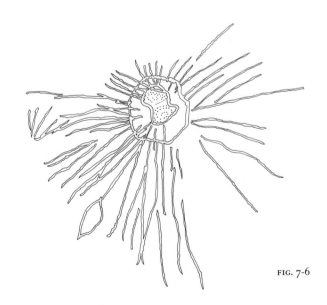

FIG. 7-6

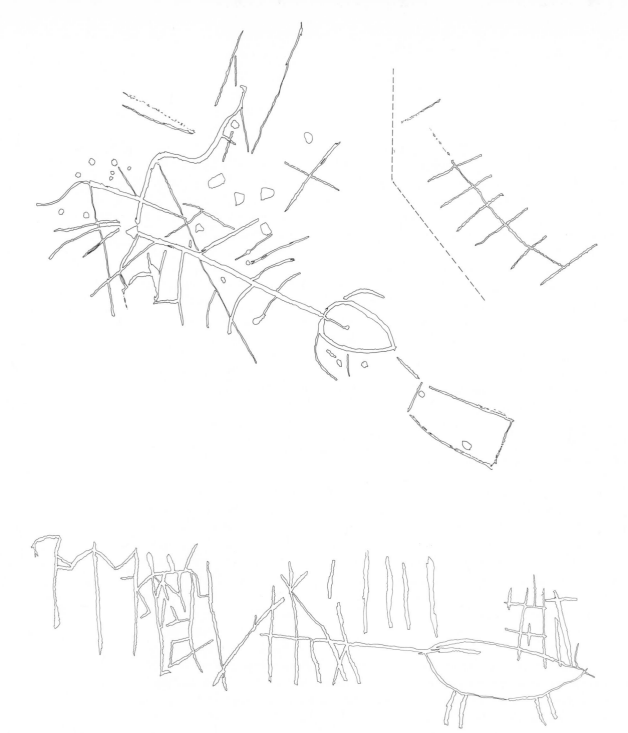

PLATE 23. Engraved on the shelf of a cave is a partial human form from which bursts a bulbous heart among cups and grooves and a skeletal pattern. Dashes indicate abridged space.

PLATE 24. Heart on a heart-line emerging from a tipi metamorphoses into a four-legged animal from which rises a phallic human figure. Joined to the tipi on the left is a human form in three phases.

categorize them strictly as one thing or an-other, but must accept them as evidence of the artists' synthesizing vision.

Phallic imagery at Milk River is dense as well with allusions to the intermeshed themes of creative intellect and energy, fertil-ity and regeneration, renewal and rebirth, all embraced in the shaman's person as pictured on the rocks. The image of the phallus re-peats itself, not only in his heart, but in his head (Figs. 6-5 and 7-7). The serpentine phal-lus, known by now as the emblem of the li-bido, is a fairly frequent motif (Figs. 7-8 and 7-9). Sometimes it links bodies undergoing transfiguration (Plate 20). Like the heart, the phallus sometimes floats free of the body. A sixteen-inch bodiless phallus, engraved with fine reticulations, contains an emerging X-shaped form, perhaps an abbreviated birdlike human (Fig. 7-10).

None of the phallic figures at Milk River – and there are many – is "erotic" in today's sense of the word. Rather, most of them bear witness to the intense interest of the tribal community in the continued proliferation of life in all its forms, and, as Vastokas and Vas-tokas aptly explain, to the shaman's role as a "phallic instrument" capable of influencing the cosmic processes of fertility.[7] Not even the sympathetic magic of folkways seems rel-evant to these pictures. Squatting figures in the midst of visions of horses display male genitalia with all the force that intaglio en-graving can impart (Fig. 7-7). Beneath an ex-tensive mural of other-worldly activity the legs of a reclining figure are likewise drawn up to emphasize the phallus (Foldout 1). This posture, intended to manifest the numi-nous power of the phallus as a sacral image, is analogous to ancient images from both the Old World and the New in which the naked goddess, in precisely the same posture, dis-plays the "birth-giving orifice," the image it-self invested with fecundating power.[8]

The interpretation of a vignette (Fig. 7-11) as a "sexual act" trivializes a profound re-ligious sensibility which saw regeneration and fertility bound up with all of beneficent nature, and hence with the fate of the hu-man community. In this petroglyph an atten-uated female figure fifteen inches long bends her head to the phallus of a ten-inch bean-shaped figure who is almost doubled up with the excruciating charge of her blessing. The difference in size of the two, the preg-nant shape of the male in contrast to the slen-der, elongated female, her four (?) breasts emphasizing her nourishing aspect, her want of genitalia as if here a matter of indiffer-ence, and finally the birdlike and therefore spiritual heads of the two – all these details bespeak an act of mystical initiation per-formed by a superior spirit on a lesser being who now must follow the shaman's profes-sion with its obligation to insure the continu-ation of life. Moreover, as if to stress the sa-

FIG. 7-7

FIG. 7-9

FIG. 7-8

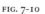

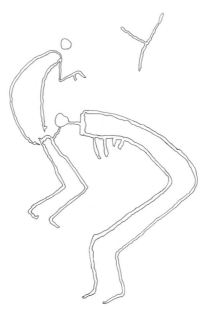

cred meaning and power of this vision the artist has carved above their heads the Y-shaped cryptogram, which, as already mentioned, has long served as a concise shamanic symbol of the male and female principles combined.

The ubiquitous phallic figures of Milk River rock art testify to a cultural milieu in which the shaman-artists were predominantly male. A few female figures occur, marked by breasts, vulva, or uterine cavity, but these are apt to be paired with a phallic partner, as in Plate 16 and Foldout 4. In the former, the masked female is accompanied by a larger male, also masked, and both are "rake"-bearers displaying the shaman's posture, with partial heart-lines shown. Two or three distorted figures, one incorporating something of animal form, the others show-

ing feet and phalli, link this pair together as if they are graduated stages of changing shape. Thus, the spectral female actually may be a transfiguration of the male in a graphic demonstration of the shaman's acquisition of the powers of both sexes. As in many complex murals, darting tool grooves fill the space around the two, and around a deeply ground out vulva form nearby. A long bracketing line leads upward toward the couple from the image of a sheep, the apparent starting point of this vision of transformation. The entire panel is bounded at the top by rows of tiny natural holes, at the bottom by larger *tafoni,* framing a surface suitable for a coherent composition, rather than spaces for random unrelated pictures.

More difficult to interpret is a pair of figures, visible in Foldout 1, heretofore de-

scribed as a "birth scene" and as a "sexual act."[9] If the former, it depicts no normal parturition, for the relatively huge child comes forth feet first between the legs of the mother (Fig. 7-12). As a sexual exploit it makes no ordinary sense either. The smaller figure has no phallus; it is, however, a shaman, whose uplifted arms show power fingers reaching toward his companion's vulva. Moreover, compared to the other figures swarming over this extensive panel, these two are more or less upside down, diving or falling through an inverted world, as does the fringed shaman in Plate 15.

What should we understand by this strange encounter? That by his gesture the visitor gains passage through a hostile nether region, here personified in female form? Or that by this means he seizes some occult

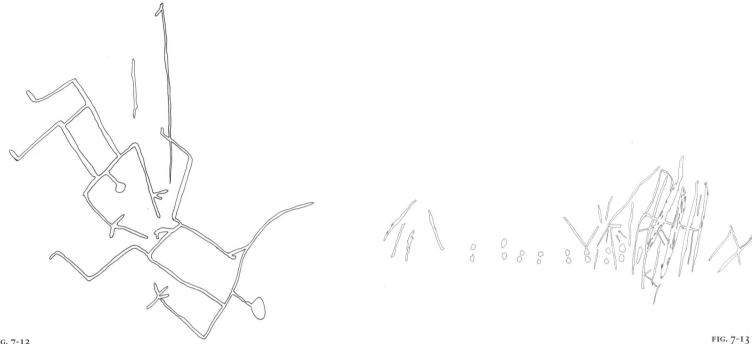

FIG. 7-12

FIG. 7-13

power from the depths of the Mother Earth? Whatever the interpretation, it is easy to see that this pair comprises but a single episode among the many complex doings pictured around them, all ostensibly emanations of the underlying dreamer's trance, and all within the baleful glance of a bizarre concretion.

The label of "birth scene" perhaps applies more plausibly to two other engravings, although both are so curious in context as to warrant interpretation only in the spiritual sense of rebirth. In the first, an upright V-neck figure is female by virtue of the crossed inner lines of the legs enclosing a tiny crescent in the groin. Between the "legs" an abbreviated figure descends in the form of two long parallel lines. A few inches away is yet another abbreviated figure with what may

be a drum attached to one side. The implication of this composition is that the drum is the instrument making the rebirth possible. As for our other example, the female is one of two figures incorporating a pair of rayed concretions (Plate 12). One, the headless male, possesses legs and phallus, the 8½-inch concretion serving as body or shield. But the somewhat smaller concretion opposite serves as the head of another figure; the neck, M-shaped body, and the legs extend upward so that it is actually upside down, a being from the underworld perhaps. We can assume it is female because emerging head first from the empty space between the legs is a very small oval-bodied figure right side up, its torso marked with a version of the skeletal pattern and its head treated as a bunch of feathers.

The female principle found expression in

Milk River art much oftener than a mere count of figures reveals. Cup-and-groove petroglyphs, symbolic acts of coitus manifesting the ancient veneration of the uterine earth, are so widely distributed – from the British Isles to India, Australia, British Columbia's coast, and interior Brazil – that the Texas art historian, Terence Grieder, believes the motif was carried to the Americas with the first wave of immigrants long before the period of high sea levels some 8,000 years ago.[10] Some such concept may lie behind the Egyptian egg-and-dart motif still used to ornament public buildings.

Precisely this motif appears in a cave where about seven feet above ground level a double row of drilled holes merges with a series of deep grooves (Fig. 7-13). The same pattern of cups or pits occurs again on a

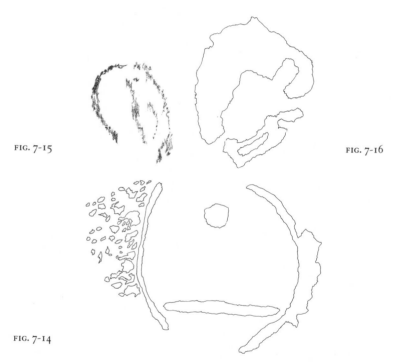

FIG. 7-15

FIG. 7-16

FIG. 7-14

lower ledge, where a great heart and heart-line break forth from a reclining V-neck figure along with a scattering of fine grooves and skeletal patterns (Plate 23). In the cumulative way that archaic symbolism works, the artist here has saturated his dismemberment theme with cryptic sexual imagery combining signs for the female principle with grooves alluding simultaneously to bones and phalli. A painted treatment of the cup-and-groove motif is on an inner facet of the wall of another cave where a row of about thirty ochre dots and dashes arches around a cluster of other forms, including heart, heart-line, and head, as if these represented the breakup of a human figure, together with ritual signs of coitus essential for its re-creation.

The very geology of the Milk River sanctuary allowed the female element of sexual symbolism to remain an inferential presence. The valley itself, a holy yet demonic place, was the image of the prolific womb of the world, its femaleness a substrate of the mystic's ideology. Further, the innumerable *tafoni,* crevasses, and clefts, and the deeply embedded concretions, as in Foldout 1, provided natural omphali (navels), vulvae, birth-giving chambers, and vestibules of the underworld. We can well imagine how the artist crouched in a cave less than two feet wide believed himself cramped in a womb awaiting rebirth as a hero, while he painted and en-

graved his visions of adventures in the underworld (Plate 15).[11]

Many figures surround and impinge upon these queer formations as if there were a ceaseless coming and going between the surface and the interior of the earth. Engravers directed their fertilizing tool grooves at the holes, corners, and crannies, occasionally enhancing the power of this repetitious creative act with applications of the sacred red paint. Several of the hole-and-groove compositions, as we are bound to call them, are interesting for the additional motifs worked into them – a feather in one, skeletal patterns and reticulations in others – and for the human and animal forms rising from them or disappearing into their imagined depths.

Vulva designs, or "yoni," which according to Grieder typify the next stage of artistic development after the elementary cup-and-groove motif, also appear in Milk River rock art.[12] Here, horseshoe-shaped forms are among the symbols of female sexual power. So are more or less circular clusters of "cups" and pits. An apparent shield with a smaller shield-figure as its emblem may be a vulva design as well, for it conforms to the usual patterns and is underlined by about twenty firmly engraved tool grooves. The yoni shape, or vertical eye favoured by some artists sometimes appears among rows of phallic tool grooves as a broader, much deeper intaglio groove contrasting with the rest.

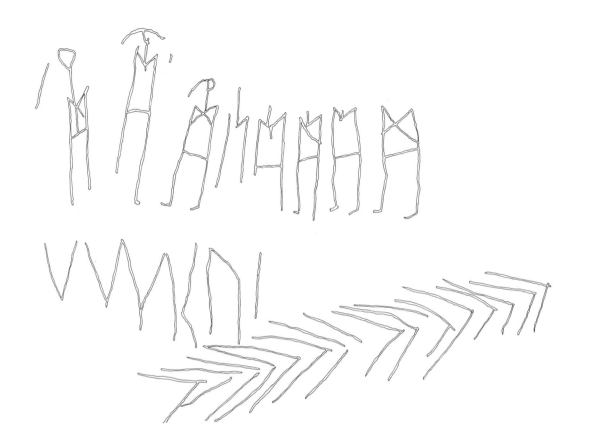

Unusual is a shallow intaglio treatment of the vulva design twenty inches in diameter (Fig. 7-14), which dwarfs human and animal figures emerging from it. Most vulva designs are quite small, and therefore hardly distinguishable in the uneven rock surface. The vulva design (Fig. 7-16) which lies directly over the pair of swaying figures shown in Fig. 6-3 is only five inches broad.

A number of deep-seated concretions are vulva symbols, too, whether marked by a pattern of parallel grooves at the rim, or simply surrounded by figures that seem to issue from the mysterious centre (Foldout 1). One such concretion opened to view by pecking is central to a mural with at least three other vulva signs in intaglio (Foldout 4).

The artist who painted the drama pictured in Plate 11 along some sixty inches of smooth coulee wall placed a three-inch vulva design (Fig. 7-15) at the far right end of his mural, where rough spalling, already present at the time, somewhat obscures this motif from view. A long track of painted lines, dots, and dashes leads from the vulva to the scene of action. The significance of this sign of the female principle (heretofore interpreted as a gun emplacement) seems obscure until we carefully analyze the main composition.

In the centre left at the top the hero, a horseman riding under the emblem of the sun and wielding an ambiguous weapon in the shape of a long fringed phallic lance, fells a giant (comparatively speaking), a hollow-bodied spirit whose heart gushes forth as he drops his gun. Another like him, who joins the fray with an immense sabre, already has a painted wound in his phantom body; a third, headless, approaches with bow and arrow. Backing them up from the right are two "materialized" figures with guns, their

PLATE 25. The eight variations of the same figure may refer to stages in the other-worldly life of the artist. The two sets of glyphs below are enigmatic, although the series of "chevrons" resembles treatments of tails and feathers in other Milk River pictures.

73

bodies also patchily filled with paint, possibly to indicate wounds. Behind them all and to the right lie the tracks leading from their source, namely, the vulva. From other directions three smaller conventional figures, two of them headless, one losing his gun, and all on horses, converge upon the solitary hero, who deflects the spattering of bullets bursting from the guns. Finally, painted in the lower left corner are three or four tiny figures, two bound together; just beyond them and linked to the attacking horsemen by a line of horse-shoe tracks, are four large X-shaped forms of the sort representing powerful beings in pictures examined already. Except for the hero, whose head is an open ring, the heads of all figures are irregular and filled with paint.

What is here depicted verges on myth, for it represents, as the sign of the vulva succinctly indicates, a foray by the artist's heroic self into the underworld, his errand the rescue of souls held captive by subterranean powers. Though these entities threaten him with an array of weapons partly modelled on European trade goods, the intrepid mystic seems more formidably equipped. Instead of turning his hero upside down, the device that identifies the inverted world in another mural (Plate 15), this artist simply shows the figure on his horse descending rightside up into an ambush by demonic forces. Using the space available to him as best he might, he

has balanced his composition admirably: the hero is surrounded by menacing figures; the vulva off to the right indicates the locale and origins of the enemy; and the complementary vignette to the left provides further details of the underground world.

A series of panels at an upstream site epitomizes, according to one artist's understanding, certain transformational implications of the two-fold scheme, skeletal and visceral, at the core of the Plains Indian shaman's mystical physiology. This series, the work of an accomplished engraver who varied his tools and repeated certain motifs for subtlety of expression, is admirable for its technical clarity alone. But it is also a surprisingly analytical treatment of the shaman's ideology.

We shall look at the first group of this series later on in Chapter 9. It is the second group (Plate 14), just to the right and by the same firm hand, that interests us at the moment. Here a contiguous arm holding up a large "rake" interlocks a pair of conventional V-neck figures about eighteen inches tall, each with a ring-shaped head. The one with tiny eyes on the left wears a single head-feather; its firmly engraved ribs branch from a long heart-line ending in an ambiguous blob. Its alter ego is eyeless, but wears fringed ear-pieces; its body is empty, and over its head soars a pointed compartmentalized heart attached to a length of heart-line. To either side of the linked pair with their

contrasting internal conditions and sensory organs are traces of other figures, now obscured by cattle rubbing. One of these dimmer figures is still marked by a set of deep round holes that commonly indicates testicles: it was originally phallic.

At one time the entire group probably comprised a row of four related figures, each differently endowed with symbolic motifs expressing different stages of transformational experience, the same principle that organizes quite different sets of figures elsewhere, for example as seen in Plate 25. But our two figures in Plate 14 demonstrate that the shaman's experience of a profoundly altering inner person could involve the essential organs – in this case the heart – and that these organs were capable of escaping from the spiritual body as if containing the independent soul.

Only four feet to the right of the united rake-bearers and their shadowy associates a third, more complex sequence of figures illustrates the process of dismemberment undergone by initiates into the shaman's profession during transformations of their inner structure (Foldout 2). This additional sequence, incorporating at least four more recognizable human forms and spread for more than five feet along the lip of a fissure, begins at the left with the long reclining shaman looked at earlier. This dreamer, who is drawn in narrow lines, is only perfunctorily

phallic compared to others nearby; his body is empty except for three lines measuring off sections. From the Y-shaped bowl of his heavily incised pipe bursts a profusion of helter-skelter grooves and broken or incomplete forms. And from his ring-shaped head springs another shaman, more vigourously drawn, with fringed dancing legs, a sparking phallus, and parts of internal organs; this one wears a straight-up crown of feathers on his rather shapeless intaglio head, the sort of headdress traditional among Plains Indians before the adoption of the flowing Siouian bonnet. He is endowed with power fingers on either hand.

Still farther to the right are patches of delicately drawn bony patterns, bits of ribs and backbones, what looks like a heart-line attached to a V-neck, and indications of an organ or two, all dispersed in disorganized fashion around a third figure quite fully formed with internal organs partly in place. The surrounding bones and other debris connect with this figure through long heavy strokes of the engraving tool. Among the disorganized parts attached to him we discern partial formations of other bodies, as if these amounted to imperfect stages in the spirit's reconstruction. This third figure, reassembled as it were from scattered parts, is treated differently from the first two in its group, more in the manner of the sturdy figures in other groups of the entire series: the straight body outlines are broadly engraved, the powerful phallus is thick, and the knoblike head sits on a long thick neck and heart-line. The upraised arms and power hands of his shamanic posture reach much higher than those of his other selves. We detect a feeling of triumph and wholeness in these signs, a graphic expression of renewal.

It is not for us to decide exactly how this mural should be read, whether successively to right or left, or whether we should even presume a narrative programme on the part of the artist. Indeed, the whole series of images may not represent a temporal sequence at all. Rather, the overlapping and expanded subject matter, the repeated and shifting motifs, allusions to flight, sexual power, and so forth may add up to a set of vignettes analyzing a single complex experience of several simultaneous events. At any rate, it is doubtful if any written document can explicate more plainly than this the arcane doctrine of dismemberment and renewal that was central to the shamans' ideology. Certainly words do not suffice; pictures do somewhat better.

Animalistic Nature

An independent invention of Milk River artists is the bow-shaped animal that appears repeatedly in an extensive series of murals at adjacent petroglyph sites first recorded by Dewdney in 1962. Variations of this distinctive form occur here and there at other sites, some departing considerably from the typical. But their concentration in a special locale suggests that the bow-shaped animals are largely the work of a "school" of engravers who inherited an antecedent tradition. It would seem that this motif of many nuances developed long before our surviving examples were engraved.

The bow-shaped animals ordinarily have a deeply curving belly-line and a straight or slightly curved line for the back from neck to rump (Plate 26). The grooves delineating back and belly usually intersect high on the rump at a fairly decisive angle, sometimes extending to form a stiff short tail. Legs and phallus, if any, are separate grooves added to the body. The treatment of the hindquarters as separate from the legs, and indicating the root of the tail where the back ends, effectively distinguishes this category of animals from others, but more especially from most of the horses.

Some bow-shaped animals tend toward the crescent or serpentine; others outline a stockiness of body evocative of worldly animals. But the basic allusion to the bow is al-ways present, even when abbreviated, when partially eroded, when coalesced with other motifs, or when taking on ambivalent meaning through modifications of the formula. In the case of an elongated upcurving creature (Fig. 8-1) a nearby upright arrow, two feet long, reinforces the imagery of the bow.

The bow as much as the arrow signifies mystical flight, which, as Blake's poem reminds us, is the elevation of mind and imagination above vain and trivial contradictions. The bow is a sacred instrument too, one closely related to the drum, and so by inference a vehicle of the shaman's ecstatic journeys of supra-mundane realms.[1] In addition, the bow, like the Taoist yin-yang motif, is an ancient and all-embracing symbol of the harmony to be discovered in opposing tensions. As known to the earliest Greek philosophers on record, it signified the "coincidence of opposites," from the male and female principles to the destructive but creative libido.[2] These are paradoxes recognized by the shaman and compassed in his personality, as noted earlier on. The six-inch winged animal soaring upwards in Plate 20 is a graphic expression of the symbolic bow, with all its accretions of meaning, as transporting the spirit to higher and more comprehensive stages of mystical knowledge.

While the bodily form of these animal images alludes to the numinous symbolism of

the bow, it also tends to be a schematic treatment of the fleetest of ungulates – pronghorn antelope, deer, sheep, and the like – all indigenous to the Plains and antecedent to the horse. Yet such resemblances can be deceiving. The bow-shaped creatures do not represent terrestrial fauna: we cannot identify them with any sureness as to one species or another. One may resemble a skunk (Plate 4) or a beaver (Foldout 1), but another is a horned monster (Plate 27), and often they display fantastic horns, antlers, tails, or hoofs appropriate only to the supra-normal plane of existence. In fact, they are closer in spirit to the creatures with exaggerated attributes shown, for instance, on the prehistoric painted potteries of Iran (4000 B.C.) and the horse-trappings of Luristan (1000 B.C.) than they are to earthly animals of the northern plains.[3]

As are all animals in Milk River art other than birds, the bow-shaped creatures are profiles, not the splayed animals found in rock art in the south which imitate the shaman's posture of uplifted arms.[4] Like the frontally-oriented human forms around them, however, bow-shaped animals emphasize the open transparent space of the mid-section. And for good reason: their outlines are apt to contain skeletal patterns, heart-lines, and organs similar to those in the shaman figures. Besides giving heart, heart-line, and

ribs to each of the two sheep in Plate 26, their engraver has further stressed their transparency by giving each of them two eyes although both are profile figures.

Such animal figures are the local counterparts of the so-called "X-ray" animals pictured by Norway's early rock artists, the makers of bronze placques found in the Volga-Kama region of Europe (first millennium A.D.), and native Australian painters. Everywhere these physiological motifs reflect shamanistic concepts. They are the esoteric version of motifs that became greatly simplified on the level of folk art, from the Plains Indian tipi to Zuni pottery.[5]

Several sets of figures at various sites pair bow-shaped animals with conventional human figures in the Milk River style, illustrating a fundamental tenet of shamanism: that the shaman was essentially an animalistic being as well as androgynous (Plates 28 and 29). This concept goes beyond the more commonplace idea of the animal familiar or guardian spirit sought by ordinary mortals in their vision quests. It involves a higher, more arcane spiritual principle allowing the mystical adventurer to achieve the farthest ranges of experience and power. The bow-shaped animal is the shaman's alter ego. The series of paired human and animal forms represent dual manifestations of a single essence; here the shaman enters his animal

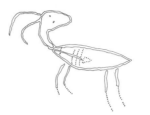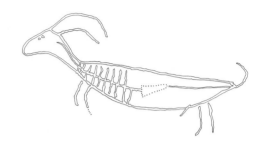

PLATE 26. Except for their eyes, this pair of "sheep" conforms to the principal Milk River conventions for bow-shaped animal figures. Dotting approximates features appearing in photos by Lawrence Halmrast (drawn with his permission).

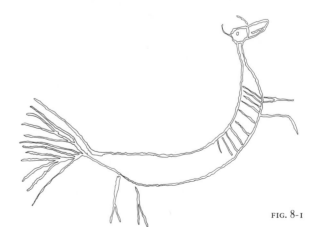

FIG. 8-1

77

PLATE 28. A truncated figure in the posture of a shaman and paired with a bow-shaped animal expresses the mystical concept of the shaman's animalistic nature.

PLATE 27. Positioning of the three figures suggests that the bow-shaped animal in this engraving represents an underworld spirit rising to meet the shield-men's attack.

PLATE 29. This treatment of the bow-shaped animal as alter ago of the shaman is one of several petroglyphs that follow the same formula. Dotting approximates features of the animal that appear in Lawrence Halmrast's photos (drawn with his permission).

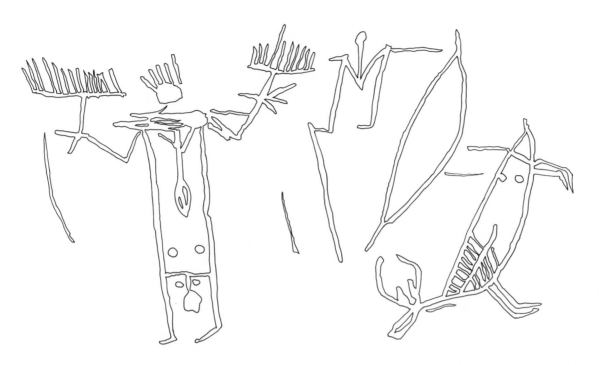

shape spontaneously, of his own will. He transfers his metaphysical bones and organs to his animal phase, sometimes as a bizarre rack of antlers on the head of a deer. The smaller shaman figure in Plate 4, surrounded as he is by three or four different animals, reminds us that the more animal forms the shaman comprehended the greater his power as a Master of Animals, and the more efficacious his communications with invisible worlds.[6]

The paired figures, then, reveal something of what could take place when the shaman metamorphosed himself into animal shape. So far, his transformation would be comparatively simple. But more recondite

transformations were possible, it seems. The artist working at the mural in our Plate 4 opened further mysteries to view. His group of human and animal figures as shown at the far left also involves a violent dismemberment of an adjacent shaman figure (Plate 30), apparently the threshold of increasingly intricate manipulations of animalistic nature. The episode of mutilation merges uninterruptedly with the rest of the panel, which passes through the conjuring of many animals to its culmination on the right in a row of interlocked figures to which tiny bow-shaped animals are attached. Here is the part of the mural that needs closest attention.

Dominating this part of the composition

is a thirteen-inch masked shaman, arms upraised in the claim of divine power, and midsection encircled by finely grooved semicircles as if expressing a dancer's movements. From his head projects a pipe, intimating that, though he stands upright, he is in much the same kind of trance as the reclining dreamer in Foldout 2. What issues from him are powers actuated in rapture. Here the pipe connects with his hand, shaped as a triangular "rake," that mysterious implement of power; the large plume overhead may be the transforming pipe-smoke, though it is ambiguously treated as a fringed or feathered headdress. Pipe and "rake" together form links with three smaller figures be-

PLATE 30. A shaman figure transfers his physiological elements to his animal shape. Between these two are transitional forms. Violent strokes of the engraving tool express the dismemberment involved in certain mystical experiences. This set of figures is at the far left of the mural shown in Plate 4.

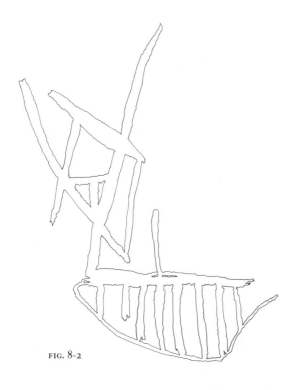

FIG. 8-2

yond, whose fingers are tied in a queer knot declaring their interdependence. The linkings and knottings are evidently the artist's device for analyzing the tripartite personality of the masked shaman as a ramification of his trance-inducing exercises. This sequence recalls sculptured images based on similar artistic devices among the antiquities of Rome and India, the Triple-bodied Hecate, for one, and the four-armed Vishnu, in which each aspect of the divine entity displays a distinct set of symbolic attributes.[7]

So with the Milk River tableau, but confined to one plane, the rock face. Clusters of symbolic forms, among them bow-shaped an-

imals, differentiate one-by-one the triune aspects of the large pipe-smoking shaman. The first of these manifestations is a square-shouldered figure, strongly marked with phallus and other mystical organs, and linked to a pair of horned empty-bodied animals, vertically oriented, head up and head down, and one of them humped somewhat like a bison. These creatures would seem to be, not his alter egos as in other pictures, but rather symbols of his function as a "phallic instrument" capable of ensuring the ongoing plenitude of animal nature. His phallic power and potential for flight are simultaneously emphasized by the great fringed or feathered spear with bow-shaped point passing downward through his arm.

Next in line is an X-shaped figure alluding, as we suspect, to the Thunderbird. A reticulated pattern fills the torso, while the legs are fringed with a heavy growth of streaming feathers. The head of an attached animal is a bunch of protuberances, including curved horns; one of its legs ends in a birdlike claw, and a skeletal pattern fills the forepart of its body. The transformational relationship of animal-human-bird is much more emphatic here than in the preceding figure, and obviously has to do with a mystic's spiritual ambitions.

Reaching across this middle figure to the knot of fingers near the fringed spear is the long arm of the third aspect. This figure,

which echoes the form of the pipe-smoker, seems to be dissolving in the intensified vibrations of its supposed dance. Before vandals sawed off a portion of the mural, this figure, too, possessed an animal: an antlered creature about as large as its master, positioned vertically with head up.[8] If this reading is correct, this pair refers once again to the animalistic shaman as pictured in the nearby murals, the personality of which is also an animal. Thus the composition as a whole defines through symbolic motifs three different provinces of the holy man's relationship with animal kind: his influence over regeneration, his means of spiritual ascendance, and his manifestation as his animal double.

The attractive creatures in this mural, and the odd symmetry in which some of them are enmeshed is scarce preparation for the startling imagery in an adjacent cave where larger bow-shaped animals are implicated in a different process of transfiguration. Here, in contrast to the delicate pictures outside, broader tools have attacked the rock; even the skeletal structure of one of those figures is done in the same ferocious strokes as the body outline (Fig. 8-2). The cave's animal figures are invariably incomplete, their heads deliberately distorted or omitted. Though all are subject to the same controlled formalism already seen, one by one the treatment of these grows in violence.

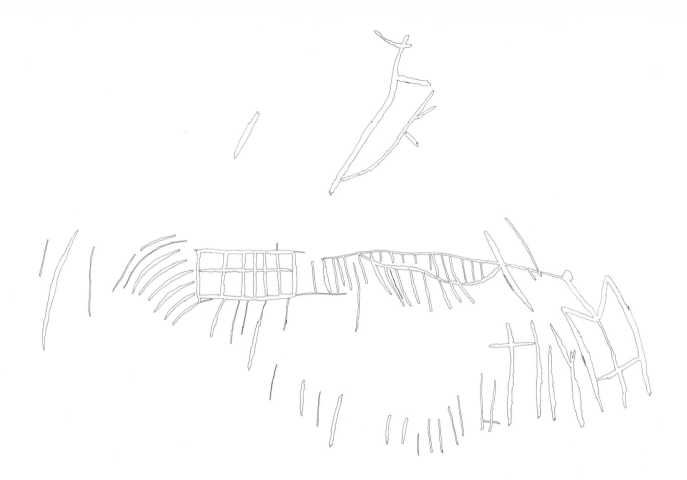

The artist's unmistakable passion reaches a climax in his main composition (Plate 31). A powerful stroke of the engraving tool wrenches an armless, empty-bodied V-neck figure toward a skeletonized animal form, ten inches long. This somewhat bow-shaped animal merges in turn with a skeletonized "bearpaw." More vigourous tool grooves furnish the animal with many "legs" and the bearpaw with numerous "claws." Other vertical tool grooves drop from the bearpaw and then, in a pattern of parallel lines of increasing size, march in pairs around to meet

the twisted human figure. The whole series of forms and grooves, one sort born from another, has a circular movement, as if whatever is happening could go on forever. And above this scene rises a legless, empty-bodied animal form, ascending at a steep angle.

The "bearpaw" is a ubiquitous sign in the arts of North America. Similar ones are engraved here and there along the Milk River. It is significant that a bearpaw was a notable item in a medicine bundle belonging to Wolf Collar, the Blackfoot shaman of Gleichen, Alberta (1853–1928), and that a single bear

claw is in a bundle with a beaded human effigy that is armless like the twisted figure in Plate 31.[9]

One ponders this disturbing composition in vain, identifying its more obvious symbols, sensing its organizational power, imagining some terror that it probably represents, but baffled as to its core of meaning. One detail offers a slender lead. Alongside this composition is a short series of drilled cups, exactly like those deeper in the cave where they accompany a row of large grooves (Fig. 7-13), and also concentrate round a figure express-

PLATE 31. Merged forms resembling the claw of a grizzly bear and a skeletal bow-shaped animal connect with the head of a human figure wrenched to one side. A bow-shaped animal rises from the bizarre composition which makes ambiguous use of tool grooves.

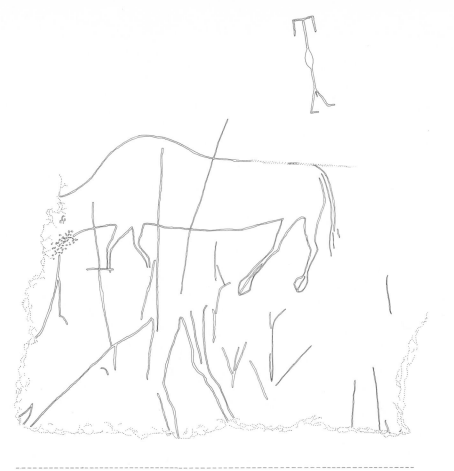

PLATE 32. Two large animals resembling bison, positioned to suggest copulation, fill a projecting rock face as one level of a mural devoted to the theme of sexual generation. The animals seem deliberately beheaded. Several feet below them (dashed line indicates abridgement of space) a bow and arrow float above a band of tool grooves bordering a deep crevasse and overlain with red paint.

ing shamanism's doctrine of mystical dismemberment (Plate 23). The cup-and-groove motif may serve as the "signature" of a single artist working from time to time in this location, linking the subjects of his several compositions, however variable his technique. We surmise that the "bearpaw" mural, with its empty contorted human figure, its accent on skeletal patterns, and its nearby figures of incomplete animals, is another view of dismemberment, one unrecorded in the literature and hence a personal elaboration of the theme. In this light we recognize at the top of the mural the shaman in his animal guise rising above the round of painful events pictured a few inches below. Nevertheless, the conflation of bow-shaped animal with bearpaw motif remains enigmatic as the crux of the scheme.

The ungainly creatures that dominate the murals at other Milk River sites belong to a completely separate genre of animal imagery illustrating divergent lines of thought about the sacred unity of human and animalistic nature. Compared to the bow-shaped animals just examined, their outlines are vague and loosely defined, as though seen in cloud formations or constellations. These are monumental figures, whether in terms of the picture space they occupy or in comparison to other figures around them. The largest such animal is some three feet long, overshadowing a crowd of smaller figures underfoot

(Foldout 3). Creatures of this sort are meant to be larger than life, whether as animal ancestors often met with in native myth and folklore, or as cosmic beasts, the prototype animals from which all life descends.[10]

From the bottom to the top, motifs of the mural reproduced in Plate 32 cohere about a main theme of sexual generation. The base of the composition is a band some 2½ feet long of numerous fine tool grooves bordering the upper edge of a long low crevasse; a dense pattern of painted flecks and swirls, resembling sparks and flames, overlays these grooves. Directly above the hole-and-groove motif the artist has incised, side-by-side, a fifteen-inch arrow and yoni-shaped bow, a subtle restating of this theme through a complementary set of symbols.[11] The central image,

engraved on a smooth projecting surface about eight feet above the "flames," is of animals evidently copulating. The most complete of the two beasts measures some twenty-three inches in length. Just at their necks the broken edge of the rock renders them headless, deliberately so. The bent forelegs of both creatures are shown and both are humped, so that they correspond in some degree to the small but more complete image of a bison just around the corner from his mural.

A second mural carries the same theme a bit further, but in a different manner (Plate 33). The principal figure – a seeming grizzly bear about sixteen inches long – is a chimera, a composite beast in the timeless sense. Its rounded haunch and dependent tail, its

shaped forelegs, and its tubular head with pricked-up ears are forms developed for rendering horses. Although the vulva and serpentine phallus declare the bear's propagative significance, its great curving claws are the real source of proliferating forms: an intermingling of abbreviated horses, the humped shoulder of a bison, a heart and heart-line, scattered bony patterns, and an elongated shape, about seventeen inches long, composed of three parallel lines which overarch all the emergent animals.

The swollen beasts in a mural familiar to park visitors figure in yet another version of the fecundity theme (Foldout 3). Features of the animal at the upper right suggest a muskrat: rows of teeth, weak little forelegs, a ratlike tail. Hanging from its belly like a pen-

PLATE 33. A dancing shaman casts a visible spell producing the profusion of forms surrounding a bearlike beast. The spearhead engraved on the bear's chest signifies the animal's sacrificial function. Rhythmic strokes beside the shaman's arm are actually red paint, not shown here in colour.

FIG. 8-3

FIG. 8-4

dulum is a heart and heart-line entangled with ambiguous figures below. The bulbous animal to the left has short knobby horns, a sharply pointed hump, and the forelegs of an ungulate. Underneath it is a shapeless suckling calf. The two larger animals may be intended as mates; if so, they call to mind native legends in which unlike animals marry, thus preserving the memory of a merger of clans in times long past.

Besides their varying expressing of fertility themes, these three "cosmic animal" murals have in common certain sub-themes. In each, the figure of the shaman is present in one guise or another. But his image is not juxtaposed with the animals as in the petroglyphs of bow-shaped creatures which represent the alter ego. Instead, he is withdrawn from the pictured transformations, masterminding or presiding over the proceedings of the main composition. In Plate 32 the shaman is the small androgynous "walking T" overlooking the large copulating beasts, the motifs of his own figure echoing in yet another set of symbols the main theme of the mural. In Foldout 3 he appears at least twice: as the abbreviated wand-bearer floating above the scene at the left, and again standing between the two large beasts, his phallic bow-spear in hand. In Plate 33 the shaman appears as a twelve-inch tall dancer casting forth a stream of power that generates the bear and its creations; a few strokes

of red ochre next to his hand express his rhythmic movements.

Another sub-theme of these murals has to do with the ritual killing of the sacred beast. The pictured piercing of the bodies of animals, whether by arrows, huge spears, or a slashing tool groove, is a calculated part of composition. Even more striking is evidence of external attacks on the pictures. Various scars, grooves, and what has been interpreted as bullet chips were present in 1895 when the mural shown in Foldout 3 was first photographed. Although vandals have been busy inscribing names and initials, notably over the calf, in all probability the artists themselves – or other native visitors – mutilated their figures in the first place, by stoning, chipping, or hammering, and by breaking off rock to behead an image. This sort of purposeful destruction is quite in keeping with an archaic idea mankind has never completely abandoned: that since the image contains the spirit of what is pictured, "killing the picture" destroys the resident entity.

Ritual destruction of imagery in Milk River art is not confined to these three murals. A number of human and animal figures exhibit pecked-away or damaged heads and bodies (Figs. 8-3 and 8-4, for example). Yet in only a few is the destruction concentrated on the figure as a whole, and in none of these others does it complement an apparent theme of regeneration. The three composi-

tions just examined are exceptional in that they employ the imagery of violence as a sacrifice of animals representing the regenerative forces of nature.

The practice of slaying the image of a venerated animal, whether by means of artistic devices or in ritualistic enactments, arose in primordial times. Tempting as it is to interpret pictures of slain beasts as merely the hunting magic of simple souls, we must credit some individuals among early mankind with more complex ways of reasoning, ways indeed that are traceable in religious thought well into our own era.

In southern France and northern Spain, where inspired Ice Age artists transformed vast uterine caves into symbolic birthplaces of animal hordes, we find clay animals with heads broken off, and paintings of bears, bison, and other creatures which have suffered symbolic death from spears, clubs, and showers of stones in pictorial form as well as from the impact of real weapons. Two or three such pictures occur in Montana.[12] Like those cave images, our three Milk River murals illustrate a characteristic feature of archaic thought: the idea of fecundating and annihilating powers of nature as inseparable elements of the same world phenomenon. In this conception the sacrifice is essential to the renewal of life in Mother Earth.

Researches of Soviet ethnologists on Siberian myths and rituals that persisted well into the twentieth century elucidate the matter a little further. The dual concept of death and rebirth, sacrifice and procreation, they remind us, is written in the apparent movements of sun and stars, and in the phases of the moon, which brought about the repeated demise and renewal of the cosmic animal, envisioned as an elk or bear in the heavens. The Evenks pantomimed the cosmic hunt in their spring religious rites, when a wooden image of the sacred animal was killed, and then, after being chopped up and divided among all participants, magically revived.[13]

Rites of this kind perpetuate a timeless myth, the eternal repetition of the cycle of nature. Eliade explains: "the mythical animal ancestor is conceived as the inexhaustible matrix of the life of the species.... It is a matter of mystical relations between man and his prey, relations that are fundamental for hunting societies...."[14] The same principle, reoriented by agricultural peoples, underlies the rituals associated with Tammuz and Adonis in the eastern Mediterranean, and the elements of it were absorbed even into patristic Christianity.

Curiously, the cosmic animal, in its character of clan ancestor harking back to matriarchal times, had come to be regarded in Siberia as a transformation of the shaman's spirit, in other words, his animal double. However remote the details of Siberian practices are from those of North American Indians, they offer suggestive parallels for understanding the Milk River murals, especially in pointing to the figure of the shaman as a comparatively late intruder into the primeval myth.

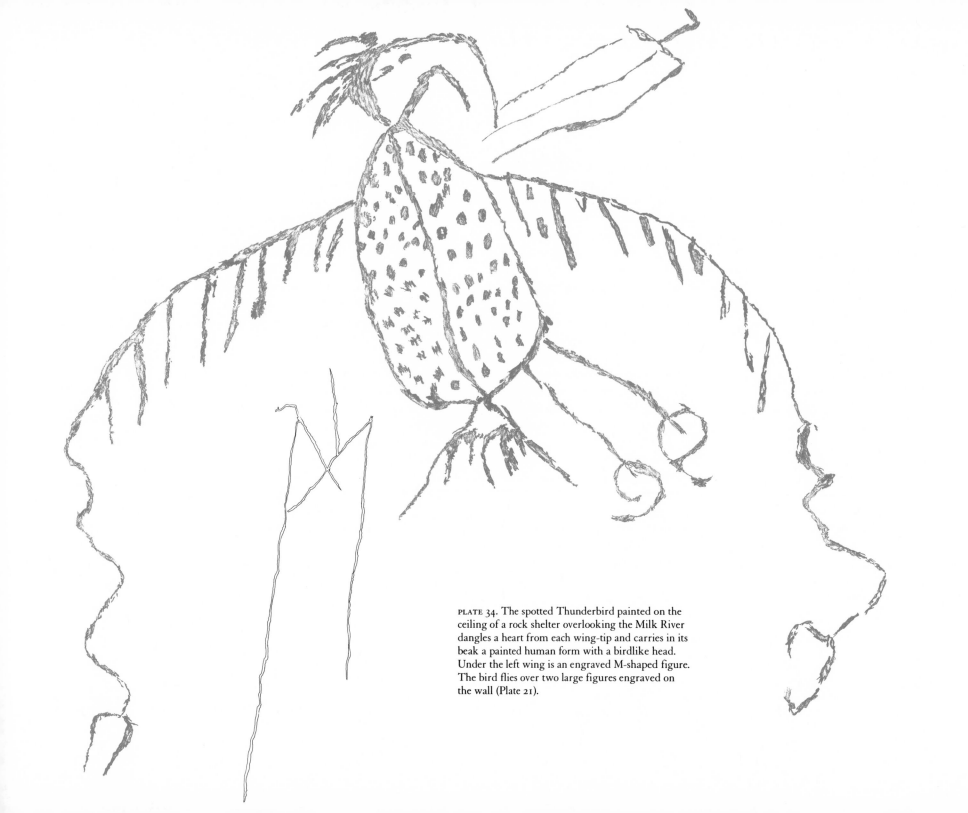

PLATE 34. The spotted Thunderbird painted on the ceiling of a rock shelter overlooking the Milk River dangles a heart from each wing-tip and carries in its beak a painted human form with a birdlike head. Under the left wing is an engraved M-shaped figure. The bird flies over two large figures engraved on the wall (Plate 21).

NINE

The Celestial Bird

Because it speaks directly to the innate longings of earth-bound mankind the bird is the one mystical image inherited from time immemorial that continues to move human hearts. As a glance at the media informs us every day, the bird, wings outspread, is still the viable symbol it always was, still capable of inspiring reverential feelings and the yearning to escape mundane conditions. Not unexpectedly, then, the bird is an important element in Milk River rock art. What does take us by surprise is our own response to the bird's peculiar appeal, even when it is surrounded by the unfamiliar imagery of primitive mysticism. No picture in the valley is more treasured by the people who have seen it than the spotted Thunderbird painted on the ceiling of a rock shelter overlooking the river (Plate 34).

Universally, the bird has always been a two-fold symbol. On the one hand, it represents the desire for accomplishments beyond human power, the longing to penetrate the divine, and even to consubstantial with the gods. It is thus the quintessential symbol of wishful thinking.[1]

At the same time, the bird is a messenger of the divinity itself. This identification has persisted in human affairs since the ancient love goddesses, themselves winged and attended by birds, ruled the heavens long before Gnostics and Christians adopted the dove as a sign for God, and Oriental mystics

established the crane as the figure of immortality.[2] The same conception, that it is a representative of the Supreme Being, is fundamental to the meaning of the Thunderbird of North American Indians.

The dual character of the bird as symbol lies behind Milk River bird imagery as a matter of course, but it scarcely accounts for the accretions of meaning these artists attached to its signs. One layer of signification belongs to shamanic tradition. Although the symbolism of the celestial bird was never exclusive to the shamans, they assigned it special meanings in keeping with their ideology. For them the bird was a sign of their election to shamanistic powers, emblem of the moment when the candidate expired as a human being in the strict sense, and became the receptacle of the divine essence. And so it was for Wolf Collar, the Blackfoot shaman who as a youth of seventeen received his personal Thunderbird imagery during a coma caused by a lightning bolt.[3]

More generally, the shaman's bird and his birdlike accoutrements expressed his ability to fly at will, to enjoy the unbound freedom of celestial space and to visit extraterrestrial regions. To him, flying was more than a wish; it was a fact of his mystical experience. The ability to become a bird, Eliade informs us, is the common property of shamanism everywhere, from the Turko-Mongol, Asian Indian, and Oceanian to the circumpolar and

PLATE 35. Figures of shaman and Thunderbird merge in an engraving illustrating their identity. Note the similarity of their legs. Dotting indicates flaking rock.

American versions. Yet Eliade accounted the bird a mere tutelary spirit, on the same level as animal familiars, perhaps because he shrank from the obvious implication: that the shamans considered themselves incarnations of the godhead.[4] More than one hundred years ago a shaman of the Eastern Woodlands provided a more credible interpretation of this whole stratum of bird imagery, at least as it pertains to North American shamanism: "By the thunderbird the shaman means himself."[5] As well, picture-by-picture comparisons show that the Milk River artists usually differentiated quite precisely between the bird-as-shaman and his animal al-

ter ego. In this context even a feather or a bit of fringe was a sign of transcendent power.

The point to notice now is how rarely Milk River birds are represented in their wholeness and for their own sake as birds, without admixtures of motifs or fusion with other forms. The most complete and uncomplicated bird figures in the valley are the tiny emblems engraved on shields (Fig. 9-1), the one resembling a goose and the other an eagle, crow, or raven in an unusual three-quarter-view.

But the simplicity of these miniatures is exceptional. The Thunderbird in Plate 35 merges with a shaman figure in a transfor-

mation begetting a swarm of abbreviated quasi-human forms. Its legs exactly duplicate those of its partner. An egg-shaped, egg-headed bird about twenty-four inches high (Fig. 9-2) occupies the centre of another series of transformations, fine vertical scratches suggesting upward movement. Just to the left is a loosely outlined animal some thirty inches long; on the right is an abbreviated version of the bird which merges in turn with forms suggesting conventional human figures.

Taken all together, elements of these two bird murals are reminiscent of the painted tipi cover belonging to Loud Voice (d. 1884),

FIG. 9-1

FIG. 9-2

last of the great Plains Cree shamans. On his tipi numerous small figures spring from the outspread wings of a huge bird with human legs; since its wings virtually encompass the tipi, this bird symbolizes the divine universe as centred on the lodge and concentrated in the shaman.[6]

In a corner of the ceiling of the same cave where the engraved shaman dives against his enemies the circular body, and the tail, legs, and claws of a painted bird emerge from a cloud of feathers formed by crescent- and V-shaped dabs of ochre. Halmrast, who has repeatedly studied this pictograph *in situ* for his photographs, sees these dabbed feath-

ers as symbolic horse tracks, like other larger dabs in rows nearby and in other painted murals.[7] His observation is probably correct, which makes this bird all the more interesting from an iconographic point of view. As we shall see in the next chapter, Milk River artists invented devices to amalgamate their bird and horse imagery, and these oddly shaped feathers may be one of them.

Two very different birds in the large rock shelter also incorporate features that carry extrinsic meanings. The somewhat bow-shaped bird with finely-feathered wings that is engraved on the floor has little human feet, the sort that often appear on shaman

figures (Fig. 9-3). Furthermore, this bird intersects a form of much broader, deeper grooving, which echoes the bird's shape in reverse, but is more like the skeletonized bow-shaped animals incised with a heavy hand in the cave farther up-river (Fig. 8-2). Yet this crosswise form also strongly suggests a boat. And, although a boat is an unexpected motif for the Plains cultures, it is not impossible that this artist has purposely superimposed the one figure on the other as a play on meaning, since boat and bird alike are symbolic vehicles of the spirit.

As for the remarkable red ochre bird on the ceiling just above (Plate 34), compared to

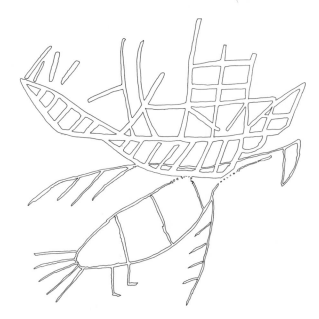

FIG. 9-3

painted figures at other sites it is of monumental proportions, with a wingspread of some thirty-three inches. Its uncommon size, its starlike spots, its circular feet (again, similar to a form sometimes used for horses' hoofs), not to mention its uncannily blissful expression and the quasi-human figure it seems to carry in its beak, all contribute a complicated ambiguity to its self-evident birdness. Adding to the effect of unfathomable mysteries focussed in this bird is its context, not only the cavelike atmosphere, but also the symbolism directly linking it to engravings on the walls below. For the spotted bird flies over the heads of the two huge masked figures, one of them forty-two inches tall, pictured in the act of exchanging painted hearts (Plate 21). The bird soaring

over them dangles a heart-shaped object from the tip of each wing.

The spotted Thunderbird deserves special attention here since its closest analogs – very close indeed – are painted on a calfskin tipi doorflap and on a feathered shield now in the Alberta Provincial Museum. These two artifacts are the creations of the same Wolf Collar mentioned before, who painted a third such bird on a drum that has apparently not survived.[8] Wolf Collar's birds are the products of his visions between 1870 and 1874, and like the bird on the rock shelter ceiling are spotted and round-bodied, references to the thundercloud, it is said, that brought him the lightning bolt of his election. Their claws are semi-circular. The bird on his shield dangles from its wing-tips not hearts, but metal bells.[9] We are compelled to assume either that Wolf Collar was the artist responsible for the Milk River Thunderbird, or that he was working in the same iconographic tradition. His round-bodied Thunderbirds suggest conceptual connections between the bird, certain quasi-shield figures, the drum as vehicle, and the circle as image of the universe.

Besides the striking similarity between Wolf Collar's Thunderbirds and the one in the rock shelter, other facts point to a connection between this versatile shaman and the Milk River sanctuary, even long after Treaty 7 (1877) purported to confine the Blackfoot

people strictly to their reservations. Several inscriptions engraved in the valley are in the syllabic characters that missionaries based in Gleichen developed about 1900 to propagate the Christian faith in the Blackfoot dialect. By the time of his baptism in 1906, Wolf Collar, already known as a sculptor and engraver as well as a painter, had versed himself in this writing system, which he also claimed to have invented. It is conceivable that this holy man, whose mysticism accommodated both Christian and shamanic revelations, was the engraver of the syllabics in the valley, as well as painter of the red ochre Thunderbird.[10]

The bird pictures just examined represent but a small portion of bird-related imagery in the valley. Much more common are human figures whose oblique references to the Thunderbird subtly amplify their meaning. To appreciate how thoroughly allusive bird imagery permeates Milk River rock art we must first take another look at the many X-shaped figures cited in Chapter 5.

The X shape itself, as Habgood explained some years ago, alludes to Thunderbird imagery and forms of birdlike humans. It is an ubiquitous feature of North American rock art. Two examples in Pictograph Cave, Montana, indicate that the X-based Thunderbird is one of the oldest images of Plains rock art. In Alberta the form occurs in pictographs in Painted Canyon, and as a petroglyph on a

boulder at Airdrie.[11] An engraving of precisely this type of Thunderbird, albeit headless, appears in a Milk River mural, where it is one of several emanations rising obliquely from a reclining human form in a tipi (Fig. 9-4).

Two pictographs in northern Saskatchewan vividly illustrate the transformational themes that native artists were able to impute to this convention. The more spectacular is a female figure composed on the basic X shape; the other is an X-shaped bird flying upward from an animal-headed human.[12] These analogs and the examples Habgood assembled persuasively argue that many of the Milk River's X-shaped figures that pass for human forms are actually incipient Thunderbirds. The two-inch headless figures with upraised arms rising from numerous fine tool grooves, and an eight-armed "compass" may thus be shamans becoming birds. By the same token, a series of eight large X-figures parading across the upper register of a busy mural merges the idea of the human form with allusions to the bird as a divine entity. Among the forms generated by the Thunderbird in Plate 35 is a small soaring X-shaped figure metamorphosing into a bird, one arm already changing into a wing with budding feathers (Fig. 9-6). Similar figures in other murals seem to acquire birdlike tails, claws, or feathers (Figs. 5-3 and 9-5).

Two less obvious motifs mark a few conventional shield-bearers and V-neck figures as human birds. Hook-shaped intaglio heads duplicate the heads of Thunderbirds in Habgood's, Mulloy's, and Wellman's illustrations. The quasi-human figure carried aloft by the spotted Thunderbird (Plate 34) has this same sort of head. The more egglike of the intaglio heads already noted repeat the form of the "bald" rounded head on the Thunderbird in Plate 35; this motif, though uncommon, is not purely local, but occurs even in California.[13] Indeed, it may be that a good many of the round intaglio heads on Milk River's conventional human figures refer to birds.

Feathers, fringes, and plumes, however, are the minor motifs preferred by Milk River artists for equating their human figures with birds. In North America the shaman's feathery fringe is at least as old as rock art itself, and an evident contribution from shamanism in Siberia.[14] At Milk River fringe is ubiquitous. Thus a horned V-neck figure with an X-shaped body is already a Thunderbird by implication; further emphasizing his divine birdlike quality are thick leg fringes and a ceremonial bonnet of trailing feathers. The headdress of upright plumes on a transformational figure in the pipe-smoker's dream (Foldout 2) is an older version of bird-related plumage revived in recent times by Horn Society dancers.[15] Plumed headdresses likewise allude to birds.

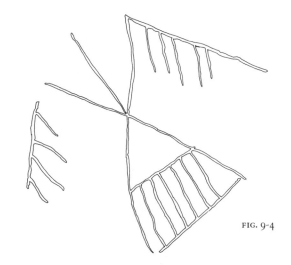

FIG. 9-4

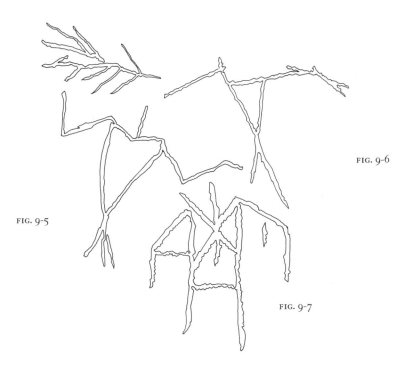

FIG. 9-6

FIG. 9-5

FIG. 9-7

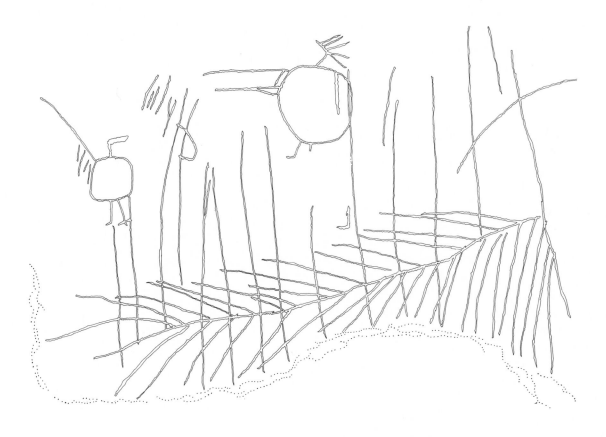

PLATE 36. Excerpt from a sprawling composition displays a feather combined with vertical grooves at the edge of a natural hole (dotting), from which emerge bird-humans. In Plains rock art the hook-shaped head is a mark of the Thunderbird.

If at times these resemble the rays of the sun the result is to coalesce two symbols of divinity. The feather and fringe sort of bird imagery extends to lances, and often to animal tails. The tail of the skunk in Plate 4 carries more than a hint of feathers.

Detached winglike forms occur here and there, above an X-based bird-human (Fig. 9-6), for instance, and among what seem scattered parts of a human figure with a knoblike head. At least one bow-shaped animal is winged (Plate 20). The dancing figure drawn in charcoal (Plate 18) connects with a double-winged form, which the authors of *Story on Stone* observe to be a partial Thunderbird, perhaps the shape the dancer is about to assume.[16]

The feather itself becomes more than an attribute of human figures. It can signify the action of a dynamic force or power, on the same order as the "rake." Such a feather pierces like an arrow a headless, armless V-neck figure hovering at the top of a crowded mural. Bird-related imagery permeates a panel of broadly scattered figures in a coulee opposite the park, where the controlling motif is a finely grooved feather, twenty-four inches long, engraved along the upper edge of a low deep fissure (Plate 36). From this curious variation on the hole-and-groove motif rise numerous vertical grooves which cross the barbs of the feather. Surrounding this feature are small shield-figures whose complement of bird motifs can be summarized as follows: four fringed shields, two hooked Thunderbird heads, three feathered head-

dresses, two feathered lances, one birdlike foot, and one set of winglike arms. Yet another figure is a V-neck, and its transparent shield is proportionately small and set low on the body, much like the vibrations marked around figures seen elsewhere. A drumlike circle attaches to its neighbour, perhaps serving here as a transitional form, shifting through a dancer to the many shields of the bird-men scattered about. The composition as a whole furnishes much matter for interesting speculations on its meaning, particularly on the generation of bird-humans from the great feather's barbs.

One Milk River artist merged his bird imagery with the schemes of mystical physiology described in Chapter 7. There we examined related groups of figures composing an impressive series of panels, apparently all by the same hand (Plate 14 and Foldout 2). The pictures in this series are devoted to the transformational implications of skeletal and visceral motifs, one group involving the memorable figure of a reclining pipe-smoking shaman and the emanations of his trance. The first group of this series consists of another sturdy skeletonized shaman, like the one in Plate 14, but headless and ithyphallic; he stands over a smaller V-neck figure, engraved in the same artist's style, in which jointed arms hang downward like the balancing wings of a perching bird (Fig. 9-7).

The distinctive posture of the skeletal shaman's little companion is especially interesting, for though without feathers it duplicates the posture of the painted and engraved Thunderbirds already examined (Plates 34 and 35; Fig. 9-2). Furthermore, this posture has a few far-flung rock art analogs: pictographs of birds and bird-humans in Painted Canyon, Alberta, at Medicine Rapids, Saskatchewan, and in Pictograph Cave, Montana; and petroglyphs in Iowa, Wisconsin, and Wyoming.[17] We must conclude that the odd pose of our small figure marks it as a bird-human, despite its understatement.

Apparently three of the widely-dispersed artists of the analogs just cited were privy to the same strand of obscure shamanic lore, for they seem to be alone in putting together certain motifs that are juxtaposed in this pair from Milk River. The Iowa and Wisconsin petroglyphs combine in one figure two of the principal motifs displayed separately in our two figures – the skeleton and the birdlike form; the Wyoming figure, with its exaggerated phallus, its skeletonized body, and its slightly outspread wings, synthesizes three of our motifs.

The Milk River group, then, insists on an esoteric connection between the ability to fly and the skeletal and visceral schemes. But it goes much further than its southern analogs

since, as one episode of a series of transformations, it imposes Thunderbird imagery as an essential element of the whole sequence to which this pair belongs. The allusion to the bird, in other words, colours with its special meaning the associated groups of figures: the linked "rakemen" with their ascending heart, and the recumbent shaman rapt in his dramatic ordeals. It opens up to a little better view – analyzes for us – a difficult and rarely expressed metaphysical concept in the shaman's ideology. To be more precise, the mystic's contemplation of his inner structure and his experiences of dismemberment and renewal are tributary to his divine identity as a bird.

Nothing of this sort occurs in connection with the animal forms described in Chapter 8. Nowhere do Milk River artists saturate their human figures with animal imagery. To be sure, a few human figures wear horns, and the Y-shaped heads might be viewed as symbolic horns. But, compared to rock art elsewhere, Milk River artists did not much favour horns as an attribute of human figures.[18]

On the whole, the animal figures examined so far stand quite apart from their human companions, though close to them, albeit these creatures frequently display the shaman's mystical viscera and bones. Milk River art has no animal-headed humans, as

in Saskatchewan,[19] nor four-footed shaman figures, as in the splayed animals of the southwest. Connected animal and human figures are superficially joined, each kind keeping its conventional shape instead of merging identities as happens with the birdlike humans.

The contrasting treatment of integrated bird forms and segregated animals reveals that native mystics supposed a qualitative difference in their relationships to the two kinds. The many pictures of bird-humans declare that the shaman, as a concomittant of his election, was identical to the bird. The animals forms, however, when not symbols of the living creatures he supposedly controlled, were shapes he could enter for magical purposes, spiritual masquerades, but not the essence of his personality.

On the one hand, then, the shaman's image as a bird-man asserted his inherently divine qualities, and his ability to visit otherworldly realms at will. On the other hand, his animal alter ego had to do with control and maintenance of the ongoing bounties of the earth and with feats of magic performed in the interests of the everyday world. The few winged and ascending bow-shaped animals tell us that even in his assumed form of a beast, without human attributes appearing at all, the shaman was still essentially a bird.

The fine distinction between the shaman-as-bird and shaman-as-animal is the graphic equivalent, in the language of symbols, of the ancient duality of spirit and soul, sometimes termed mind and matter. This dichotomy has been a common element of religious thought since earliest times, and is embedded in the classical European languages as a legacy of Indo-Aryan invaders from central Asia; for example, Latin: *anima* (feminine) soul, and *animus* (masculine) spirit. For in this specialized sense the soul is the material, malleable part of the mind, related to the earth and fertile animalistic nature, whereas the spirit is the will striving to escape mortal existence and be one with the gods. Black Elk expressed this notion in part when he said that the bird, being nearest to heaven, corresponds to mind or spirit.[20]

As their pictures show, the shaman-artists of Milk River subscribed to this view of mankind's two-fold constitution, a view that probably originated with their remote Asian ancestors eons before. They incorporated the concept in their ideology, shaped their bird and animal imagery accordingly, and asserted control over both principles through the mystical power of their sacred art.

This neat dichotomy, though valid for millennia, was destined for obsolescence. The next chapter documents changes in bird and animal imagery when the artists were obliged to accommodate the unexpected introduction of the horse.

The Spirit of the Horse

Conventions closely related to the Milk River mystical style and quite unmodified by European artistic taste continued to appear in the perishable arts of the Plains Indians during the historical period: in the structure of sundance lodges and rituals, and in horse-and-rider regalia, for instance, as well as on certain tipi covers, buffalo hide robes, moccasins, pipes, pouches, shields, and so on.[1] Though few such works survived the collapse of native culture in the late nineteenth century, enough supplementary evidence exists in photographs and written documents to caution against the hasty generalization that native art of all sorts was becoming more "naturalistic" or secularized during the era of the horse. Given the tensions of those turbulent 150 years, very likely the opposite was true.

The durability of shamanism helps explain the persistence of old conventions, especially in rock art. It is plain that, once horsemanship opened the Milk River valley to frequent visitors, extraordinary numbers of painters and engravers passed through who possessed only an exoteric knowledge of shamanism and the levels of mysticism manifest in its art. Yet the shamans maintained a vigourous influence there, contributing more compositions of their own, and interpreting existing works for their unsophisticated companions. And because the shamans had always cultivated a spiritual sensibility among the common people, notably through rites of passage and elaborate ceremonials, the newcomers were already receptive to symbolism as the formal basis of art. Finally, as the highly mobile youth gained independent access to the older pictures, they could see for themselves examples of style and meaning, make of them what they would.

In rock art, therefore, horse imagery incorporated many motifs and themes of long standing, albeit these were reworked, or, as was often the case, fell short of the complex formulations that distinguished works of the shamans. Some new artists edged their horse-and-rider images into the peripheries of prehistoric murals as if to benefit from their holier provenance.

All told, during the release of the artistic impulse among the laity, mysticism – whether naive or otherwise – remained the rule in Milk River art. Consequently, although several scholars may disagree, there is little assurance that historical narrative or biographical incidents are the principal content of purpose of "action scenes" involving horse imagery. Compositions exhibiting a semblance of naturalistic detail or containing stylized symbols for such secular subjects as stolen horses, scalps, scouting expeditions, and so forth, seem always to incorporate mysterious features that defy literal translation. Furthermore, the equestrian trappings often represented in our pictures – whips, lances,

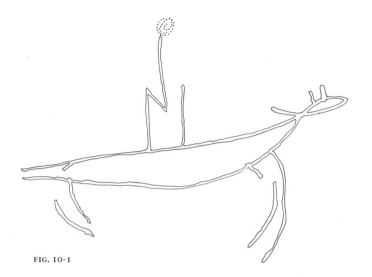

FIG. 10-1

FIG. 10-2

and probably guns as well – were sacred objects, employed in rituals, and hence infused with meanings transcending every day utility.[2]

Dempsey, the most sensitive to Plains Indian thought of any writer on the subject, insists that all authentic Milk River pictures had religious or supernatural implications. In his estimation, Writing-on-Stone "was not simply a place for a man to record his war exploits," that is, as "announcement to others." Rather, "he would more likely do this because he had been instructed to perform this duty, or before he set out on his raid he made a vow that he would make the recordings as a religious offering of thanks."[3]

Of initial interest here are the attempts to reconcile the fixed forms of shamanic symbolism with the novel characteristics of the introduced horse. With their prestige challenged by mere youths and lay chiefs, the shamans themselves, as prototype heroes, were caught up in an ongoing contest of conspicuous bravery accomplished on horseback. As a matter of course, they sought to harmonize the psychological impact of life centred on the horse with their exalted view of themselves and with the subtleties of their occult experience. A result of their efforts in this line is the horse-and-rider image based on the traditional bow-shaped animal form (Fig. 10-1), a configuration inconceivable before the advent of a rideable animal that

functioned as virtually one being with its master.

These scattered pictures, which syncretize two kinds of conventional figures once held formally distinct, contradict a fine point of doctrine already noticed in Milk River art. Previously, the bow-shaped animal represented the alter ego of the shaman, the human spirit temporarily occupying an entirely different and separate shape; only bird and shaman merged as identical spirits. Now, in horse-and-rider figures based on the bow-shaped animal form human and beast are one entity, a radical shift of meaning from traditional terms. Perhaps the bow-shaped horses document the early sanctification of the new animal as different from indigenous animal nature, yet similar in shape. On the other hand, artists of the horse culture may have adopted the form of the bow purely for its special symbolic value, quite apart from the shaman's cerebrations.

The shamans were not alone in seeking a form suitable for the sacred horse. The novices, who also may have felt a surge of mystical power arising from mastery of their steeds, had ideas of their own about how this spirit should look. Less constrained by traditions which they may not have fully grasped, they spontaneously produced a diversity of horse shapes, frequently with rectangular bodies and rigid legs. The prodigious energy and stamina of the horse, and its capacity for

96

vastly extending human perspectives called forth monumental forms, ranging up to the thirty-three-inch hulk with a roached mane (Fig. 10-2), which classes them proportionately with the cosmic beasts discussed in Chapter 8. Other horses appear as minute creatures, exquisitely engraved though only two or three inches long (Figs. 10-3, 10-4, 10-5, 10-6).

Some experimental horse imagery seems artless, imitative, and lacking either in discipline or a clear conception of the animal's mystic implications. At the same time we recognize a fresh vision, vigourous if unconventional drawing, and an expression of spirituality through devices of transparency and transformation adapted from already existing models. Hence, later Milk River art presents a varied and contradictory artistry reflecting confusion and reorientation, so that lifeless and clumsy figures appear alongside those of grace and surprising originality. Some panels are full of dissociated figures. One such is a display of painted power-laden symbols with no discernible connection among its miscellaneous parts: two or three travois, at least seven guns, a phallic shaman with uplifted arms and power hand, a reticulated tipi, a stylized bison skull, and, finally, off to one side an awkward little horse and rider. Perhaps most of the objects depicted amount to votive offerings.

The compromises and experiments just

described apparently satisfied few. The horse-as-spirit required a shape of its own, and that was soon forthcoming. The creation of a wholly new form defining the horse as a uniquely superhuman power is perhaps the younger generation's finest artistic accomplishment. In the "classic" version a long line extends from the muzzle along the neck and back, curving or angling around the haunch and continuing down the hind leg (Fig. 10-7).[4] This single stroke conveys an awareness of the physical basis for the unprecedented speed and strength of the animal under the horseman's immediate control. Similarly, the tubular head and elongated neck, usually rather serpentine in shape, regard from the rider's position the means of manoeuverability and the leading point of forward drive.

The form constitutes a newly-established convention within the canon of Milk River sacred art. It had several advantages which account for its popularity. Amateur artists could manage it. The adept could perfect it – even endow it with illusion of motion (Figs. 10-8 and 10-9), or an apparent musculature (Plate 3). Indeed, two strokes of engraving tool could render an entire horse figure in pleasing proportions. Allusive outlines disregarded irrelevant detail, yet allowed room for motifs reflecting a broad range of mystical preoccupations, from an elementary faith in magic talismans to the shaman's recondite visions. Like other conventional forms in the

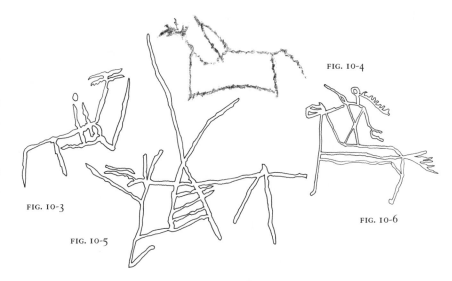

FIG. 10-4

FIG. 10-3

FIG. 10-6

FIG. 10-5

FIG. 10-7

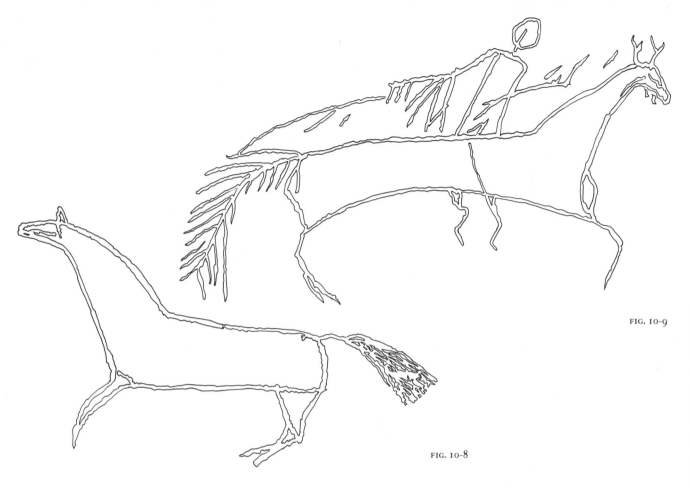

FIG. 10-9

FIG. 10-8

how it looked to the worldly eye. In the words of Franz Boas, here was "nature remodeled by thought."[5]

So pervasive is the conformity of line and shape that horse imagery in the valley is recognizable even in extreme abbreviation. Here, two simple lines define the neck and foreparts of a horse rising above one more fully drawn; there, we can see the underparts of one horse and the hindquarters of another amongst a profusion of forms and lines. The eleven-foot mural excerpted in Plates 6, 7, and 8 depicts a multitude of horses by means of their heads only in a long sequence of brief curved parallel scratches, now so eroded they are barely noticeable. Keyser found about 250 horse figures in the valley; allowing for numerous abbreviations, which cannot, of course, be counted with any exactness, we should probably increase that number by half at least to fully appreciate the role of the horse in the spiritual life of latter-day artists.[6]

Many Milk River horse figures appear in unadorned outline. Others carefully define parts imbued with special magic: the mane, sometimes roached; the round or semi-circular hooves; the pricked-up ears, which may be split or so exaggerated as to resemble antlers; and eyes (Fig. 10-10) – perhaps referring to a spirit mask, just as eyes do in human figures.

The meticulous attention given to flow-

Milk River style, its structure was that of a bodiless entity, as transparent as the human figures could be. Finally, the image of the horse could stand for itself, important in its own right as a spiritual being and not to be mistaken for some other animal.

Once a satisfactory formula was achieved – perhaps the invention of a single insightful shaman – artist after artist followed suit, each in his own manner. Thus scores of

horse images resemble each other in general conformation, and consequently in their meaning. For, although the structure of these figures derives largely from the intense experience of managing the animal rather than from ageless formal authority, it nonetheless adheres to the principle of conceptual symbolism, ever appropriate to religious art. The visible stood for the invisible: it signified what the animal meant as a spirit, not

FIG. 10-10

FIG. 10-11

FIG. 10-12

ing tails implies that this feature signified the magic of birdlike flight. The tail of a horse was probably additionally potent when fringed to resemble a wing, in actual practice the effect of binding or braiding. This same motif appears on horse figures on a famous Mandan buffalo robe collected by Lewis and Clark, and on horses in Navajo rock art.[7] But exactly the same kind of tail adorns a bison painted on the rock at Cow Narrows on the Churchill River in northern Saskatchewan.[8] The context of the Saskatchewan pictograph, in which power lines connect the beast to a shaman figure, argues that the motif of the fringed tail originated with prehistoric shaman-artists, then was widely adapted by horsemen as a convenient symbol of their new-found sensation of flight.

The fringed or feather nosepiece is an-

other motif specific to horse figures, not only in the Milk River valley but elsewhere as well. It is the nose-piece, together with the ears, that identifies the image of a large rubbed animal as undoubtedly a horse, though to us it may look more like a dog (Figure 10-12). Nosepieces tend to resemble "rakes," but like other fringes and feathers represented in rock art they are probably yet further references to powers of birdlike flight. The Blackfoot warrior's practice of hanging scalps and feathered medicine bundles on the bridles of their war horses does not stray from the basic symbolism of this mystical device, but instead enriches its meaning.[9]

With so many motifs pointing to the identity of horse and bird it is no surprise to find beak-headed horses among the petroglyphs,

as in Plate 15, for instance, and horse forms or their riders dissolving into birdlike shapes. Nor does it seem quite so odd that rows of painted horse tracks should coincide ambiguously with a cloud of feathers surrounding the legs of a bird. The impulse behind this sort of imagery is fundamentally the same as that of the famous Chinese bronze of second century A.D. in which a galloping horse balances by one hoof on the back of a swallow.[10]

Alongside the horse another motif, the tipi, gains importance in Milk River art. And with good reason: horses soon eclipsed women and dogs as pack animals, permitting larger, more prestigious portable dwellings. A Blackfoot encampment under the ample sky of the short-grass prairie was a stirring sight of the times, not least for the

99

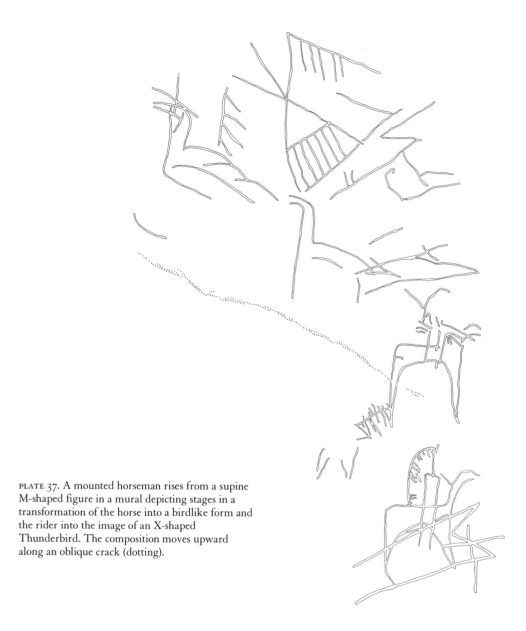

PLATE 37. A mounted horseman rises from a supine M-shaped figure in a mural depicting stages in a transformation of the horse into a birdlike form and the rider into the image of an X-shaped Thunderbird. The composition moves upward along an oblique crack (dotting).

natives. The atmosphere within each lodge – "where the sacred paths crossed" at the axis of the universe – deeply marked the minds of all.[11] It follows that the image of the tipi, with its wealth of cosmic connotations revolving about the central altar of the heart, appeared in numbers in the rock art of the horse era, sometimes standing as emblem of the mystical place involved in transformations of horse and rider.

The distinctive "attribute" of the Milk River horse is its rider – the human figure that accompanies it, merges with it, or rises from it as if a transformed being. Where the two kinds of spirit-figure fuse and interpenetrate, horse and human are manifestly a single being, partaking of each other's ghostly transparency and potential for metamorphosis.

The shapes of human figures preferred by artists of the horse culture shifted noticeably. Aside from the three horsemen and their opponents (Figs. 3-1, 3-2, and 3-3), and a few vague and doubtful traces of circular form around riders elsewhere, the traditional shield-figure was no longer very relevant. A new tendency was toward the irregular. Round-shouldered, even loop-shaped horsemen abound (Fig. 10-13). So do straight-shouldered figures. These unconventional forms usually lack even a vestige of the mystical V-neck esteemed by old-time artists and some of their successors.

FIG. 10-13

FIG. 10-14

FIG. 10-15

The trend away from traditional form does not necessarily mean an absolute decline in the complex iconography of the past. Rather it reflects the rudimentary understanding of upstart artists who by this time probably out-numbered the shamans as visitors to the holy precincts. The prehistoric V-neck figure nevertheless retained some favour, whether as rider or companion of the horse (Fig. 10-1). And wherever it appears this motif keeps its mystical quality, especially where the image of a horse superimposed on a human figure tells us that the spirit of the new animal had become intrinsic to the state of rapture (Plate 37). The X-based figure, too, was as valuable, probably because of its long associations with the Thunderbird (Figs. 10-5 and 10-6). This form implicitly completes the unity of horse, horseman, and bird, a repeated theme of the period.

The urge to abbreviate continued as strong as ever, reducing the horseman to a set of parallel lines (Fig. 10-3), or even to a single vertical line, as where four "stick figures" occupy a single horse (Fig. 5-5). Inverted Vs also indicate riders (Fig. 10-4). Variations of the double cross serve the same purpose (Fig. 10-14). The "round-up" mural, with its stream of abbreviated horses, presents a considerable diversity of horse-and-rider figures, too, all helpful in interpreting fragmentary figures elsewhere (Plates 6, 7, and 8; Fig. 10-13). Once aware of these devices we discover horse-and-rider images hidden in seemingly impenetrable designs, for instance, in a maze of calligraphic scratches (Fig. 10-15), or enclosed in the corrallike form in Plate 6.

Many riders are headless and armless, and at least one of them amounts to no more than a set of legs and feet astride a horse.

Others are entirely legless, including two triangular riders which may be reduced X-forms. Where they are not simply the result of erosion these abbreviations and reductions heighten the ambiguity of human forms associated with horses, emphasizing their immateriality. Thus we cannot arbitrarily say whether these spiritualized horsemen fading into invisibility actually ride their mounts in the usual sense, or rise from them, merge with the animal form, or represent an inseparable element of the horse. Whatever their precise meaning, and however vaguely expressed, such images obviously pertain to the persistent theme of transformation, a concept clearly as desirable for the ordinary man as for the shaman in his private ecstasies.

Once in a while the power hand occurs as an attribute of horsemen, doubtless because it was a conspicuous and easily imitated convention with a meaningful content for all

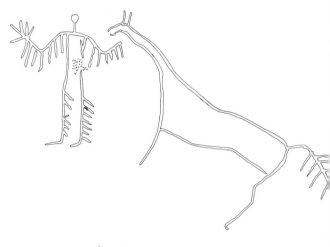

FIG. 10-16

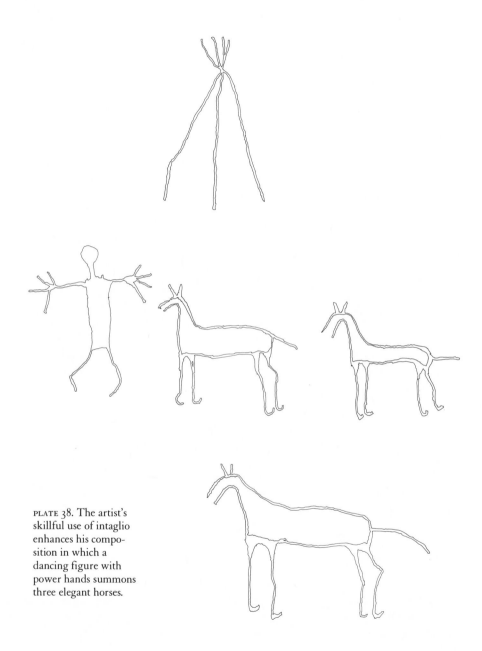

PLATE 38. The artist's skillful use of intaglio enhances his composition in which a dancing figure with power hands summons three elegant horses.

(Plate 7). High on a rock face in the park a virtuoso engraver has executed in intaglio a dancing human figure, splayed fingers on each exaggerated hand, in the act of summoning three splendid horses (Plate 38). But a missing element in this dancer, as in most figures of horsemen, is the more subtle motif of upraised arms, the badge of true shamanism signifying divine prerogatives. Only one or two artists of the horse culture allude to this primordial formula (Fig. 10-16), an indication of the loss, abandonment, or ignorance of esoteric doctrine.

Because much Milk River horse imagery blurs the distinction between the animal and human spirits, motifs amplifying the one form enlarge the meaning of the other in the

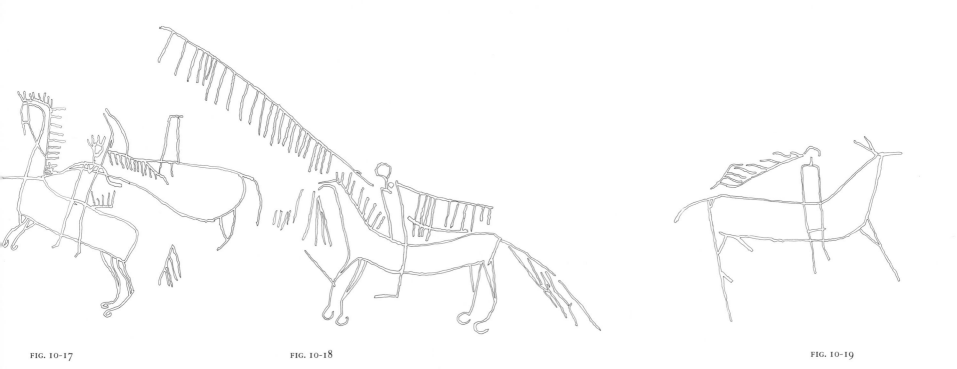

FIG. 10-17

FIG. 10-18

FIG. 10-19

picture. That is, bird motifs explicit in the horse modify the rider, too, and vice versa. Whether wings or feathers appear on the horseman or on the horse (Fig. 10-17), these attributes confer their meaning on both alike. The trailing feathered bonnet and sweeping fringed lance translated the warrior, together with his steed, into a spectacular bird skimming the prairie landscape. Pictures throughout the valley repeatedly testify that these Sioux-style accoutrements were more than theatrical effects; they conduced to a spiritual state of mind involving both man and beast as they moved in consort (Fig. 10-18 and 10-19).

The shaman's ecstatic experiences, not to mention his fluency in symbolic expression,

were beyond the reach of most newcomers to the valley. Hence, few recent pictures define with any conceptual clarity an inner mystical system either for horses or for horsemen. The twenty-three-inch polished horse near the old police post is a brave attempt to represent such ideas, but its skeletal pattern and uterine cavity, accentuated by incising, are of dubious design, lacking a spine or heart-line as a central organizing element (Fig. 10-12). Just as naive is a skeletonized horse with what seems a prickly tail (Fig. 10-20). Only occasional artists reticulated bodies of their horses or horsemen in a way that seemed to express inner mysteries of which they were more or less aware (Fig. 10-21). Most left their horses and riders empty of

bones and organs, or contented themselves with perfunctory indications of inner structure: a narrow line drawn through the horse from muzzle to rump, or a few grooves dashed in here and there, as if to satisfy a custom to which they largely were indifferent. Generally speaking, the later artists leaned toward weak and imprecise allusions to inward experience, which is only to be expected of a class unused to practicing intensive contemplation.

Another peculiarity of later Milk River art is the scarcity of conventional sexual motifs. Phallic horsemen appear here and there, but these are a very small fraction of the numerous pictures datable as post-1730. Phallic horses are fewer yet (Fig. 10-19). Most of the

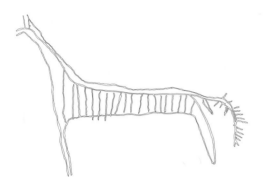

FIG. 10-20

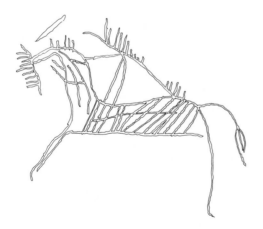

FIG. 10-21

sexually endowed figures of the horse period are either isolated petroglyphs or those in which phalli have no metaphysical relation to other elements in the mural.

It seems then that the new generation of artists was impervious to the sacral implications of sexual motifs that counted heavily with the shamans. A few exceptions come to light. The composition pictured in Plate 39 visually equates phallus and arrow, linking them and the horse and rider with a kind of celestial arch filled with comparatively large abbreviated X- and M-based figures, while another quasi-human form floats horizontally at a still higher level. At another site a large but abbreviated horse rises from a display of male genitalia, a composition revealing that in this artist's mind the proliferation of horses was subject to the same universal generative energy recognized by shaman-artists of old. Something similar can be said for the engraver who superimposed a fine small horse on a series of broad tool grooves along the upper edge of a deep hole. These compositions allude to the numinous power of sexual symbols to influence the cosmic processes of fertility, though with special reference to the horse. But this difficult concept evidently belonged exclusively to mature mysticism which only the shaman entertained. What should we say about the scores of horse pictures devoid of any customary sexual motifs?

The improbable neglect of sexuality will find an explanation if one looks at these pictures from another point of view. It is then that two themes come into focus that had not appeared in the works of the fully professional shaman.

The first thing to notice is the multiplicity of horse figures in certain compositions. The dancer in Plate 38 conjured not one, but three horses. On the wall of a cave coated with precipitates ten almost identical painted horses remain in view, possibly the remnants of a larger group (Plate 1). An eleven-horse herd is the sole subject of a mural scratched on a coulee wall (Plate 40). At another site the artist has arranged fourteen horses in groups around a row of tipis. As already mentioned, the heads of uncountable horses spread along a broad rock face (Plates 6, 7, and 8); around them circle at least eight mounted horsemen. Besides such genuine compositions as these with their repeated images of horses we find assemblages of horse art, that is rock faces covered with horses and horsemen by various hands, quite free of any overall scheme. Scattered about, too, are isolated horses and horse-and-rider figures vaguely similar to each other in their personal style; these raise the possibility that an artist might repeatedly leave pictures here and there on the rocks while travelling through the valley.

Although many of these images may indeed be the products of religious vows, the situation nevertheless strongly suggests the working of an ingenuous level of mysticism bordering on sympathetic magic. It is as if every picture of a horse amounted to a prayer for a horse: the more pictures, the more horses. Thus would ordinary minds hope to proliferate the desired species, and by much less recondite means than the shaman's obscure devices. Such artists would not envision themselves as "phallic instruments" in the universal scheme of progeneration, or think of the begetting of horses as an aspect of that system. For them, phallic symbolism had quite another significance and it took a totally different form.

This brings us to look again at the conventional shape devised to represent the spirit of the horse, and at the interpenetrating forms in horse-and-rider imagery. The "classic" Milk River horses tend to be serpentine in shape, an expression of libidinous energy oftentimes symbolized by the phallic snake. Certainly the bent willow hobby horses made for Blackfoot children established early a new symbol merging forms of serpent (libido), horse, and phallus.[12] Feelings and attitudes engendered by these associations naturally intensified with approaching manhood. As the boy gained expertise in managing the living animal and sensed the

PLATE 39. A unique combination of phallic symbolism with a horse-and-rider figure connects with a "celestial arch" filled with large quasi-human forms in abbreviation. Floating over all is a horizontal figure. The theme and artistic style of this engraving are related to the ascension in a nearby panel (Plate 37).

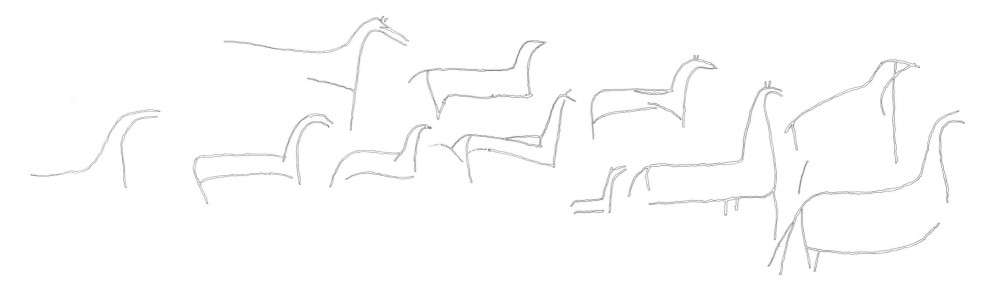

PLATE 40. A herd of eleven horses engraved on a coulee wall is one of scores of pictures along the Milk River which reflect the Plains Indians' obsession with the animal once it appeared in the region about 1735.

FIG. 10-22

autonomy of his will, the horse came to embody his most urgent drives. Mounting what they thought of as the source of their personal energetic power, native youths indeed underwent a transformation.

The very shape of Milk River horse figures, then, involved an interplay of significant form with very common feelings that had been spiritualized to some degree. We are obliged to think that many pictures of horses are figurations of the libido writ large. The sinuous form of the horse is thus a new version of the phallus. In its overwhelming repetition in the rock art of the valley this symbol nearly supersedes conventional sexual motifs. But its meaning now concentrates personal experience at the ordinary level. When combined with motifs alluding to birdlike flight, the horse-and-rider image perfectly expresses the psychic make-up of

the headstrong warrior of the Plains. Such pictures are not very different in meaning from the classical Greek centaur; the artists who made them belong to the dragon-fighting class of mystics, looking for heroic conquest.[13]

All told, the horse culture contributed to Milk River sacred art two new thematic devices. One was the multiplication of pictures of an animal as if to multiply its kind. The other was the figuration of the libido in the image of the horse. Neither of these innovations reflect an especially profound level of mysticism. Yet mystical they are; they expressed popular ideas of the numinous in the symbolic language appropriate to religious feeling.

To conclude on a more rarified note we look finally at a work that imparts a superior level of mysticism through its unique treat-

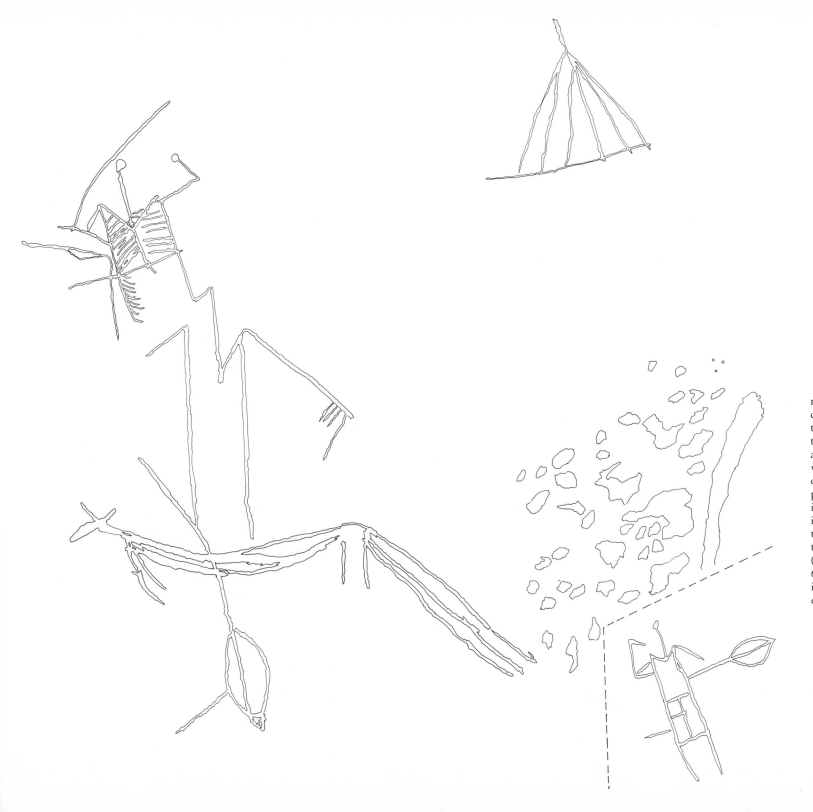

PLATE 41. An engraved composition on the theme of mystical transformation invests a bow-shaped horse with mystical symbols derived from prehistoric iconography. Pecked into the rock between the figures is a twenty-inch vulva sign (shown in full as Fig. 6-14). Dashed line indicates abridgement of panel.

ment of horse-and-rider imagery (Plate 41). Here the symbolic inner structure of both horse and human forms articulates several main themes of shamanic iconography. Horse and horseman are the salient elements of this engraving in which repeated motifs of mystical physiology distinguish a sequence of four ascending forms.

The composition begins in the lower register with a floating V-neck human figure only five inches high, its head inscribed as a tiny intaglio dot, and its one uplifted arm proclaiming the superhuman power of a shaman. Its torso is divided, the lower portion containing a central stem and indications of other organs. Protruding straight out from the empty upper section, like a soul departing from a body, is a heart-line with a sharply pointed, double-chambered heart.

Diagonally opposite this diminutive personage – just the other side of a pecked out vulva symbol some twenty inches in diameter (shown in full as Fig. 7-14) – is the horse, seemingly drifting upward. Its bow-shape is so thin and attenuated that it stretches out far beyond the usual proportions for such forms; together with its flowing tail, the animal measures fifteen inches long. And passing through its elongated mid-section, like an arrow through an ordinary bow, is a heart and heart-line fully nine inches long, an enlarged duplicate of the little shaman's soul.

This magnified visceral motif does not belong to the horse alone. At its upper end it connects with the leg of an over-sized rider, a headless empty V-neck figure whose one extended arm bears just enough feathering to suggest a wing. The horseman does not exactly ride the horse; more accurately, he seems levitated from its heart-as-arrow soul.

Further, surmounting the horseman and rising from his neck is yet a third quasi-human figure, one that echoes the posture of the shaman down below. But this top-most figure is fringed, phallic, and completely filled with a skeletal pattern of exceptionally fine design. On the same level, but off to the right is the image of a tipi, perhaps an emblem of the cosmic, yet local precincts of the pictured transformations.

This mural is unquestionably a masterpiece of deeply complex meaning compressed into a few multivocal symbols. Uncluttered, deceptively simple in composition, it touches on themes that are by now familiar evidence of shamanistic thought: the transformational potential of the human spirit; magic flight in the shape of a celestial bird; the claim of divine identity; emancipation of the independent soul from earthly bounds; and finally, initiatory death and resurrection of which the sacred skeleton is a succinct summation. None of these themes relates to the shaman's social functions as

healer, as guarantor of the earth's fecundity, or as a hero defeating evil influences. All have to do entirely with his personal mystical aspirations.

But there is still something to add. The master stroke of this artist is his insistence on the horse, through expressive exaggeration, as a tensely drawn bow, and its combination with the soul-like heart-as-arrow which makes his meaning all the more emphatic. For him the horse is not, as it was for his inferiors, a mere version of the phallus, but the much richer symbol of the coincidence of opposites, the hidden attunement of significant contradictions.

His singular discovery is the appropriateness of the horse for conveying this idea. For the horse embodied and reconciled contradictions in a manner wholly new to indigenous experience. This creature alone was both animalistic nature and yet an artifact, "nature remodeled" by human ingenuity. And functioning together, two contradictory elements – the human and the animal – became one entirely different being. From these insights, characteristic of the highest order of philosophical and mystical contemplation, the shaman rises in birdlike flight to celestial heights for his great adventure of mind and spirit. Transformed and then renewed he becomes a divine being on a new plane of reality.

Conclusion

Step-by-step analysis of forms found in Milk River sacred art has shown how closely many images agree with what we know of shamanistic tradition. The principal convention of imagery datable to the earliest rock art of the Northwest Plains is the transparent spirit-figure in quasi-human shape, a symbolic self-portrait of the artist himself whose very act of inscribing or drawing is endowed with divine energy and whose finished picture is thenceforth infused with a numinous efficacy. A wealth of amplifying motifs organized into complex images express the transformational mysteries in which this class of mystics typically engaged. The primordial posture of epiphany, the skeletal and visceral structures, the varied phalli, and the associated animal forms are among the devices articulating the familiar themes of the shaman's personal experience. In the archaic language of multivocal symbols these motifs tell of his initiatory death and dismemberment, his rebirth as a superhuman personality; his reception of sacred powers from the Great Spirit with whom he identifies in his character of a bird; his euphoric journeys to celestial realms and adventures in the underworld; his interiorization of the cosmic scheme; and his role as a mediator assuring the continuity of earthly life. Sequential and interpenetrating forms proclaim his powers of self-transformation.

Pictures belonging to this category of Milk River art constitute a wordless ontology, figuring the natural, essential properties, and relations of being as understood by archaic philosophers of the region. They support the likelihood that in prehistoric times the sanctuary was primarily the resort of shamans seeking seclusion to explore otherworldly states of reality appropriate to their calling. Other pictures, notably certain formal shield-figures bearing emblematic symbols, raise the possibility that sodalities under the guidance of shamans may have occasionally ventured into the sacred precincts for ceremonial purposes, leaving pictures of their identifying medicine bundles in the shapes of shields and drums. Nevertheless, the device of the shield merges with similar motifs to express deeper mysteries to which the shaman was privy.

Another category of paintings and engravings based on a more popular level of mysticism appeared in the valley with the advent of horses in the Northwestern Plains. The newcomers, for whom the sacred site was now easily accessible, created an original animal form to convey the libidinous spirit of the speeding horseman. At the same time they borrowed, reoriented, or simply copied some of the more traditional motifs already present, touching even their narratives of worldly adventure with spiritual significance. Yet the shaman-artists continued to contribute their esoteric art, which incorpo-

rated their own versions of the horse as symbol.

Keyser's secular interpretations of Milk River rock art are inadequate to account for popular native mysticism, let alone the shamans' level of religious experience. The shortcomings of his views illustrate a common difficulty in the way of understanding the arts of early peoples, namely the deep cleavage between the materialism of modern western culture, which acknowledges the evidence of the senses as the only reality, and spiritually-oriented archaic thought, which recognized invisible powers animating nature. To Keyser and others of his persuasion a sequence of figures on the rock walls becomes a kind of comic-strip account of "real" or historical events; sexual imagery refers to erotic exploits; what resemble shields and spears are *ipso facto* battle gear or hunting equipment. In their eyes, figures lacking "naturalistic" features are crude art. In part they may be right. But only in part, for they have ignored the suggestive indeterminacy of mystical symbols.

The apparent incompatibility of native religious feeling and modern habits of thought has disturbed more than one scholar who has attempted to identify the cause. The chief difference between the man of the archaic and traditional societies and the man of modern societies, Eliade wrote, "lies in the fact that the former feels himself indissolua-

bly connected with the Cosmos and the cosmic rhythms, whereas the latter insists that he is connected only with History."[1] Radin put it this way: the great difference lies in "the written word and the technique of thinking elaborated on its basis."[2]

More recently, Hans Peter Duerr made this rift in mental attitudes the issue of a complicated book critical of anthropological and ethnological investigations (mostly European) of mystical phenomena among people of archaic cultures.[3] Subtly, and with much wit and erudition, he likens certain scientific studies to Inquisition testimony concerning flying witches: in both cases all that appears in the record is couched in terms acceptable to the judges only. From the mystic's point of view this process distorts meaning. Duerr quotes approvingly an anthropologist who saw this kind of work as "slash-and-burn" technique, leaving nothing of value standing.

Criticism such as Duerr's can serve as a useful corrective, alerting us to the prejudicial effects of conditioned thinking, and more particularly to the special interests that sometimes motivate inquiries into mysticism. An extreme instance is the Soviet material mentioned here from time to time. We sense that it does not present a dispassionate account of Siberian shamanism, but rather a selected version worded perhaps to satisfy commissars bent upon bringing a recalcitrant people to heel; we learn more about the pop-

ular myths and rituals the shamans invented than about their mystical experience. The shamans who blocked the advance of Sovietization in remote regions (what was their fate under the Stalinist regime?) would probably not have recognized themselves in these accounts.

On the whole, however, Duerr's sweeping judgments are unduly harsh. Much of value does stand. The collections, transcriptions, and descriptions provided by anthropologists and archaeologists, schooled as they are in a rigorous tradition of precision and accuracy, are essential to those who would study either rock art or shamanism as an extension of our knowledge of human potential. The cultural historian relies on the results of their energy and diligence, and on the ingenuity of their methods. For instance, the Soviet ethnologists, whatever their failings, are especially admirable for linguistic analyses that demonstrate the layering of mystical terminology as the result of population movements; would that similar work existed to clarify the religious concepts of Plains Indians.

As for Keyser's work in the Milk River valley, it goes without saying that, without the evidence furnished in his tracings of the pictures, this book would have been impossible.

The practice of shamanism-by-inheritance reaches into the prodigious depths of

the human past, perhaps deriving ultimately from the earliest cultures in Africa where similar phenomena have prevailed. So far as we know, shamanism radiated out of central Asia as one of the most persistent expressions of spiritual sensibility, one that coexisted with other forms of magic and religion. The mystical concepts of the shamans are the root source from which spring themes characteristic of dogmatic religious movements, albeit these were continually restated and redefined according to shifting doctrinal principles.

Shamanism is peculiarly relevant to the study of rock art because the shamans have been agents for the preservation and transmission of symbolic imagery, the richly allusive language of the nonliterate archaic world that conveys concepts of invisible, intangible reality in pictorial form. Though subject to much local and regional variation, and in our time to commercial debasement, this language, reflecting as it does psychic impulses and metaphoric thought processes typical of human nature, endures more or less intact in the arts of all cultures. It translates fairly readily into such verbal arts as poetry.

Thus traditional symbolism as employed by the shamans crosses the boundary between archaic and modern thought, becoming a main avenue for understanding the mystical meanings of rock art. It is a significant advance in methodology that Vastokas and Vastokas grounded themselves thoroughly in both the shamanism of the Eastern Woodlands and in the history of symbolic art as preparation for their analysis of the Peterborough petroglyphs. They have pointed the way for others. Interestingly, within this decade J. David Lewis-Williams and his colleagues have taken a similar approach to rock art in southern Africa, linking its symbolic imagery to the visions of San (Bushman) mystics during their ecstatic trances.[4]

Finally, the complementary study of shamanism and the mystical symbols found in rock art promises to enlarge our knowledge of shamanism itself. Aside from Eliade's compilation and synthesis of existing literature on the subject, the shamans have rarely received serious attention. We need more precise information about their level of mysticism as a phase of religious development. And this is exactly what can come of iconographical studies of rock art. Indeed, one of the unanticipated discoveries emerging from this analysis of Milk River art is the qualitative distinction – heretofore unrecognized – between the shaman in animal shape and the shaman as bird. It is likely that further studies along similar lines will reveal other refinements in the shamans' ideology.

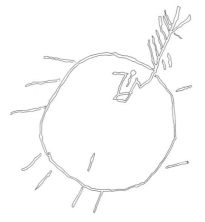

NOTES

1. DOCUMENTS OF THE INNER LIFE

1. For typical problems see David M. Hopkins, John V. Mathews Jr., Charles E. Schweger, and Steven B. Young, eds., *Paleoecology of Beringia* (New York: Academic Press, 1982), and D.W. Clark, "Some Practical Applications of Obsidian Hydration Dating in the Arctic," *Arctic* 37, No. 2 (June 1984), pp. 91–109. Jack Brink, *Dog Days in Southern Alberta,* Archaeological Survey of Alberta Occasional Paper 28 (1986), demonstrates difficulties in working out tribal locations for the Blackfoot and their neighbours. J. Roderick Vickers, *Alberta Plains Prehistory: A Review,* Archaeological Survey of Alberta Occasional Paper 27 (1986), juxtaposes conflicting interpretations of data on the cultural history of the Northwest Plains.

2. John C. Ewers, *The Horse in Blackfoot Culture, with Comparative Material from other Indian Tribes,* Bulletin 159 Smithsonian Institution, Bureau American Ethnology (Washington, D.C.: Government Printing Office, 1955), p. 18; Hugh A. Dempsey, *A History of Writing-on-Stone,* unpubl. ms. (1973), in Alberta Provincial Archives, p. 12.

3. H.M. Wormington and Richard G. Forbis, *An Introduction to the Archaeology of Alberta, Canada,* Proceedings, Denver Museum of Natural History 11 (August 1965), p. 32.

4. Gerardus van der Leeuw, "Primordial Time and Final Time," in Joseph Campbell, ed., *Man and Time: Papers from the Eranos Yearbooks* 3, Ralph Manheim, trans. (Princeton: Princeton University Press/Bollingen, 1983), p. 333.

5. Åke Hultkrantz, *The Religions of the American Indians,* Monica Setterwall, trans. "Hermeneutics: Studies in the History of Religions" (Berkeley and Los Angeles: University of California Press, 1967), p. 84. In the native languages the concept of "medicine" comprises every manifestation of supernatural power, but not all "medicine men" are shamans in the strict sense.

6. Mircea Eliade, *Shamanism: Archaic Techniques of Ecstasy,* Willard R. Trask, trans. (Princeton: Princeton University Press/Bollingen, 1974), pp. 13–23; Henry N. Michael, ed., *Studies in Siberian Shamanism,* "Anthropology of the North: Translations from Russian Sources" 4 (Toronto: Arctic Institute of North America, University of Toronto Press, 1963), passim; Black Elk, *The Sacred Pipe, Black Elk's Account of the Seven Rites of the Oglala Sioux,* Joseph Epes Brown, ed. (Harmondsworth: Penguin, 1983); Joseph Campbell, *The Masks of God,* V. 1. (Harmondsworth: Penguin, 1976), pp. 282–83; John H. Brumley, "The Laidlaw Site: An Aboriginal Antelope Trap from Southeastern Alberta," in *Archaeology in Alberta, 1983,* Archaeological Survey of Alberta Occasional Paper 23 (1984), pp. 96–127. Document on rituals, etc. involved in bison hunts during the historic period are excerpted in Eleanor Verbicky-Todd, *Communal Buffalo Hunting among the Plains Indians,* Archaeological Survey of Alberta Occasional Paper 24 (1984).

7. Eliade, *Cosmos and History: The Myth of the Eternal Return,* Willard R. Trask, trans. (New York: Harper Torchbooks/Bollingen Library, 1959), pp. 3, 141, 154; and his *Patterns in Comparative Religion,* Rosemary Sheed, trans. (New York: New American Library, 1974), pp. 4–7.

8. Sam D. Gill, *Native American Religions: An Introduction* (Belmont, Calif.: Wadsworth Publishing Co., 1982), pp. 62–66.

9. Eliade, *Patterns,* p. 33.

10. Joan M. Vastokas and Romas K. Vastokas, *Sacred Art of the Algonkians: A Study of the Peterborough Petroglyphs* (Peterborough, Ont.: Mansard Press, 1973).

11. Erich von Däniken, *Chariots of the Gods?* (New York: G.P. Putnam's Sons, 1974), and Barry Fell, *Bronze Age America* (Boston: Little, Brown, 1982).

12. Thelma Habgood, "Petroglyphs and Pictographs in Alberta," *Newsletter,* Archaeological Society of Alberta, No. 13–14 (Summer 1967), pp. 1–30; and James D. Keyser, "Writing-on-Stone: Rock Art on the Northwestern Plains," *Canadian Journal of Archaeology* 1 (1977), pp. 15–80. One sheet of Selwyn Dewdney's drawings of Milk River pictographs is reproduced in Wormington and Forbis, *An Introduction,* Fig. 51, p. 127; Dewdney published much of his work in southern Alberta in "Writing on Stone along the Milk River," *The Beaver* (Winter 1964), pp. 22–29. Two unpublished works are Stuart W. Conner, *Comparisons of Prehistoric Picture Writing at Writing-on-Stone Provincial Park, Alberta, with that of Central and South Central Montana* (1961); and D.R. King, *Prehistoric Rock Art in Alberta* (1965), both in Glenbow Museum Archives, Calgary.

13. *Story on Stone* ("a photographic record of rock art in the southern Alberta area surrounding the City of Lethbridge"), Project 20, Archaeological Society of Alberta, Lethbridge Centre, 1980. A new edition is in preparation.

14. Lawrence Halmrast, personal communication; *Story on Stone,* p. 24.

15. Keyser, *The Rock Art of Writing on Stone: Report Submitted in Partial Fulfillment of Rock Art Research Project at Writing-on-Stone Provincial Park,* funded by Alberta Provincial Parks Dept., typescript d. 1976 in archives, Archaeological Survey of Alberta (hereafter called Keyser, *Report*).

16. Glenbow Archives Photograph Collection NA-2956: 1–9; Dewdney, "Writings on Stone."

17. Erich Neumann, "Art and Time," in Campbell, ed., *Man and Time,* pp. 15–16.

18. Erwin Panofsky, *Meaning in the Visual Arts: Papers in and on Art History* (Garden City, N.Y.: Anchor Books, 1955), pp. 26–54.

19. Jean Seznec, *The Survival of the Pagan Gods: The Mythological Tradition and Its Place in Renaissance Humanism and Art,* Barbara F. Sessions, trans. (New York: Harper Torchbooks/Bollingen Library, 1961), p. 7.

20. On these and other works expressing astronomical orientations, see E.C. Krupp, *Echoes of the Ancient Skies: The Astronomy of Lost Civilizations* (New York: New American Library, 1984). The astronomer-anthropologist Anthony F. Aveni has studied the time schemes of pre-Columbian American culture as reflected in their visual imagery. See his *Empires of Time: Calendars, Clocks, and Cultures* (New York: Basic Books, 1989), especially on Venus as symbolized by the Maya, pp. 201f.

2. THE NATURAL HISTORY OF A SACRED SITE

1. Meriwether Lewis, William Clark, et al., *History of the Expedition under the Command of Captains Lewis and Clark to the Sources of the Missouri, across the Rocky Mountains, down the Columbia River to the Pacific in 1804,* Vol. I, repr. of 1814 ed. (New York: New Amsterdam Book Co., 1902), pp. 280–81.

2. Alice M. Johnson, ed., *Saskatchewan Journals and Correspondence 1795–1802,* The Hudson's Bay Record Society Publication 26 (London: 1967), p. 153 n.; Peter Fidler, *Peter Fidler Journals,* Hudson's Bay Co. Archives, Provincial Archives of Manitoba, E3/2: fos. 103d, 104, 104d–105, 105d–106, 106d–107. The Blackfoot name for the Milk River was probably phoneticized by Fidler himself; it seems related to the present-day Peigan name, *Ínuksisuhk* or *Ínuxsisuxk,* which also means Little River. Dempsey, personal communication. Fidler records another name for the Milk River – "Pun-na-kicks" – on the 1801 version of a map by The Feathers. See Judith Hudson Beattie's discussion of these maps in "Indian Maps in the Hudson's Bay Company Archives: A Comparison of Five Area Maps Recorded by Peter Fidler, 1801–1802," *Archivaria* 21 (Winter 1985–1986), pp. 166–75.

3. William J. Byrne, *The Archaeology and Prehistory of Southern Alberta as Reflected in Ceramics II,* Archaeological Survey of Canada Paper 14, National Museum of Man Mercury Series (Ottawa: 1973), p. 509.

4. Ibid., pp. 369–70; Andreas Graspointer, *Archaeology and Ethnohistory of the Milk River in Southern Alberta* (Calgary: Western Publishers, 1980), pp. 30–31; *Lethbridge, Alberta,* Map 82H, 1:250,000, Dept. Energy, Mines, Resources (Ottawa, 1977); G. Brown, E. Gasser, and R. McIsaac, *Biophysical Features and Land Use, Ross Lake Candidate Ecological Reserve,* Report for Alberta Recreation and Parks, Ecological Reserves Comm., by ERS Environmental Research Services, 1986.

5. Graspointer, *Archaeology and Ethnohistory,* p. 118; Wormington and Forbis, *An Introduction,* pp. 8–9; Edward J. McCullough, *Prehistoric Cultural Dynamics of the Lac La Biche Region,*

Archaeological Survey of Alberta Occasional Paper 18 (1982), p. 17. But see *Retreat of Wisconsin Recent Ice in North America,* Map 1257A, Geological Survey of Canada (Ottawa, 1969). Vickers, *Alberta Plains Prehistory,* reviews the literature on this unresolved issue, providing sketch maps of various theories of ice margins and isochrons of Late Wisconsin deglaciation, pp. 18–24.

6. Taryn Y. Campbell, *Writing on Stone Provincial Park: Master Planning Study* (Edmonton: Alberta Recreation and Parks, 1981), pp. 6–12.

7. Ibid., passim; C.R. Wershler, *South Writing-on-Stone Natural History,* unpub. ms., (1980), Alberta Recreation and Parks, Edmonton Office; Graspointer, *Archaeology and Ethnohistory,* pp. 20f.; R.G.H. Cormack, *Wild Flowers of Alberta* (Edmonton: Queen's Printer, 1967); Ellen Gasser, personal communication.

8. Eliade, *Patterns,* p. 271.

9. Claude Lévi-Strauss, *The Savage Mind [La Pensée Sauvage]* (London: Weidenfeld and Nicolson, 1966), discusses the systematic knowledge of "primitives," that is, unwesternized people, pp. 1–33. For the network of symbols known to present-day Sioux (Lakota), see Black Elk, *The Sacred Pipe,* passim.

10. Joan M. Vastokas, "The Shamanic Tree of Life," in Anne Trueblood Brodzky, Rose Danesewich, and Nick Johnson, eds., *Stones, Bones and Skin: Ritual and Shamanic Art* (Toronto: Society for Art Publications/Artscanada, 1977), p. 108; Verbicky-Todd, *Communal Buffalo Hunting,* pp. 44–45 and passim.

11. Eliade, *Patterns,* p. 19f.

12. Graspointer, *Archaeology and Ethnohistory,* p. 34. The Sweetgrass Hills rise 6,000 feet above sea level, i.e., about 4,000 feet above the surrounding prairie (p. 18).

13. Campbell, *Masks of God* I, pp. 267f.; Eliade, *Patterns,* pp. 419f.; Paul Radin, *The Trickster: A Study in American Indian Mythology,* Karl Kerenyi and C.G. Jung, comm. (New York: Greenwood Press, 1969), pp. ix–x and passim.

14. Vastokas and Vastokas, *Sacred Art,* pp. 80–82 and Fig. 19R; on the earth as a bearing and nourishing mother, Neumann, *The Great Mother: An Analysis of an Archetype,* Ralph Manheim, trans. (Princeton: Princeton University Press/Bollingen, 1972). Cf. V.N. Chernetsov, "Concepts of the Soul among Ob Ugrians," in Michael, ed., *Studies in Siberian Shamanism,* p. 75, and A.F. Anisimov, "Cosmological Concepts of the Peoples of the North," in ibid., pp. 167f.

3. "AYSIN'EEP" – IT HAS BEEN WRITTEN

1. Brink, *Excavations at Writing-on-Stone,* Archaeological Survey of Alberta Occasional Paper 12 (1978), p. 47.

2. D.R. King, photo of tent ring, Glenbow Archives, B 150–1 (1960); Graspointer, *Archaeology and Ethnohistory,* pp. 4, 49f.

3. Ibid., pp. 100, 103.

4. Ibid., p. 87.

5. Brian O.K. Reeves, *Culture Change in the Northern Plains: 1000 B.C.–A.D. 1000,* Archaeological Survey of Alberta Occasional Paper 20 (1983), pp. 36, 90, 168–69, and his Fig. 1, p. 314. See also the chart of palaeocultural sequence in Vickers, *Alberta Plains Prehistory,* Fig. 2, p. 11.

6. Reeves, *Culture Change,* pp. 187–88, and "Head-Smashed-In: 5,500 Years of Bison Jumping in the Alberta Plains," *Plains Anthropologist,* Memoir 14, Vol 23, no. 2 (1978), pp. 151–74.

7. Verbicky-Todd, *Communal Buffalo Hunting,* passim.

8. Radin, *Primitive Religion: Its Nature and Origin* (New York: Dover, 1957), pp. 15f. On refurbishing and elaborating myth and the rituals that myth supports by rearranging traditional elements, a process compared to *bricolage,* see Lévi-Strauss, *The Savage Mind,* pp. 17–24. Robert Graves terms this process "iconotrophy" in *The Greek Myths* (Baltimore: Penguin, 1957), p. 21. Aveni relates such changes to power shifts in his *Empires of Time,* passim.

9. Vickers, personal communication.

10. Gary Adams, Michael R.A. Forsman, and Sheila Minni, *Archaeological Investigations: Writing-on-Stone N.W.M.P. Post* I, Alberta Historic Sites Service Occasional Paper 4 (1977), pp. 213–14; Leslie J. Hurt, *A History of Writing-on-Stone N.W.M.P. Post,* Alberta Historic Sites Service Occasional Paper 5 (1979), p. 4.

11. *Peter Fidler Journals,* E.3/2, fos. 104d, 105.

12. Stuart Baldwin, *The Elk Point Burial,* Archaeological Survey of Alberta Occasional Paper 11 (1978), pp. 32–34, 60–61. Tinkling cones were available at Fort George (1792–1800) and Rocky Mountain House (1799–1834).

13. Byrne, *Archaeology and Prehistory* II, pp. 298, 508f.

14. Reeves, *Culture Change,* pp. 99–100; Verbicky-Todd, *Communal Buffalo Hunting,* pp. 177f.

15. Dewdney, *Dating Rock Art in the Canadian Shield Region,* Royal Ontario Museum Occasional Paper 24 (Toronto: University of Toronto Press, 1970). His book is valuable nonetheless for its reproductions and comments.

16. Keyser, *Report.* Reeves outlines three major periods of early Plains culture, characterized by projectile or point systems: (1) Early Prehis-

toric, c. 10,000 B.C. to c. 5,500 B.C., heavy spears for throwing or stabbing; (2) Middle Prehistoric, c. 5,500 B.C. to B.C., 200–700, spear-throwers (atlatls); and (3) Late Prehistoric, A.D. 200–700 to 1725, points designed for arrows and bow. *Culture Change,* pp. 36–37.

17. William Mulloy, *A Preliminary Historical Outline for the Western Plains,* University of Wyoming Publishing 20, No. 1 (Laramie, 1958), passim.

18. *Story on Stone,* p. 23.

19. See the map of "postulated positions" of Plains groups c. 1700, in Brink, *Dog Days,* p. 57. Similar pictures of armoured horses appear in Montana. Photo in Glenbow Archives, Connor Photograph Series C267, pp. 168–69.

20. Lewis and Clark, *History of the Expedition* II, pp. 123–24. Shoshone horse armour, they say, was constructed of folded dressed antelope skin stiffened with sand and glue. Habgood notices that the protective armour of the Shoshone does not appear in their hide paintings. "Petroglyphs and Pictographs," p. 17.

21. J.B. Tyrrell, ed., *David Thompson's Narrative of His Explorations in Western America* (Toronto: The Champlain Society, 1916), pp. 328–29. See also Dempsey, *A History of Writing-on-Stone,* pp. 13–14; McCullough, *Prehistoric Cultural Dynamics,* pp. 41–46, 52, 56; Keyser, "A Shoshonean Origin for the Plains Shield Bearing Warrior Motif," *Plains Anthropologist* (1975), pp. 207–16.

22. R.G. Forbis, *A Review of Alberta Archaeology to 1964, National Museum of Canada. Publications in Archaeology* 1 (Ottawa: 1970), p. 45, cited as still valid in 1986, in Brink, *Dog Days,* p. 52. Arrival of the N.W.M.P. in 1874 ended the "proto-

historic" period in Southern Alberta, Vickers, *Alberta Plains Prehistory,* p. 103.

23. Brink, *Dog Days,* pp. 59–60.

24. Byrne, *Archaeology and Prehistory* II, p. 552.

25. Ibid., pp. 519–20. Brink follows up with a review of historical documents pertaining to the Snake-Shoshone controversy and the opinions of recent authorities. *Dog Days,* pp. 41–49.

26. Ewers, *The Horse in Blackfoot Culture,* pp. 204–5, 328–29, mentions horse armour among the Wichitas and Arikaras (a Caddoan-speaking people of the Red River).

27. Byrne, *Archaeology and Prehistory* II, pp. 519–21, 530, 561.

28. Keyser, "A Shoshonean Origin," pp. 207–16, and his *Report.*

29. Brink, *Dog Days,* pp. 2–3.

30. Ibid., pp. 34–41; Byrne, *Archaeology and Prehistory* II, pp. 551–52.

31. See "stomach," in *The Shorter Oxford English Dictionary on Historical Principles* (revised), C.T. Onions, ed. (Oxford: The Clarendon Press, 1965).

32. Forbis, *Cluny: An Ancient Fortified Village in Alberta,* Dept. of Archaeology, The University of Calgary, Occasional Paper 4 (1977); Byrne, *Archaeology and Prehistory* II, pp. 366–68.

33. Ibid., p. 554.

34. Ibid., pp. 421, 547.

35. McCullough, *Prehistoric Cultural Dynamics,* pp. 41–46, 52, 56.

36. Reeves, *Culture Change,* p. 20.

37. Brink, *Dog Days,* pp. 5–9; Canon H.W. Gibbon Stocken, *Among the Blackfoot and Sarcee,* intro. Georgeen Barrass (Calgary: Glenbow-Alberta Institute 1976), pp. viii, 43.

38. Dempsey, *A History of Writing-on-Stone,* p. 23.

39. David Gebhard's "Foreword" to Campbell

Grant, *Rock Art of the American Indian* (New York: Thomas Y. Crowell, 1967), p. vi.

4. THE VISITORS

1. Dempsey, *A History of Writing-on-Stone,* pp. 45–46.

2. Selwyn Dewdney and Kenneth E. Kidd, *Indian Rock Paintings of the Great Lakes* (Toronto: University of Toronto Press/Quetico Foundation, 1967), p. 13.

3. Dempsey, *A History of Writing-on-Stone,* pp. 23f.

4. Ibid., p. 44; Lawrence Halmrast, personal communication.

5. Ronald Getty, *The Many Snakes Burial (DgOv 12): A Primary Inhumation from Southern Alberta* (Calgary: The University of Calgary, 1971).

6. Ibid., p. 26; Wormington and Forbis, *An Introduction,* pp. 97, 121–22, 134; Brumley, "The Ellis Site (EcOp4): A Late Prehistoric Burial Lodge/Medicine Wheel Site in Southeastern Alberta," In *Contributions to Plains Prehistory,* Archaeological Survey of Alberta Occasional Paper 26 (1985), pp. 180–232; Dempsey, "Stone 'Medicine Wheels' – Memorials to Blackfoot War Chiefs," *Journal Washington Academy of Science* 46, No. 6 (1956), pp. 177–82; Graspointer, *Archaeology and Ethnohistory,* p. 64. See also Baldwin, *The Elk Point Burial.*

7. Gill, *Native American Religions,* pp. 97–101; Radin, *Primitive Man as a Philosopher* (New York: Dover, 1957), p. 92; Black Elk, *The Sacred Pipe,* pp. 44–66; Vastokas and Vastokas, *Sacred Art,* p. 35; Campbell, *Masks of God* I, pp. 178–79.

8. Eliade, *Shamanism,* pp. 106–7; Neumann, "Mystical Man," in Campbell, ed., *The Mystic Vision: Papers from the Eranos Yearbooks* 3, Ralph

Manheim, trans. (Princeton: Princeton University Press, 1968), pp. 375–415.

9. Campbell, *Masks of God* I, pp. 88–118, 242, and 254.

10. Graspointer, *Archaeology and Ethnohistory*, p. 68. Cf. Ewers, *The Blackfeet: Raiders on the Northwest Plains* (Norman: University of Oklahoma Press, 1958), p. 163.

11. Campbell, *Masks of God* I, pp. 300–34, 374–75. See also Anisimov, "Cosmological Concepts." Marija Gimbutas thinks that traits that appear among Arctic hunters – which shamanism does – point to a Palaeolithic origin. *The Gods and Goddesses of Old Europe, 7000 to 3500 B.C.: Myths, Legends and Cult Images* (Berkeley and Los Angeles: University of California Press, 1974), pp. 116, 152, 195, 216, 237.

12. Dewdney, *Indian Rock Art* (Regina: Saskatchewan Museum of Natural History, 1963), pp. 8–9. On the dating of Magdelenian art, Henri Laville, Jean-Philippe Rigaud, and James Sackett, *Rock Shelters of the Perigord: Geological Stratigraphy and Archaeological Succession* (New York: Academic Press, 1980), p. 42.

13. Eliade, *Shamanism,* passim.

14. Ibid., pp. 375f, 428f; *Patterns,* pp. 108, 146–47; Campbell, *Masks of God* I, pp. 229–81.

15. Herbert Kühn, "Das Problem des Urmonotheismus," trans. in Campbell, *Masks of God* I, p. 345; Eliade, *Patterns,* p. 345.

16. Campbell, *Masks of God* I, pp. 329–30; Eliade, *Shamanism,* p. 333.

17. Eliade, *Shamanism,* pp. 107–9. He is at pains to refute the equation of shamanism with mental disorder, pp. 5, 23f.

18. Grinnell is quoted in Campbell, *Masks of God* I, p. 294. North American anthropologists regard pan-tribal societies (sodalities as the earliest stage in the integration of tribal culture beyond kinship units. When the tribal population reaches a certain size, kin links, even "mythical" ones, break down as the basis of "we" groups; by cutting across kin units, sodalities seem to be an "initial force in providing social cohesion in larger populations." Vickers, personal communication. Anisimov, in "Cosmological Concepts," offers information based on symbolism and layers of linguistic elements about the development of Siberian cultures from matriclans to patriarchal kin systems.

19. Eliade, *Shamanism,* p. 166.

20. Ewers, *The Horse in Blackfoot Culture,* pp. 261, 264f.

21. Ibid., pp. 129–30; Campbell, *Masks of God* I, p. 286.

22. Eliade, *Shamanism,* p. 166. See also the array of emblematic shields in George Catlin's painting, *Interior of the Mandan Medicine Lodge,* reprod. in Mary Sayre Haverstock, *Indian Gallery: The Story of George Catlin* (New York: Four Winds Press, 1973), pp. 88–89.

23. Eliade, *Shamanism,* p. 313f; Ewers, *The Horse in Blackfoot Culture,* pp. 253, 280.

24. Eliade, *Shamanism,* pp. 299–318. Cf. Vastokas and Vastokas, *Sacred Art,* on the place of the Medewiwin organization in Ojibwa society, pp. 31, 36f, and Hultkrantz, *Religions of the American Indians,* pp. 84–102.

25. Ewers, *The Horse in Blackfoot Culture,* pp. 59, 274.

26. Keyser, "A Shoshonean Origin," p. 208.

27. Mulloy, *A Preliminary Historical Outline,* Fig. 43–12. Habgood's transcription of this pictograph in "Petroglyphs and Pictographs," Fig. 48, differs slightly from Mulloy's version.

28. Alberta Provincial Museum Catalogue Number H68.117.2.

29. Ewers, *The Horse in Blackfoot Culture,* pp. 311–12.

30. Dempsey, *A History of Writing-on-Stone,* pp. 26 f.

5. SPIRITS IN HUMAN SHAPE

1. William Rubin, *"Primitivism" in 20th Century Art: Affinity of the Tribal and the Modern,* 2-vol. catalog (New York: Museum of Modern Art, 1984), p. 247.

2. Cf. Keyser, "A Lexicon for Historic Plains Indian Rock Art: Increasing Interpretive Potential," *Plains Anthropologist* (1987), pp. 43–44, 50.

3. R.H. Lowie, *Primitive Society* (New York: Boni and Liveright, 1925), pp. 5–6, 55f.

4. Heinrich Wölfflin, *Principles of Art History,* M.D. Hottinger, trans. (New York: Dover, 1950), pp. vii–lx; he is mindful of primitive as well as European art.

5. Erich Auerbach, "Figura," in his *Scenes from the Drama of European Literature,* Ralph Manheim, trans. (New York: Meridian Books, 1959), pp. 56–57.

6. Examples are in Mulloy, *A Preliminary Outline;* Habgood, "Petroglyphs and Pictographs;" Vastokas and Vastokas, *Sacred Art;* Dewdney, *Indian Rock Art;* and Marion Robertson, *Rock Drawings of the Micmac Indians* (Halifax: The Nova Scotia Museum, 1973), especially for the X-shaped figure.

7. Examples from Neolithic cliff paintings in Spain are in Neumann, *The Great Mother,* Fig. 5. Comparable figures, some with fringed arms, some with facial features, are the bases of formal designs on Tartar and Mongolian drums. Garrick Mallery, *Picture-Writing of the*

American Indians, 10th Annual Report, Bureau of Ethnology, Smithsonian Institution, 1888–1889 (Washington, D.C.: Government Printing Office, 1893), Figs. 721, 723.

8. Cf. these shapes with those in Delcie H. Vuncannon, "Grand Gulch: Southeastern Utah's Picture Gallery," in Kay Sutherland, ed., *American Indian Rock Art* 2 (El Paso, Tex.: El Paso Archaeological Society, 1976), Figs. 11–12.

9. Dewdney, "Writings on Stone"; Habgood, "Petroglyphs and Pictographs"; Keyser, *Report.*

10. *Bloody Hand,* 1832, reprod. in Haverstock, *Indian Gallery,* p. 91; John G. Bourke, "The Medicine-Men of the Apache," in *9th Annual Report,* Bureau of Ethnology, Smithsonian Institution, 1887–1888 (Washington, D.C.: Government Printing Office, 1892), Plate III.

11. Ye. D. Prokofyeva, "The Costume of an Enets Shaman," in Michael, ed., *Studies in Siberian Shamanism,* Figs. 15–16, 24; J. Vastokas, "The Shamanic Tree of Life," p. 98 and illus.; Peter T. Furst, "The Roots and Continuities of Shamanism," in Brodzky, Danesewich, and Johnson, eds., *Stones, Bones and Skin,* p. 4.

12. Habgood, "Petroglyphs and Pictographs," pp. 11, 13, 17, Figs. 30, 37; Mulloy, *A Preliminary Historical Outline,* Figs. 42–44, 52; Keyser, "A Shoshonean Origin," Figs. 1–2; Mimi Buck and Cheryl Rhodes, "Rock Art of West Central Colorado and Periphery," in Sutherland, ed., *American Indian Rock Art* 2, pp. 1–4; Kenneth B. Castleton, "Rock Art of the Uintah Basin of Utah," in ibid., pp. 19–25; P.S. Barry, *Sketches of Pictographs near Tucson, Arizona,* personal archives, 1985; Thomas J. Maxwell Jr., *The Temiscals of Arroyo Conejo* (Thousand Oaks: Calif. Lutheran College, 1982), cover.

13. Mulloy, *A Preliminary Historical Outline,* Fig. 43.

14. Two transparent shieldmen also occur in Pictograph Cave, Montana. Ibid., Fig. 44.

15. Black Elk, *The Sacred Pipe,* p. 69; Habgood, "Petroglyphs and Pictographs," Figs. 38, 44; Castleton, "Rock Art of the Uinta Basin," Fig. 2; J. Vastokas, "The Shamanic Tree of Life," p. 98. Furst, "Roots and Continuities of Shamanism," publishes photos of a shaman's drum, now in Sheldon Jackson Museum, Sitka, Alaska, which duplicates the Milk River imagery pictured in Plate 12 and the Endpiece, except that the legs and feet of the human figure are the drum's handle. Drum handles with human features were common among Point Barrow natives. John Murdoch, "Ethnological Results of the Point Barrow Expedition," *9th Annual Report,* Bureau of Ethnology, Smithsonian Institution, 1887–1888 (Washington, D.C.: Government Printing Office, 1892), Figs. 384, 385. Human forms quarter the entire drumhead in Turkish and Mongolian examples. Mallery, *Picture-Writing,* Figs. 721–723.

16. For the ubiquity of circle-based designs as a mystical symbol in North American Indian costume, etc., including many Blackfoot objects, Ted J. Brasser, *"Bo'jou, Neejee!" Regards sur l'art indien du Canada* (Ottawa: Une exposition itinérant de Musée national de l'Homme, 1976); Haverstock, *Indian Gallery;* and J. Vastokas, "The Shamanic Tree of Life."

17. Cf. Vastokas and Vastokas, *Sacred Art,* p. 139, Fig. 32, Plate 13.

18. Ibid., p. 69, Fig. 14, for mention of pregnant shamans. The shamans may have assumed their androgynous character when they monopolized the prerogatives, powers, and accoutrements of the female shamans during dissolution of the matriarchal clan system. See Anisimov, "The Shaman's Tent of the Evenks and the Origin of the Shamanistic Rite," in Michael, ed., *Studies in Siberian Shamanism,* pp. 84–123.

19. On the serpent, often horned, in North American rock art, Habgood, "Petroglyphs and Pictographs," pp. 58–59; Dewdney, *Indian Rock Art,* p. 5; Ken Hedges, "Southern California Rock Art as Shamantic Art," in Sutherland, ed., *American Indian Rock Art* 2, Figs. 11, 25–27. Images of serpents merge with those of lizards and alligators in the southwest and Central America. Grant, *Rock Art,* p. 107. The Blackfoot adopted dragon images found in trade goods as a serpent device. Glenbow Archives, NA-2084-63 (d. 1889). Vastokas and Vastokas present examples of snakes merged with phallic boat imagery. *Sacred Art,* Plate 19, Figs. 24, 28–33, 55, pp. 86–103. See also Gerardo Reichel-Dolmatoff, *Amazonian Cosmos: The Sexual and Religious Symbolism of the Tukano Indians* (Chicago: University of Chicago Press, 1971). On the serpent as a shamanic spirit since ancient times, Anisimov, "Cosmological Concepts," pp. 165–66; J. Vastokas, "The Shamanic Tree of Life," p. 152. For libido images involving the serpent in religious art and literature, Eliade, *Patterns,* pp. 164–71; Neumann, *The Great Mother,* passim; and C.G. Jung, *Symbols of Transformation,* R.F.C. Hull, trans. (Princeton: Princeton University Press, 1972), passim.

6. MOTIFS THAT AMPLIFY MEANING

1. Neumann, *The Great Mother,* Fig. 11; Campbell, *Masks of God* I, pp. 300–34, 374–75; Anisimov, "Cosmological Concepts," p. 97, and

"The Shaman's Tent," p. 110. Gimbutas calls attention to aspects of the Neolithic "great goddesses" derived from preagricultural times. *Gods and Goddesses of Old Europe,* p. 152 and passim. But not all cultural historians accept a connection between the female divinities of Palaeolithic hunters and those of agricultural societies (Vickers and J. Vastokas, personal communication).

2. P.R.S. Moorey, Emma C. Bunker, Edith Porada, and Glenn Markoe, *Ancient Bronzes, Ceramics and Seals,* The Nasli M. Heeramaneck Collection (Los Angeles: L.A. County Museum of Art, 1981), passim, and Cat. Nos. 1010, 1024; Neumann, *The Great Mother,* Plates 26–27, 126, 136, Figs. 5, 12–13, Frontispiece; Jung, *Symbols of Transformation,* Figs. 7, 34, Plates I,V.

3. Neumann, *The Great Mother,* Fig. 40, Plates 29, 66, 103, 116; Asian Art Museum, *A Decade of Collecting* (San Francisco: 1976–1977), Plates VI, XVI; H.S. Janson and Dora Jane Janson, *The Picture History of Painting* (New York: Harry N. Abrams, 1957), Plate 207.

4. Neumann, *The Great Mother,* p. 116; Fig. 54 shows a central *crux ansata* with upraised arms imitated by worshipping animals and humans. See also Jung, *Symbols of Transformation,* Plate I and Fig. 7. Mallery quotes an Ojibwa shaman's interpretation in *Picture-Writing,* p. 235; his examples include a twenty-seven-foot high pre-Columbian figure on the Stone of the Giants, Orizaba, Mexico (Plate XIV), interpreted by a Catholic priest as alluding to the coming of Christ.

5. Vastokas and Vastokas, *Sacred Art,* pp. 35, 69f. Along with examples at Peterborough they adduce many analogues (Figs. 11, 17, 25, 45). See also figures illustrating Hedges, "Southern California Rock Art"; Vuncannon, "Grand Gulch"; Dewdney and Kidd, *Indian Rock Paintings;* Habgood, "Petroglyphs and Pictographs"; Mulloy, *A Preliminary Historical Outline;* Keyser, "A Lexicon"; Brasser, *"Bo'jou, Neejee!";* Ewers, *Indian Life on the Upper Missouri* (Norman: University of Oklahoma Press, 1986); Bourke, "The Medicine-Men," Figs. 434, 444–445, Plates V–VII; and the carved stone at Stavely, Alberta, photo by Dewdney, Glenbow Archives C-192.

6. Olive P. Dickason, *The Myth of the Savage and the Beginnings of French Colonialism in America* (Edmonton: The University of Alberta Press, 1984), p. 255.

7. Reductions of the upraised-arms image into a geometric abstraction are at Signal Hill, in Arizona. Barry, *Sketches.* Animal imagery displaying the shaman's posture is in Maxwell, *The Temescals,* pp. 56, 62–63, 69.

8. Rubin, "Picasso," in *"Primitivism,"* p. 268 and illustrations.

9. Seals temporarily displayed in Los Angeles County Museum of Art (no catalogue numbers).

10. For body paint, Catlin's portrait of *Sturgeon's Head,* 1832, with black and white hands painted on the upper shoulders and chest of a Sauk and Fox warrior, reprod. in Haverstock, *Indian Gallery,* p. 114; a necklace of mummified human fingers collected by Captain Bourke belonged to High Wolf, foremost Cheyenne shaman in Montana and Wyoming. Bourke, "Medicine-Men," pp. 480–87, Plate IV.

11. Klaus F. Wellman, "Some Observations on the Bird Motif in North American Rock Art," in Sutherland, ed., *American Indian Rock Art 2,* Fig. 5.

12. Habgood, "Petroglyphs and Pictographs," p. 20 and several figs.; Mulloy, *A Preliminary Historical Outline,* Fig. 47; Bourke, "Medicine-Men," Fig. 434.

13. Keyser, "A Lexicon," pp. 58, 62–63, Fig. 12c.

14. Vuncannon, "Grand Gulch," Fig. 11. Ellen Gasser tells of another such figure in the vicinity of W-O-S Park, but which does not appear among photographs or tracings (personal communication).

15. Krupp, *Echoes of Ancient Skies,* pp. 70–71; Graves, *The White Goddess: A Historical Grammar of Poetic Myth* (New York: Vintage Books, 1958), pp. 361–62; Eliade *Shamanism,* pp. 470f; Campbell, *Masks of God* II, pp. 391–92.

16. Vuncannon, "Grand Gulch," Fig. 12. Cf. Jumping, dancing shaman figures from Colorado, in Mallery, *Picture-Writing,* Fig. 34.

17. J. Vastokas, personal communication. "Totem animals" are also portrayed upside down.

18. Eliade, *Shamanism,* pp. 34–36, 429–30 and passim.

19. The Star Tipi, photographed by R.N. Wilson, 1892, on the Blood Indian Reserve, is filled with rows of circles. Glenbow Archives Photo NA 668.10.

20. Eliade, *Shamanism,* pp. 148f; Prokofyeva, "The Costume," Fig. 18, p. 140.

21. *Blackfoot Medicine Man in Curing Costume,* reprod. in Haverstock, *Indian Gallery,* p. 60; Mulloy, *A Preliminary Historical Outline,* Figs. 43, 46. Cf. also the St. Victor, Sask., petroglyph with great eyes and toothed mouth, recorded in Dewdney, *Indian Rock Art,* p. 13. Petroglyph figures in the littoral zone of British Columbia are "dominated by eyes." Beth Hill, *Guide to In-*

dian Rock Carvings of the Pacific Northwest Coast (Surrey, B.C.: Hancock House, 1980), passim.

22. *Old Bear,* reprod. in Brasser, *"Bo'jou, Neejee!"* p. 186. The device of the personified phallus, represented as the double of the principal figure, appears in Roman grotesques and again in Renaissance art and poetry, e.g. Nicoletto da Modena, *Ornamental Panel,* in Jay A. Levenson, *Prints of the Italian Renaissance: A Handbook of the Exhibition* (Washington, D.C.: National Gallery of Art, 1973), Catalogue No. 327; and Cornelis Floris, *Grotesque,* in André Chastel, *The Crisis of the Renaissance, 1520–1600,* Peter Price, trans. (Geneva: Skira, 1968), p. 86.

23. Habgood, "Petroglyphs and Pictographs," Figs. 30, 44.

24. Vastokas and Vastokas, *Sacred Art,* Plate 25, Figs. 16–18; Prokofyeva, "The Costume," Fig. 30, p. 151.

25. Gimbutas, *Gods and Goddesses of Old Europe,* pp. 89–93; Jung, *Symbols of Transformation,* p. 368; see the human cross of Agrippa von Nettesheim, 1533, Fig. 26. The sign devised by Queen Elizabeth I's personal magus, Dr. John Dee, is in his *The Hieroglyphic Monad* (1564), J.W. Hamilton-Jones, trans. (New York: Samuel Weiser, 1977).

26. Neumann, *The Great Mother,* Figs. 54, 57, Plates 93, 117; Jung, *Symbols of Transformation,* Figs. 27, 33, 36–39, pp. 233 and passim.

27. Mallery, *Picture-writing,* Figs. 721, 723, 1230, and pp. 515, 724; Black Elk, *The Sacred Pipe,* passim; Terence Grieder, *Origins of Pre-Columbian Art* (Austin: University of Texas Press, 1982), Fig. 32 from L.C. Faron, *The Mapuche Indians of Chile* (New York: Holt, Rinehart & Winston, 1968).

28. Eliade, *Shamanism,* p. 266.

7. MYSTICAL PHYSIOLOGY

1. Eliade, *Shamanism,* pp. 148f, 158f, 434f; Prokofyeva, "The Costume," Fig. 16, p. 138; Furst, "Roots and Continuities"; Hedges, "Southern California Rock Art"; Wellman, "X-ray Motifs in North American Indian Rock Art," in Shari T. Grove, ed., *American Indian Rock Art* 1974 (Farmington, N. Mex.: San Juan County Museum Assoc., 1975), pp. 137–46.

2. Smithsonian Institution, Washington, D.C., leather, hair, carved wood, Catalogue No. 89038. For an Australian version, Glenbow Archives, Photo C313-11.

3. Plains Indian hair bone breastplate, University of Alberta Collection, Edmonton; "Red Cloud, Chief of the Sioux," photo by Bell, 1880, Old West Collection Series, El Paso, Texas; "Blood Indians" and "Blackfoot Indians," provincial Archives of Alberta photos A1630 and A3249-50. Ewers investigated the origins, commercial manufacture and trade of "hair-pipes" (originally used for hair decoration), showing distribution and use of hair-bone vests among Plains Indians beginning in the mid-nineteenth century, but he neglected the question of that particular garment's symbolism and its possible connection with shamanism. *Hair Pipes in Plains Indian Adornment: A Study in Indian and White Ingenuity,* Anthropological Paper 50, Bureau of American Ethnology, Smithsonian Institution (Washington, D.C.: Government Printing Office, 1957).

4. Hedges, "Southern California Rock Art," Fig. 37; Glenbow Archives Photo Series C267-52, 91–92. Reticulated patterns appear on Blood In-

dian Moccasins c. 1910. Glenbow Archives Photo NA 1400-7.

5. Glenbow Archives photo, R.N. Wilson, 1892, NA 668.8; Ewers, *Blackfeet Indian Tipis: Design and Legend* (Bozeman, Mont.: Museum of the Rockies, 1976), portfolio of designs on tipis at encampments, 1944, 1945, especially the "person tipis," Nos. 18 and 19.

6. Glenbow Museum, Catalogue No. AF 1810-H. It is apparently the same bundle cited by Brasser in "Wolf Collar, the Shaman Artist," in Brodzky, Danesewich, and Johnson, eds., *Stones, Bones and Skin,* p. 40.

7. Vastokas and Vastokas, *Sacred Art,* pp. 83f, Figs. 22–24, Plate 17.

8. Neumann, *The Great Mother,* compares examples from Neolithic Yugoslavia, Egypt and Crete, Syria and Babylonia, India, and pre-Columbian Mexico, Figs. 22–25, Plates 50, 53–55, pp. 137–41. Mallery, *Picture-Writing,* shows squatting figures in California petroglyphs, some of them androgynous, Figs. 24 and 33. See also Vastokas and Vastokas, *Sacred Art,* Plate 8, pp. 89f; Dewdney and Kidd, *Indian Rock Paintings,* p. 77, and Hedges, "Southern California Rock Art," Fig. 17.

9. *Story on Stone,* p. 57; Keyser, "Writing-on-Stone," p. 30.

10. Grieder, *Origins of Pre-Columbian Art,* Figs. 15–17, pp. 39–43; Mallery, *Picture-Writing,* Figs. 124, 130, 146, 150–55; Stuart Piggott, *Scotland Before History, with Gazeteer of Ancient Monuments* by Graham Ritchie (Edinburgh: Edinburgh University Press, 1982), pp. 130–31, 166, 181. Grieder's developmental theories are based on archaeologically datable first appearances; he stresses, however, that once invented the motifs of each stage are not abandoned in

the next, but incorporated in the new repertoire.

11. Cf. the uterine design of chambered tombs in Scotland where the dead were buried in foetal position as if awaiting rebirth. Piggott, *Scotland Before History,* pp. 40, 50, 130.

12. Grieder, *Origins of Pre-Columbian Art,* pp. 22–28. Vastokas and Vastokas, *Sacred Art,* Plates 16, 20, Figs. 21, 24. A famous design is the vaginal or eye-shaped slot made to penetrate a cave in Santa Barbara County, Calif., so that at the winter solstice a ray of the returning sun suddenly enters to illuminate the image of a condor painted on the interior wall. Maxwell, *The Temescals of Arroyo Conejo,* pp. 61–62.

8. ANIMALISTIC NATURE

1. Eliade, *Shamanism,* pp. 174–75; Prokofyeva states that the bow preceded the drum in shamanistic usage. "The Costume," p. 140.

2. Heraclitus (c. 540–480 B.C.) made the bow and the lyre symbols of the "hidden attunement of the most divergent things." Boris Vysheslawzeff, "Two Ways of Redemption: Redemption as Resolution of the Tragic Contradiction," in Campbell, ed., *The Mystic Vision,* pp. 24–25.

3. Asian Art Museum, *Exhibition of Near Eastern Masterpieces,* catalogue, Avery Brundage Collection (San Francisco: 1984–1985).

4. Hedges, "Southern California Rock Art," pp. 131, 135; Vuncannon, "Grand Gulch," Fig. 12.

5. Johannes Maringer, *The Gods of Prehistoric Man,* Mary Ilford, trans. (New York: Alfred A. Knopf, 1960), Plates XXIV–XXVI; Moorey et al., *Ancient Bronzes,* p. 185, Catalogue No. 946; Aboriginal Arts Board, The Australia Council, *Art of the First Australians,* exhibition catalogue,

Conzinc Riotinto of Australia Collection (Canberra: n.d.), pp. 65–66; Ewers, *Blackfoot Indian Tipis;* Glenbow Archives photos NA 668-12, 668-8; Alberta Provincial Archives photos P39-40, P39-184; Wellman, "X-ray Motifs"; Clara Lee Tanner, *Southwest Indian Craft Arts* (Tucson: University of Arizona Press, 1968), Fig. 4.7, p. 96; Arizona State Museum Collection, Catalogue Nos. 41331–41332.

6. Eliade, *Shamanism,* pp. 90f. Shaman figures are paired with animals in Brazilian petroglyphs. Mallery, *Picture-Writing,* Fig. 112. In India, the conjunction of "anthropomorphic to animal figure is a common trait of iconography." Heinrich Zimmer, *Myths and Symbols in Indian Art and Civilization,* Joseph Campbell, ed. (Princeton: Princeton University Press/Bollingen, 1972), pp. 70–71. "The animal symbol, placed beneath, is interpreted as carrying the human figure and is called the 'vehicle,' a motif traceable to at least 1500 B.C. in Mesopotamia, but no doubt originated much earlier in perishable works of art."

7. Jung, *Symbols of Transformation,* Plate LVIII; Zimmer, *Myths and Symbols,* Fig. 13.

8. Dewdney's drawings, Glenbow Archives, D68.18.1-21 (1960–1961); Halmrast's photos (*Story on Stone,* p. 24) show the portion at the right which vandals destroyed while trying to remove the main composition.

9. Brasser relates that Wolf Collar acquired the medicine bundle from a grizzly bear that appeared to him in a dream in 1875. This bundle empowered him to cure gunshot wounds; with the claw he could tear open a gun barrel. The dream-bear was the same as one he had fought and killed earlier. "Wolf Collar," p. 40. The

two bundles mentioned here may be the same item.

10. For example, Alice Marriott and Carol K. Rachlin, *Plains Indian Mythology* (New York: Mentor/New American Library, 1977); Richard Erdoes and Alphonse Ortiz, eds., *American Indian Myths and Legends* (New York: Pantheon Books, 1984); and Black Elk, *The Sacred Pipe.* Soviet ethnologists have analyzed these concepts as found in Siberian lore: Chernetsov, "Concepts of the Soul"; Anisimov, "The Shaman's Tent"; G.M. Vasilevich, "Early Concepts about the Universe among the Evenks (Materials)," in Michael, ed., *Studies in Siberian Shamanism,* pp. 46–83. Erwin Rouselle discusses their sources and meaning in "Dragon and Mare Figures of Primordial Chinese Mythology," in Campbell, ed., *The Mystic Vision,* pp. 103–4.

11. The sexual implications of bow and arrow together evidently derive from their analogous function as fire-making tools. Jung, *Symbols of Transformation,* pp. 159–60 and passim, expounds on this symbolism with emphasis on examples from India.

12. Maringer, *The Gods of Prehistoric Man,* Figs. 14, 16–19, 24; Mulloy, *A Preliminary Historical Outline,* Figs. 48, 49, 51.

13. Anisimov, "Cosmological Concepts," p. 163; see also his "The Shaman's Tent," pp. 84–123, and Vasilevich, "Early Concepts," pp. 46–83.

14. Eliade, *Shamanism,* p. 160.

9. THE CELESTIAL BIRD

1. Jung, *Symbols of Transformation,* p. 246n.

2. Neumann, *The Great Mother,* passim; for the bird-headed goddesses of the Eastern Mediterranean, see his several plates.

3. Eliade, *Shamanism,* pp. 82, 156–58; Brasser, "Wolf Collar," p. 38–41. This vision, which occurred about 1870, is one of many that distinguished this shaman's life. See also Brasser's "The Creative Visions of a Blackfoot Shaman," *Alberta History* 23, no. 2 (1973), pp. 14–16.

4. Eliade, *Shamanism,* pp. 245, 403f.

5. Quoted in Mallery, *Picture-Writing,* p. 247. Cf. Prokofyeva, "The Costume," p. 128f.

6. Glenbow Museum, Catalogue No. AP2563; photo in *The Spirit Sings: Artistic Traditions of Canada's First Peoples,* exhibition catalogue, Glenbow-Museum, Jan.–May, 1988 (Toronto and Calgary: McClelland and Stewart/ Glenbow-Alberta Institute, 1987), p. 79. The same or similar tipis were photographed in 1908, 1911, and 1913 at the Ochapowache Reserve, Saskatchewan. Glenbow Archives NA 1463-43, 45, 46.

7. Halmrast, personal communication.

8. Alberta Provincial Museum Collection, Catalogue Nos. H68.117.2 and 1466.394.1A; Brasser, "Wolf Collar," p. 39.

9. In Siberia the rattling metallic objects attached to the shaman's costume refer to his mystical skeleton. Eliade, *Shamanism,* pp. 158f. In North America bells and tinkling cones may have had a similar meaning. On the spotted eagle as the solar bird, in Oglala Sioux tradition a giver of revelations, Black Elk, *The Sacred Pipe,* passim.

10. Brasser, "Wolf Collar," pp. 38, 40; *Story on Stone,* p. 8; Stocken, *Among the Blackfoot,* pp. 43f; Alberta Provincial Archives phono-tape AH 68.12.1 and its translation.

11. Habgood, "Petroglyphs and Pictographs," pp. 12, 16, Figs. 32–33, 41–42, 44, 46; Mulloy, *A Pre-liminary Historical Outline,* Figs. 51, 54; Dewdney and Kidd, *Indian Rock Paintings,* passim; Wellman, "Some Observations on the Bird Motif," Figs. 1, 8, 10; Vastokas and Vastokas, *Sacred Art,* Fig. 26. The form is also called "triangular" (Habgood) and "hour-glass" (Dewdney). It was worked into circular porcupine-quill medallions worn by the Arikara and Ojibway Indians painted by George Catlin, e.g., *Bloody Hand,* 1832, and *A Troupe of Indians in London,* 1844, both reprod. in Haverstock, *Indian Gallery,* pp. 91, 176–77.

12. Dewdney, *Indian Rock Art,* p. 5, and *Dating Rock Art,* pp. 19–20.

13. A superb example of the bald-headed type of bird is the pictograph of a condor in a cave in southern California used for solstice rituals, reprod. in Maxwell, *The Temescals,* pp. 61–62.

14. Mulloy, *A Preliminary Historical Outline,* Fig. 43; Prokofyeva, "The Costume," passim.

15. Eagle-feather crowns worn by Horn Society dancers of the Blood Indian Reserve c. 1940 are in Glenbow Archives photo NA 2563-6.

16. *Story on Stone,* p. 40.

17. Habgood, "Petroglyphs and Pictographs," Figs. 32–33; Dewdney, *Indian Rock Art,* p. 5; Mulloy, *A Preliminary Historical Outline,* Fig. 41; Vastokas and Vastokas, *Sacred Art,* Fig. 26; Wellman, "Some Observations on the Bird Motif," Figs. 9–10.

18. Vastokas and Vastokas, *Sacred Art,* Plate 25 and Figs. 11, 16–18; Habgood, "Petroglyphs and Pictographs," Figs. 42, 44; Mulloy, *A Preliminary Outline,* Figs. 42, 46.

19. Dewdney, *Indian Rock Art,* p. 5.

20. Black Elk, *The Sacred Pipe,* pp. 58–59.

10. THE SPIRIT OF THE HORSE

1. See Ted J. Brasser, *"Bo-jou, Neejee!"* in which some twenty photos of Plains Indian artifacts illustrate the point, as do numerous photos and collections, Provincial Archives of Alberta, Edmonton, and Glenbow Museum, Calgary. Additional examples appear in *The Spirit Sings,* pp. 71–89.

2. Ewers, *The Horse in Blackfoot Culture,* pp. 278–79.

3. Dempsey, *A History of Writing-on-Stone,* p. 16 and personal communication.

4. I thank John Priegert, curator of collections, Archaeological Survey of Alberta, for drawing my attention to these horse images. Somewhat similar horses appeared in Arizona. Charles D. James III and Howard M. Davidson, "Style Changes of the Horse Motif in Navajo Rock Art: A Preliminary Analysis," in Sutherland, ed., *American Indian Rock Art* 2, Figs. 2–3.

5. Franz Boas, *Primitive Art* (1927) (New York: Dover, 1955), p. 80.

6. Keyser, *Report.*

7. Ewers, *Indian Life,* Plate 16, and *The Horse in Blackfoot Culture,* pp. 100, 324; James and Davidson, "Style Changes," Figs. 2, 7, 9.

8. Dewdney, *Indian Rock Art,* pp. 8–9.

9. Keyser, "A Lexicon," p. 57, Fig. 10. Horse medicine bundles, purchased from the horse medicine man and hung on the bridle, were coveted items of prestige. Ewers, *The Horse in Blackfoot Culture,* pp. 220–21, 242–44, 278.

10. *The Chinese Exhibition: Archaeological Finds of the People's Republic of China* (Toronto: Royal Ontario Museum, 1974), catalogue no. 222.

11. Black Elk, *The Sacred Pipe,* p. 23.

12. Ewers, *The Horse in Blackfoot Culture,* pp. 226–27, Fig. 32.
13. Neumann, "Mystical Man," pp. 401f.

11. CONCLUSION

1. Eliade, *Cosmos and History,* p. vii.
2. Radin, *Primitive Man as a Philosopher,* p. 387.
3. Hans Peter Duerr, *Dreamtime: Concerning the Boundary between Wilderness and Civilization,* Felicitas Goodman, trans. (Oxford and New York: Basil Blackwell, 1985).
4. A summary of these publications is in Margaret W. Conkey, "New Approaches in the Search for Meaning? A Review of Research in 'Paleolithic Art,' " *Journal of Field Archaeology* 14, no. 4 (1987), pp. 413–30.

BIBLIOGRAPHY

Aboriginal Arts Board, The Australia Council. *Art of the First Australians,* exhibition catalogue, Conzinc Riotinto of Australia Collection (Canberra: n.d.).

Adams, Gary, Michael R.A. Forsman, and Sheila J. Minni. *Archaeological Investigations: Writing-on-Stone N.W.M.P. Post* I, Alberta Historic Sites Service Occasional Paper 4 (Edmonton: 1977).

Anisimov, A.F. "Cosmological Concepts of the Peoples of the North," in Michael, ed., *Studies in Siberian Shamanism,* pp. 157–229.

———. "The Shaman's Tent of the Evenks and the Origin of the Shamanistic Rite," in Michael, ed., *Studies in Siberian Shamanism*, pp. 84–123.

Asian Art Museum. *A Decade of Collecting* (San Francisco: 1976–1977).

———. *Exhibition of Near Eastern Masterpieces,* catalogue, Avery Brundage Collection (San Francisco: 1984–1985).

Auerbach, Erich. "Figura" in his *Scenes from the Drama of European Literature,* Ralph Manheim, trans. (New York: Meridian Books, 1959).

Aveni, Anthony F. *Empires of Time: Calendars, Clocks, and Cultures* (New York: Basic Books, 1989).

Baldwin, Stuart J. *The Elk Point Burial,* Archaeological Survey of Alberta Occasional Paper 11 (Edmonton: 1978).

Barry, P.S. *Sketches of Pictographs near Tucson, Ariz., 1985* (personal archives).

Beattie, Judith Hudson. "Indian Maps in the Hudson's Bay Company Archives: A Comparison of Five Area Maps Recorded by Peter Fidler, 1801–1802," *Archivaria* 21 (Winter 1985–1986), pp. 166–75.

Black Elk. *The Sacred Pipe, Black Elk's Account of the Seven Rites of the Oglala Sioux,* Joseph Epes Brown, ed. (Harmondsworth: Penguin, 1983).

Boas, Franz. *Primitive Art* (1927) (New York: Dover, 1955).

Bourke, John G. "The Medicine-Men of the Apache," in *9th Annual Report,* Bureau of Ethnology, Smithsonian Institution 1887–1888 (Washington, D.C.: Government Printing Office, 1892), pp. 443–603.

Brasser, Ted J. *"Bo'jou, Neejee!": Regards sur l'art indien du Canada* (Une exposition itinérant due Musée national de l'Homme), Ottawa, 1976.

———. "The Creative Visions of a Blackfoot Shaman," *Alberta History* 23, No. 2 (1975), pp. 14–16.

———. "Wolf Collar, the Shaman Artist," in Brodzky, Danesewich, and Johnson, eds., *Stones, Bones and Sky,* pp. 38–41.

Brink, Jack. *Dog Days in Southern Alberta,* Archaeological Survey of Alberta Occasional Paper 28 (Edmonton: 1986).

———. Excavations at Writing-on-Stone, Archaeological Survey of Alberta Occasional Paper 12 (Edmonton: 1978).

Brodzky, Anne Trueblood, Rose Danesewich, and Nick Johnson. *Stone, Bones and Skin: Ritual and Shamanic Art* (Toronto: Society for Art Publications/Artscanada, 1977).

Brown, G., E. Gasser and R. McIsaac. *Biophysical Features and Land Use, Ross Lake Candidate Ecological Reserve,* report for Alberta Recreation and Parks, Ecological Reserves Committee (Calgary: ERS Environmental Research Services, 1986).

Brumley, John H. "The Ellis Site (EcOp4): A Late Prehistoric Burial Lodge/Medicine Wheel Site in Southeastern Alberta," in *Contributions to Plains Prehistory,* Archaeological Survey of Alberta Occasional Paper 26 (Edmonton: 1985), pp. 180–232.

———. "The Laidlaw Site: An Aboriginal Antelope Trap from Southeastern Alberta," in *Archaeology in Alberta 1983,* Archaeological Survey of

Alberta Occasional Paper 23 (Edmonton: 1984), pp. 96–127.

Buck, Mimi and Cheryl Rhodes. "Rock Art of West Central Colorado and Periphery," in Sutherland, ed., *American Indian Rock Art* 2, pp. 1–4.

Byrne, William J. *The Archaeology and Prehistory of Southern Alberta as Reflected in Ceramics,* 3 vols., Archaeological Survey of Canada Paper 14, Mercury Series (Ottawa: National Museum of Man, 1973).

Campbell, Joseph, *The Masks of God,* 4 vols. (Harmondsworth: Penguin, 1976).

————, ed. *Man and Time: Papers from the Eranos Yearbooks 3,* Ralph Manheim, trans. (Princeton: Princeton University Press/Bollingen, 1983).

————, ed. *The Mystic Vision: Papers from the Eranos Yearbooks 6,* Ralph Manheim, trans. (Princeton: Princeton University Press/Bollingen, 1982).

Campbell, Taryn Y. *Writing on Stone Provincial Park: Master Planning Study* (Edmonton: Alberta Recreation and Parks, 1981).

Castleton, Kenneth B. "Rock Art of the Uintah Basin of Utah," in Sutherland, ed., *American Indian Rock Art* 2, pp. 19–25.

Chastel, André. *The Crisis of the Renaissance, 1520–1600,* Peter Price, trans. (Geneva: Skira, 1968).

Chernetsov, V.N. "Concepts of the Soul among the Ob Ugrians," in Michael, ed., *Studies in Siberian Shamanism,* pp. 3–83.

The Chinese Exhibition: Archaeological Finds of the People's Republic of China (Toronto: Royal Ontario Museum, 1974).

Clark, D.W. "Some Practical Applications of Obsidian Hydration Dating in the Arctic," *Arctic* 37, No. 2 (June 1984), pp. 91–109.

Conkey, Margaret W. "New Approaches in the Search for Meaning? A Review of Research in 'Paleolithic Art,' " *Journal of Field Archaeology* 14, No. 4 (1987), pp. 413–30.

Conner, Stuart W. *Comparisons of Prehistoric Picture Writing at Writing-on-Stone Provincial Park, Alberta, with that of Central and South Central Montana,* unpubl. ms. (1961), in Glenbow Archives, Calgary.

Cormack, R.G.H. *Wild Flowers of Alberta* (Edmonton: Queen's Printer, 1967).

Dee, Dr. John. *The Hieroglyphic Monad* (1564), J.W. Hamilton-Jones, trans. (New York: Samuel Weiser, 1977).

Dempsey, Hugh A. *A History of Writing-on-Stone,* unpubl. ms. (1973), in Alberta Provincial Archives, Edmonton.

————. "Stone 'Medicine Wheels' – Memorials to Blackfoot War Chiefs," *Journal of Washington Academy of Science* 46, No. 6 (1956), pp. 177–82.

Dewdney, Selwyn. *Dating Rock Art in the Canadian Shield Region,* Royal Ontario Museum Occasional Paper 24 (Toronto: University of Toronto Press, 1970).

————. *Indian Rock Art,* Saskatchewan Museum of Natural History Popular Series 4 (Regina: 1963).

————. "Writings on Stone along the Milk River," *The Beaver* (Winter 1964), pp. 22–29.

———— and Kenneth E. Kidd. *Indian Rock Paintings of the Great Lakes* (Toronto: University of Toronto Press/Quetico Foundation, 1967).

Dickason, Olive. *The Myth of the Savage and the Beginnings of French Colonialism in America* (Edmonton: The University of Alberta Press, 1984).

Duerr, Hans Peter. *Dreamtime: Concerning the Boundary between Wilderness and Civilization,* Felicitas Goodman, trans. (Oxford and New York: Basil Blackwell, 1985).

Eliade, Mircea. *Cosmos and History: The Myth of the Eternal Return,* Willard R. Trask, trans. (New York: Harper Torchbooks/Bollingen Library, 1959).

————. *Patterns in Comparative Religion,* Rosemary Sheed, trans. (New York: New American Library, 1974).

————. *Shamanism: Archaic Techniques of Ecstasy,* Willard R. Trask, trans. (Princeton: Princeton University Press/Bollingen, 1974).

Erdoes, Richard and Alphonse Ortiz, eds. *American Indian Myths and Legends* (New York: Pantheon Books, 1984).

Ewers, John C. *Blackfeet Indian Tipis: Design and Legend* (Bozeman, Montana: Museum of the Rockies, 1976).

————. *The Blackfeet: Raiders on the Northwest Plains* (Norman: University of Oklahoma Press, 1958).

————. *Hair Pipes in Plains Indian Adornment: A Study in Indian and White Ingenuity,* Anthropology Paper 50, Smithsonian Institution, Bureau of American Ethnology (Washington, D.C.: Government Printing Office, 1957).

————. *The Horse in Blackfoot Culture, with Comparative Material from other Indian Tribes,* Bulletin 159, Smithsonian Institution, Bureau of American Ethnology (Washington, D.C.: Government Printing Office, 1955).

————. *Indian Life on the Upper Missouri* (Norman: University of Oklahoma Press, 1968).

Faron, L.C. *The Mapuche Indians of Chile* (New York: Holt, Rinehart & Winston, 1968).

Fell, Barry, *Bronze Age America* (Boston: Little, Brown, 1982).

Fidler, Peter, *Peter Fidler's Journals,* Hudson's Bay Co. Archives, Provincial Archives of Manitoba, E3/2.

Forbis, R.G. *Cluny: An Ancient Fortified Village in Al-*

berta, University of Calgary, Dept. of Archaeology Occasional Paper 4 (Calgary: 1977).

————. *A Review of Alberta Archaeology to 1964,* National Museum of Canada Publications in Archaeology 1 (Ottawa: 1970).

Furst, Peter T. "The Roots and Continuities of Shamanism," in Brodzky, Denesewich, and Johnson, eds., *Stones, Bones and Skin,* pp. 1–28.

Getty, Ronald. *The Many Snakes Burial (DgOv12): A Primary Inhumation from Southern Alberta* (Calgary: University of Calgary, 1971).

Gill, Sam D. *Native American Religions: An Introduction* (Belmont, Calif.: Wadsworth Publishing Co., 1982).

Gimbutas, Marija. *The Gods and Goddesses of Old Europe, 7000 to 3500 B.C.: Myths, Legends and Cult Images* (Berkeley and Los Angeles: University of California Press, 1974).

Grant, Campbell. *Rock Art of the American Indian* (New York: Thomas Y. Crowell, 1967).

Graspointer, Andreas. *Archaeology and Ethnohistory of the Milk River in Southern Alberta* (Calgary: Western Publishers, 1980).

Graves, Robert. *The Greek Myths* (Baltimore: Penguin, 1957).

————. *The White Goddess: A Historical Grammar of Poetic Myth* (New York: Vintage Books, 1958).

Grieder, Terence. *Origins of Pre-Columbian Art* (Austin: University of Texas Press, 1982).

Grove, Sheri T., ed. *American Indian Rock Art 1974* (Farmington: N. Mex.: San Juan County Museum Assoc., 1975).

Habgood, Thelma. "Petroglyphs and Pictographs in Alberta," *Newsletter,* Archaeology Society of Alberta, 13–14 (Summer 1967), pp. 1–30.

Haverstock, Mary Sayre. *Indian Gallery: The Story of George Catlin* (New York: Four Winds Press, 1973).

Hedges, Ken. "Southern California Rock Art as Shamantic Art," in Sutherland, ed., *American Indian Rock Art 2,* pp. 126–38.

Hill, Beth. *Guide to Indian Rock Carvings of the Pacific Northwest Coast* (Surrey, B.C.: Hancock House, 1980).

Hopkins, David M., John V. Mathews Jr., Charles E. Schweger, and Steven B. Young, eds. *Paleoecology of Beringia* (New York: Academic Press, 1982).

Hultkrantz, Åke. *Prairie and Plains Indians,* Iconography of Religions X, Institute of Religious Iconography, State University Groningen (Leiden: E.J. Brill, 1973).

————. *The Religions of the American Indians,* Monica Setterwall, trans. "Hermeneutics: Studies in the History of Religions" (Berkeley and Los Angeles: University of California Press, 1967).

Hurt, Leslie J. *A History of Writing-on-Stone N.W.M.P. Post,* Alberta Historic Sites Service Occasional Paper 5 (Edmonton: 1979).

James, Charles D. III and Howard M. Davidson. "Style Changes of the Horse Motif in Navajo Rock Art: A Preliminary Analysis," in Sutherland, ed., *American Indian Rock Art 2,* pp. 27–46.

Janson, H.W. and Dora Jane Janson. *The Picture History of Painting* (New York: Harry N. Abrams, 1957).

Johnson, Alice M., ed. *Saskatchewan Journals and Correspondence, 1795–1802,* The Hudson's Bay Record Society Publication 26 (London: 1967).

Jung, C.G. *Symbols of Transformation,* R.F.C. Hull, trans. (Princeton: Princeton University Press/Bollingen, 1972).

Keyser, James D. "A Lexicon for Historic Plains Indian Rock Art: Increasing Interpretive Potential," *Plains Anthropologist* (1987), pp. 43–71.

————. *The Rock Art of Writing on Stone: Report Submitted in Partial Fulfillment of Rock Art Research Project at Writing-on-Stone Provincial Park,* funded by Alberta Provincial Parks Dept., unpubl. (1976), in archives, Archaeological Survey of Alberta, Edmonton. Called *Report.*

————. "A Shoshonean Origin for the Plains Shield Bearing Warrior Motif," *Plains Anthropologist* (1975), pp. 207–16.

————. "Writing-on-Stone: Rock Art on the Northwestern Plains," *Canadian Journal of Archaeology* 1 (1977), pp. 15–80.

King, D.R. *Prehistoric Rock Art in Alberta,* unpubl. ms. (1965), in Glenbow Archives, Calgary.

Krupp, E.C. *Echoes of the Ancient Skies: The Astronomy of Lost Civilizations* (New York: New American Library, 1984).

Kühn, Herbert. "Das Problem des Urmonotheismus," trans. in Campbell, *Masks of God* I, p. 345.

Laville, Henri, Jean-Philippe Rigaud, and James Sackett. *Rock Shelters of the Perigord: Geological Stratigraphy and Archaeological Succession* (New York: Academic Press, 1980).

Lethbridge, Alberta. Map 82H, 1:250,000, Geological Survey of Canada (Ottawa: 1977).

Levenson, Jay A. *Prints of the Italian Renaissance: A Handbook of the Exhibition* (Washington, D.C.: National Gallery of Art, 1973), catalogue no. 327.

Lévi-Strauss, Claude. *The Savage Mind (La Pensée Sauvage),* trans. unknown (London: Weidenfeld and Nicolson, 1966).

Lewis, Meriwether, William Clark, et al. *History of the Expedition under the Command of Captains Lewis and Clark to the Sources of Missouri, across the Rocky Mountains, down the Columbia River to the Pacific in 1804–6,* 3 vol. limited repr. of 1814 ed. (New York: New Amsterdam Book Co., 1902).

Lowie, R.H. *Primitive Society* (New York: Boni and Liveright, 1925).

Mallery, Garrick. *Picture-Writing of the American Indians,* 10th Annual Rept., Bureau of Ethnology, Smithsonian Institution 1888–1889 (Washington, D.C.: Government Printing Office, 1893).

Maringer, Johannes. *The Gods of Prehistoric Man,* Mary Ilford, trans. (New York: Alfred A. Knopf, 1960).

Marriott, Alice and Carol K. Rachlin. *Plains Indian Mythology* (New York: Mentor/New American Library, 1977).

Maxwell, Thomas J., Jr. *The Temescals of Arroyo Conejo* (Thousand Oaks, Calif.: Calif. Lutheran College, 1982).

McCullough, Edward J. *Prehistoric Cultural Dynamics of the Lac La Biche Region,* Archaeological Survey of Alberta Occasional Paper 18 (Edmonton: 1982).

Michael, Henry N., ed. *Studies in Siberian Shamanism,* "Anthropology of the North: Translations from Russian Sources" 4 (Toronto: Arctic Institute of North America/University of Toronto Press, 1963).

Moorey, P.R.S., Emma C. Bunker, Edith Porada, and Glenn Markoe. *Ancient Bronzes, Ceramics and Seals,* The Nasli M. Heeramaneck Collection, Ancient Near-Eastern, Central Asiatic and European Art (Los Angeles: L.A. County Museum of Art, 1981).

Mulloy, William. *A Preliminary Historical Outline for the Western Plains,* University of Wyoming Publ. 20, No. 1 (Laramie: 1958).

Murdoch, John. "Ethnological Results of the Point Barrow Expedition," in *9th Annual Report,* Bureau of Ethnology, Smithsonian Institution 1887–1888 (Washington, D.C.: Government Printing office, 1892), pp. 19–441.

Neumann, Erich. "Art and Time," in Campbell, ed., *Man and Time,* pp. 3–37.

———. *The Great Mother: An Analysis of an Archetype,* Ralph Manheim, trans. (Princeton: Princeton University Press/Bollingen, 1972).

———. "Mystical Man," in Campbell, ed., *The Mystic Vision,* pp. 375–415.

Panofsky, Erwin. *Meaning in the Visual Arts: Papers in and on Art History* (Garden City, N.Y.: Anchor Books, 1955).

Piggott, Stuart. *Scotland Before History, with Gazeteer of Ancient Monuments* by Graham Ritchie (Edinburgh: Edinburgh University Press, 1982).

Prokofyeva, Ye. D. "The Costume of an Enets Shaman," in Michael, ed., *Studies in Siberian Shamanism,* pp. 124–56.

Radin, Paul. *Primitive Man as a Philosopher* (New York: Dover, 1957).

———. *Primitive Religion: Its Nature and Origin* (New York: Dover, 1957).

———. *The Trickster: A Study in American Indian Mythology,* with commentary by Karl Kerenyi and C.G. Jung (New York: Greenwood Press, 1969).

Reeves, Brian O.K. *Culture Change in the Northern Plains: 1000 B.C. – A.D. 1000,* Archaeological Survey of Alberta Occasional Paper 20 (Edmonton: 1983).

———. "Head-Smashed-In: 5,500 Years of Bison Jumping in the Alberta Plains," *Plains Anthropologist,* Memoir 14, 23, No. 2 (1978), pp. 151–74.

Reichel-Dolmatoff, Gerardo. *Amazonian Cosmos: The Sexual and Religious Symbolism of the Tukano Indians* (Chicago: University of Chicago Press, 1971).

Retreat of Wisconsin Recent Ice in North America.

Map 1257A, Geological Survey of Canada (Ottawa: 1969).

Robertson, Marion. *Rock Drawings of the Micmac Indians,* George Creed's tracings of the petroglyphs, reprod. by Lynda Peverell (Halifax: The Nova Scotia Museum, 1973).

Rousselle, Erwin. "Dragon and Mare Figures of Primordial Chinese Mythology," in Campbell, ed., *The Mystic Vision,* pp. 103–19.

Rubin, William. *"Primitivism" in 20th Century Art: Affinity of the Tribal and the Modern,* 2 vol. exhibition catalogue (New York: Museum of Modern Art, 1984).

Seznec, Jean. *The Survival of the Pagan Gods: The Mythological Tradition and Its Place in Renaissance Humanism and Art,* Barbara F. Sessions, trans. (New York: Harper Torchbooks/Bollingen Library, 1961).

The Shorter Oxford English Dictionary on Historical Principles, revised ed. C.T. Onions, ed., (Oxford: The Clarendon Press, 1965).

The Spirit Sings: Artistic Traditions of Canada's First Peoples, exhibition catalogue (Toronto and Calgary: McClelland and Stewart/Glenbow-Alberta Institute 1987).

Stocken, Cannon H.W. Gibbon. *Among the Blackfoot and Sarcee,* intro. Georgeen Barrass (Calgary: Glenbow-Alberta Institute, 1976).

Story on Stone, Project 20, Archaeological Society of Alberta, Lethbridge Centre (Lethbridge: 1980).

Sutherland, Kay, ed. *American Indian Rock Art* 2 (El Paso, Tex.: El Paso Archaeological Society, 1976).

Tanner, Clara Lee. *Southwest Indian Craft Arts* (Tucson: University of Arizona Press, 1968).

Truettner, William H. *The Natural Man Observed: A Study of Catlin's Indian Gallery,* sponsored by Amon Carter Museum of Western Art, Fort Worth, Tex., and National Collection of Fine

Arts, Smithsonian Institution (Washington, D.C.: Smithsonian Institution Press, 1979).

Tyrell, J.B., ed. *David Thompson's Narrative of His Explorations in Western America* (Toronto: The Champlain Society, 1916).

van der Leeuw, Gerardus. "Primordial Time and Final Time," in Campbell, ed., *Man and Time,* pp. 324–50.

Vasilevich, G.M. "Early Concepts about the Universe among the Evenks (Materials)," in Michael, ed., *Studies in Siberian Shamanism,* pp. 46–83.

Vastokas, Joan M. "The Shamanic Tree of Life," in Brodzky, Danesewich, and Johnson, eds., *Stones, Bones and Skin,* pp. 93–117.

——— and Romas K. Vastokas. *Sacred Art of the Algonkians: A Study of the Peterborough Petroglyphs* (Peterborough, Ont.: Mansard Press, 1973).

Verbicky-Todd, Eleanor. *Communal Buffalo Hunting among the Plains Indians,* Archaeological Survey of Alberta Occasional Paper 24 (Edmonton: 1984).

Vickers, J. Roderick. *Alberta Plains Prehistory: A Review,* Archaeological Survey of Alberta Occasional Paper 27 (Edmonton, 1986).

von Däniken, Erich. *Chariots of the Gods?* (New York: G.P. Putnam's Sons, 1974).

Vunconnon, Delci H. "Grand Gulch, Southeastern Utah's Picture Gallery," in Sutherland, ed., *American Indian Rock Art* 2, pp. 5–18.

Vysheslawzeff, Boris. "Two Ways of Redemption: Redemption as Resolution of the Tragic Contradiction," in Campbell, ed., *The Mystic Vision,* pp. 3–31.

Wellman, Klaus F. "Some Observations on the Bird Motif in North American Rock Art," in Sutherland, ed., *American Indian Rock Art* 2, pp. 97–108.

———. "X-ray Motifs in North American Indian Rock Art," in Grove, ed., *American Indian Rock Art* 1974, pp. 137–46.

Wershler, C.R. *South Writing-on-Stone Natural History,* unpubl. ms. (1980), Edmonton: Alberta Recreation and Parks.

Wölfflin, Heinrich. *Principles of Art History: The Problem of the Development of Style in Later Art,* M.D. Hottinger, trans. (New York: Dover, 1950).

Wormington, H.M. and Richard G. Forbis. *An Introduction to the Archaeology of Alberta, Canada,* Proceedings, Denver Museum of Natural History 11 (Aug. 1965).

Zimmer, Heinrich. *Myths and Symbols in Indian Art and Civilization,* Joseph Campbell, ed. (Princeton: Princeton University Press/Bollingen, 1972).

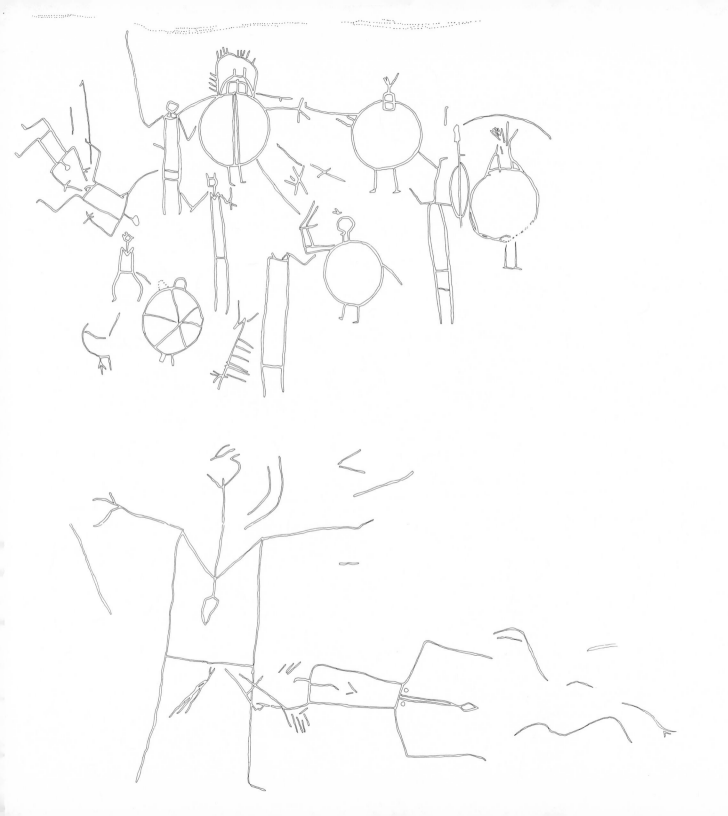

FOLDOUT I

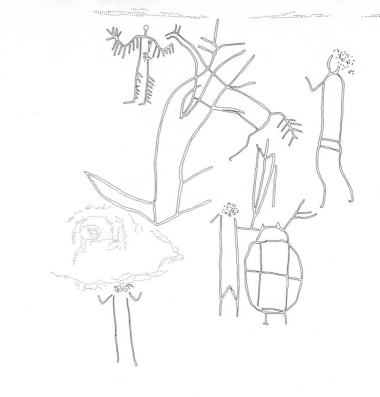

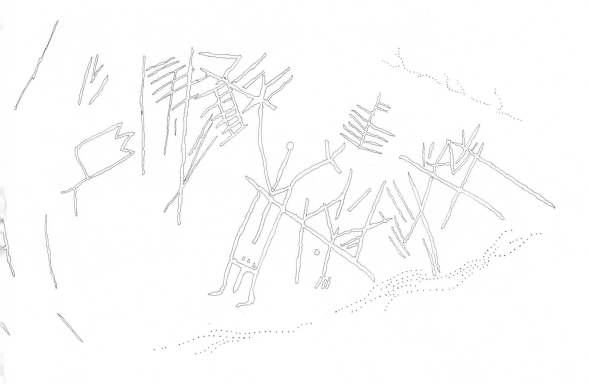

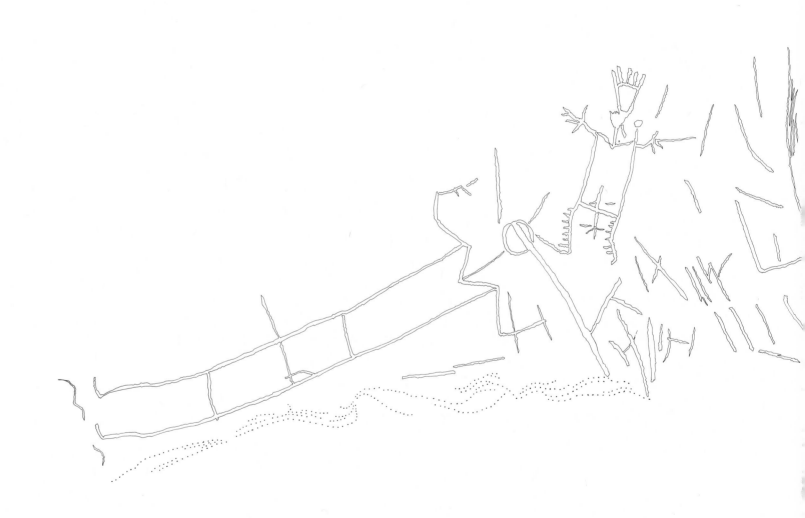

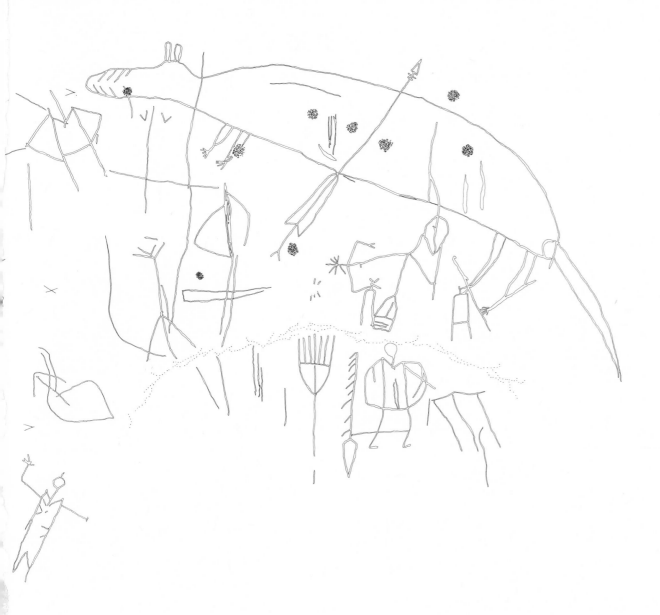

FOLDOUT 3

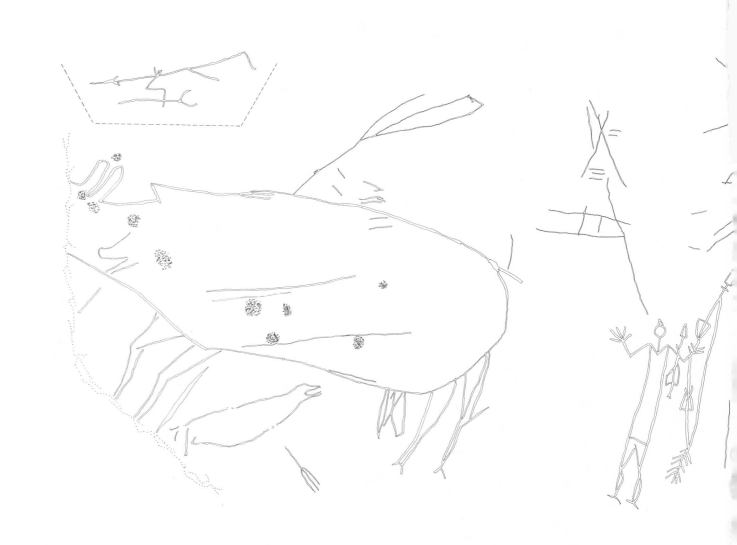